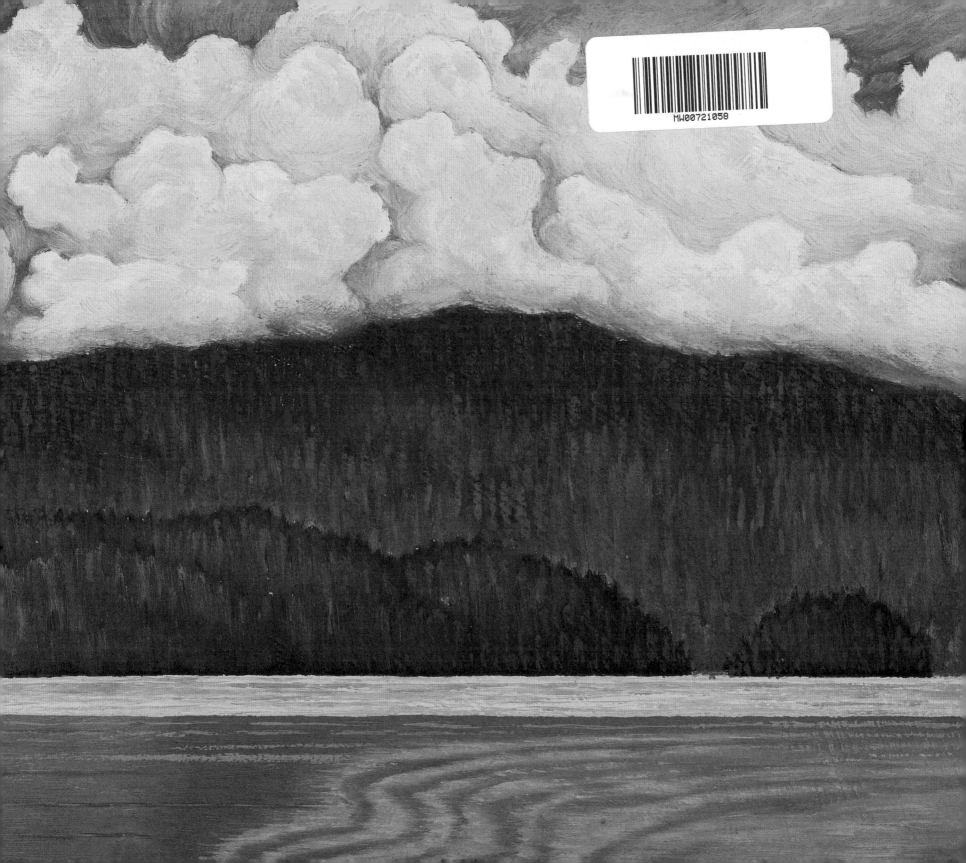

A JOURNEY WITH E.J. HUGHES

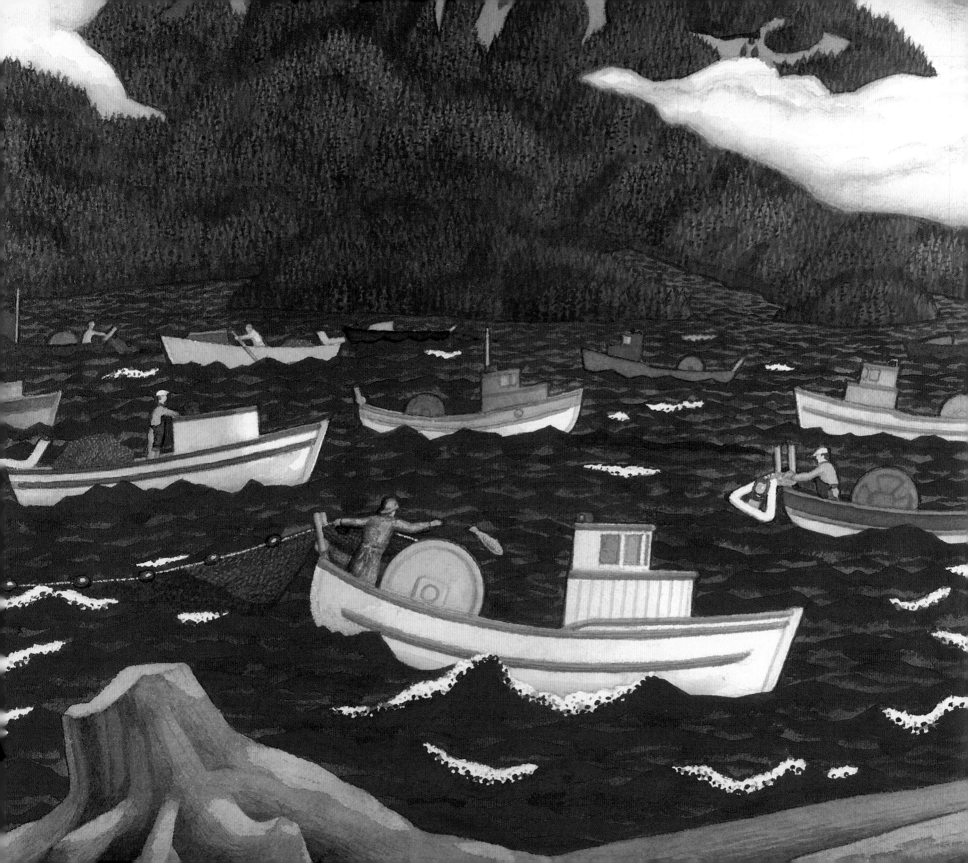

A JOURNEY WITH E.J. HUGHES

One Collector's Odyssey

JACQUES BARBEAU, QC

DOUGLAS & McINTYRE

VANCOUVER/TORONTO

Second edition 2005

05 06 07 08 09 5 4 3 2 1

Douglas & McIntyre Ltd.
2323 Quebec Street, Suite 201
Vancouver, British Columbia
V5T 4S7
www.douglas-mcintyre.com

Library and Archives Canada Cataloguing in Publication

Barbeau, Jacques, 1931–
 A journey with E.J. Hughes : one collector's odyssey / Jacques Barbeau. — 2nd ed.

Includes index.
ISBN 1-55365-153-7

 1. Hughes, E. J. (Edward John), 1913– 2. Barbeau, Jacques, 1931–
3. Painting—Collectors and collecting. 4. Collectors and collecting—British
Columbia—Biography. I. Hughes, E. J. (Edward John), 1913– II. Title.

N6549.H84A4 2005 759.11 C2005-903267-7

Editing by Naomi Pauls (*second edition*)
Jacket and text design by Lara Shecter, Bodega Books
Jacket front: *Steamer in Grenville Channel, B.C.*, 1952 oil on canvas, 71.12 x 91.44 cm, Barbeau Foundation
Photographs by Lara Shecter (p. *vi*), Jim Allan (p. *viii*) and *Victoria Times Colonist* (p. 154, courtesy of Andrew Phillips)
Printed and bound in China, P.R.C., by C&C Offset Printing Co., Ltd.
Printed on acid-free paper ∞

To Margaret,
who supported me so loyally
in my journey with E.J. Hughes
For Jean, Jacqueline, Monique, Paul
and our grandchildren

E.J. Hughes, RCA, *D.Lit,* DFA

May 2005

CONTENTS

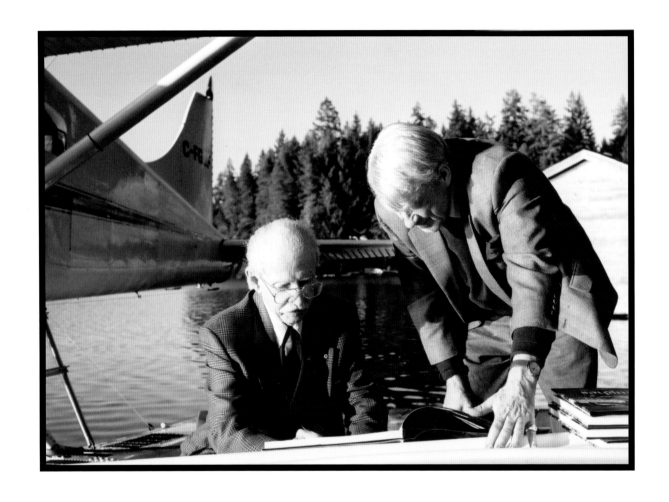

E.J. Hughes and Jacques Barbeau

The artist signs copies of Ian Thom's book _E.J. Hughes_, 2003

Preface to Second Edition

In the first edition of *A Journey with E.J. Hughes* I intimated that, subject to one missing link, I had completed the collection of works of this great artist. Though this limitation was circumvented by the inclusion of a last-minute visual postscript, I was convinced that the fifty-five-piece collection was a *fait accompli*. Little did I know that my obsession would rule otherwise and compel me to carry on my mission! The journey was yet to be completed.

The art of E.J. Hughes was simply too seductive. I could not resist adding to the collection. No other pastime— business or otherwise—was as fulfilling. At seventy it seemed too early to give up the chase, even though the impending challenge was to uncover a Hughes rather than merely buy one at the Dominion Gallery. With a reduced business schedule, time, if not money, was more readily available to pursue my avocation. Now, with twenty-one works added to the collection since 2000, an updating of the journey seemed apropos.

Thanks to Ian Thom, an addendum was also required to correct certain errors in the first edition and to include a particularly significant linocut—*Near Second Beach*—that I failed to include in my original text. In his majestic opus *E.J. Hughes,* Ian subtly corrected certain factual inaccuracies in my original text that need to be acknowledged. A second edition also permits me to reply to certain critiques of my original monograph.

This new edition includes a commentary upon the publication of Ian Thom's book and the opening of the E.J. Hughes national retrospective exhibition organized by the Vancouver Art Gallery in 2003. All this new stuff, again in chronological order, is found beginning on page 79, for those who may be familiar with the contents of the first edition.

Finally, a word of appreciation to a few people who made this revision possible. Naomi Pauls, as editor-in-chief, is to be commended for having transformed a raw manuscript into a grammatically readable text. Her suggestions and *savoir faire* on matters of content were as necessary as they were welcomed. It is an enlightening—and enjoyable— experience to work with such an astute and sensitive editor. Only my stubbornness stood in the way. Again, dear Brian Goble exercised his extraordinary talents on the Leica camera to replicate Hughes' art on paper. This is never a facile task, and Brian achieves a standard that is envied by his profession. He contributed much to the appeal of the monograph—perhaps even more than the commentary. For the aesthetic layout of the text, the sensitive calibration of the colour reproductions, and more particularly for the edifying book cover, my special thanks to the multi-talented Lara Shecter of Bodega Books.

To leave a book behind you is the surest form of afterlife. —Samuel Pepys

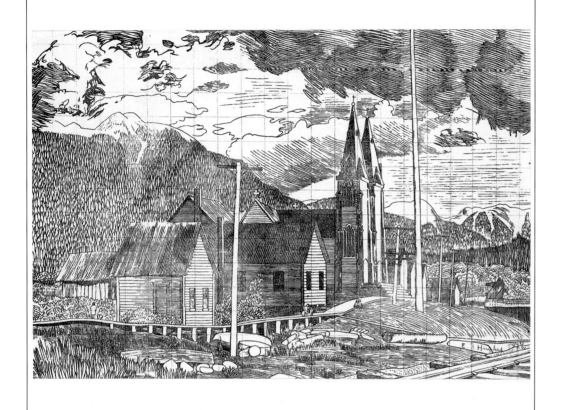

To Jacques Barbeau:
Just two prints made from this
linoleum block, probably just before
W.W. II. I had hoped to make more
prints but enlisted in the Coast Artillery.
I don't have the block any more.
Thanks again for the lunch
at the Empress.
E. J. Hughes.

Indian (Church) Study

1934 pencil, 30.5 x 25.4 cm

Preface to First Edition

I have undertaken this monograph as a labour of love to relive the joy and fulfillment of my journey with E.J. Hughes and to provide a family record of the circumstances under which the collection was assembled.

If this journey was possible at all, it is largely thanks to Michel Moreault of the Dominion Gallery in Montreal, who first introduced me to the art of E.J. Hughes. In addition to guiding and directing me on my journey, he has become a valued friend and a wise counsellor. We indeed made the journey together.

Obviously, however, the real catalyst was the artist himself. E.J. Hughes not only shared his art with me, but also gave of his precious time to afford me the benefit of his observations and insights on matters ranging from the aesthetic to the mundane.

I am particularly indebted to Pat Salmon, the official biographer of E.J. Hughes, for her many insightful suggestions. Whether correcting an error relating to the provenance of a given work or providing the historical background to a particular Hughes canvas, Pat Salmon's contribution to this overall project was much needed and appreciated.

David Heffel, who is as enthusiastic about Hughes' art as I am, has been a truly dedicated supporter of my cause during the past ten years. His wise counsel has also been much appreciated. To his financial detriment he directed me, on more than one occasion, to a new acquisition. His skills with modern technology, much relied upon to redact this manuscript, were indispensable. A great partner indeed!

Andy Sylvester, the director of Equinox Gallery, was also a loyal supporter. His knowledge of E.J.'s works, imparted with his usual grace and sensitivity, was always welcome.

Without the loyal support of my wife, Margaret, this journey would not have been possible. While she perhaps understood my "obsession" with E.J. Hughes better than I ever did, she never discouraged me from fulfilling my mission, notwithstanding the consequential impact on our lifestyle.

I would be remiss if I did not acknowledge the contribution of each one of my children—Jean, Jacqueline, Monique and Paul—for their always-unfettered opinion as to the "pecking order" of any recent acquisition. While they may have wondered from time to time why we still could not afford a second children's phone line, they supported my objective, or at least I would like to believe they did.

Adopting a pseudo-professional posture, may I conclude by readily accepting and acknowledging sole responsibility for all errors and omissions and my liberties with the English language.

Anno Domini 2000 (revised 2005)
Vancouver and Point Roberts

Steamer in Grenville Channel, B.C.

1952 oil on canvas, 71.12 x 91.44 cm

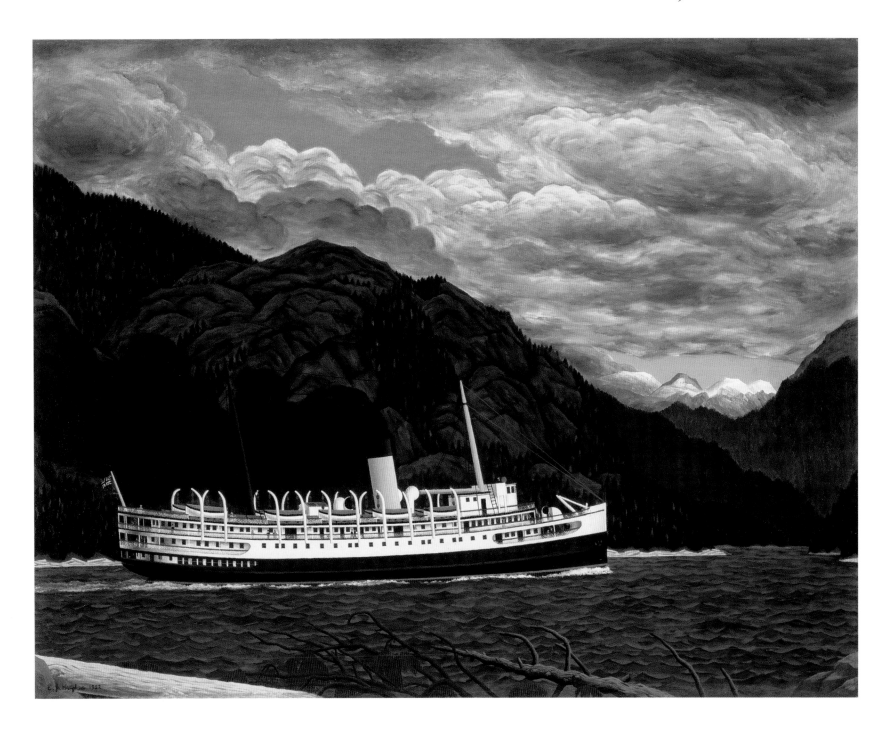

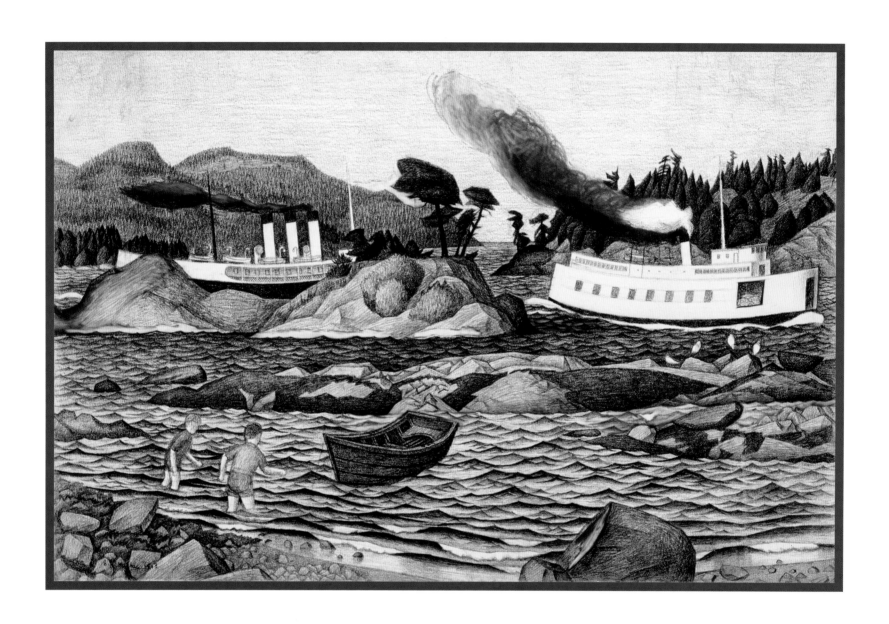

Steamers
1947 graphite cartoon, 50.8 x 76.2 cm

From *Steamers* to *Maple Bay*

I saw my first "Hughes" in 1958 on the cover of the Vancouver telephone directory. That was the beginning of a long relationship. I was twenty-seven at the time, recently called to the Bar and about to be married. Even more than forty years later, the experience is easily remembered. The painting was bold and daring. It captured that untamed vibrant character of British Columbia. It did not generate any identifiable aesthetic response, but it awoke feelings that I had never previously experienced. No other work of art had ever affected me so.

Notwithstanding my initial reaction, the possibility of acquiring a painting or sketch by E.J. Hughes never entered my mind. My salary as a civil servant with the Department of National Revenue did not permit it. Unfortunately, contemplation without the possibility of acquisition was of no interest to me at that time.

Twelve years elapsed before I "met" Hughes again.

In the intervening period, I acquired a decorative watercolour from a local artist while on our honeymoon at Point No Point on the west coast of Vancouver Island. Soon after, I bought another watercolour and my first oil painting from two local artists in the course of a Bar convention in Quebec City. These works were as primitive and innocent in substance and quality as I was in aesthetic taste. Nonetheless they still remind me how much I enjoyed my first venture into the "art" world.

While in the noble service of the Department of National Revenue in Ottawa, I graduated to Henri Masson.

Henri Masson was an enigma on the Canadian art scene. Undoubtedly a highly competent draftsman with a distinctive style, critical acclaim has eluded him. His popularity in the marketplace has never been reflected in professional recognition. Perhaps his day on centre stage is yet to come! Still, in the late 1950s, Masson was highly fashionable and as well known in Vancouver as he was in Ottawa, where he lived.

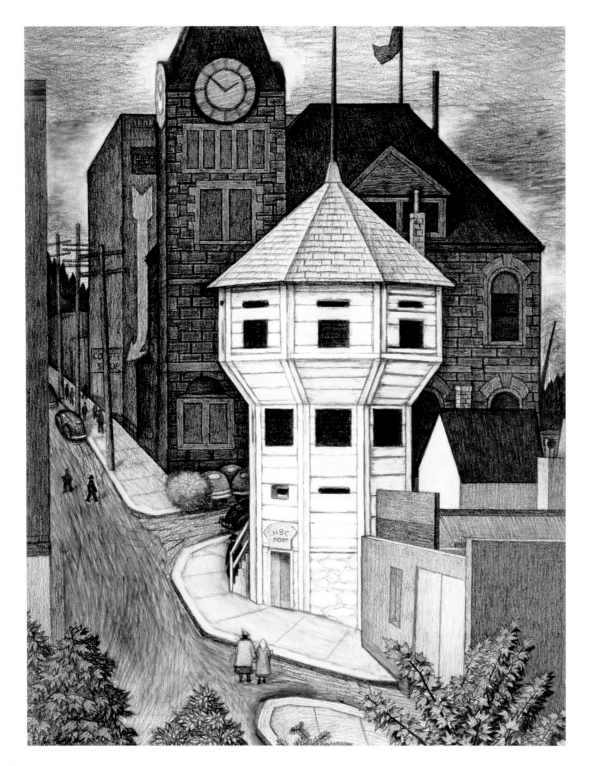

The Bastion, Nanaimo, B.C.
1950 graphite cartoon, 48.26 x 27 cm

My first visit with Henri Masson was a memorable one. Margaret and I met him at his red brick home on a rather cold Saturday afternoon. In appearance he was the embodiment of the classic artist. Unpretentious yet confident, he exhibited a bonhomie that was disarming. His personality was as charming as his art.

He had very few paintings in his third-floor studio. We were attracted nonetheless to a small semi-abstract oil painting entitled *Speakers' Falls.* Sensitive to our financial situation and our relative inexperience in the art world, Masson tactfully initiated the negotiations. A deal was struck: the painting was ours with a $15 down payment plus four quarterly payments of $25.

In retrospect, meeting Henri Masson for a few hours on a cold Saturday afternoon had an influence on me perhaps as great as that of *Speakers' Falls.* The observation is not intended to undermine the painting but rather to accentuate the personality of the man. A meeting shortly thereafter with Gordon Smith at his studio/home in West Vancouver had a similar impact upon me.

Soon after returning to Vancouver in 1962, I acquired two more works from Henri Masson. The first was a loosely drafted watercolour. The second was somewhat more significant: a brown charcoal nude of his wife, Germaine, which had been hanging in their second-floor bedroom. That work remains, sentimentally and aesthetically, a prized possession.

Apart from acquiring a small Robert Genn in 1963 to commemorate the birth of Jacqueline, my interest in art was sidetracked by family and business commitments for the next seven years.

Getting Started

It was not until 1969 that my interest in E.J. Hughes was renewed. Since then the pursuit of his work has become an ever more absorbing affair. I cannot recall whether it was my early interest in Hughes, or the fact that as a young boy I had lived practically next door to the Dominion Gallery on Sherbrooke Street in Montreal, that propelled me into the gallery in November 1969.

The Dominion Gallery had an imposing facade as well as an equally impressive director. Dr. Max Stern had a presence that was both intimidating and engaging. He exuded authority and was always prepared to act as godfather to the novice collector. He personally guided me on a grand tour of the gallery.

Perhaps as a francophone who lived and worked in Vancouver, I piqued Dr. Stern's interest. In contrast Mrs. Stern, possibly being more sensitive to the cost of my suit, did not display any interest, least of all in my cultural background. When it became apparent that my financial status did not warrant Stern's exclusive tutelage, I was—not so subtly— handed over to Michel Moreault. Fortunately for me, he soon became my mentor and advisor on the art of E.J. Hughes.

Michel Moreault fits the description of the perfect *gentilhomme*—well educated, highly sensitive and forthright with his opinions. Of approximately the same age, we developed a comfortable relationship. He guided me wisely over the years and allowed me to acquire some extraordinary examples of Hughes' work.

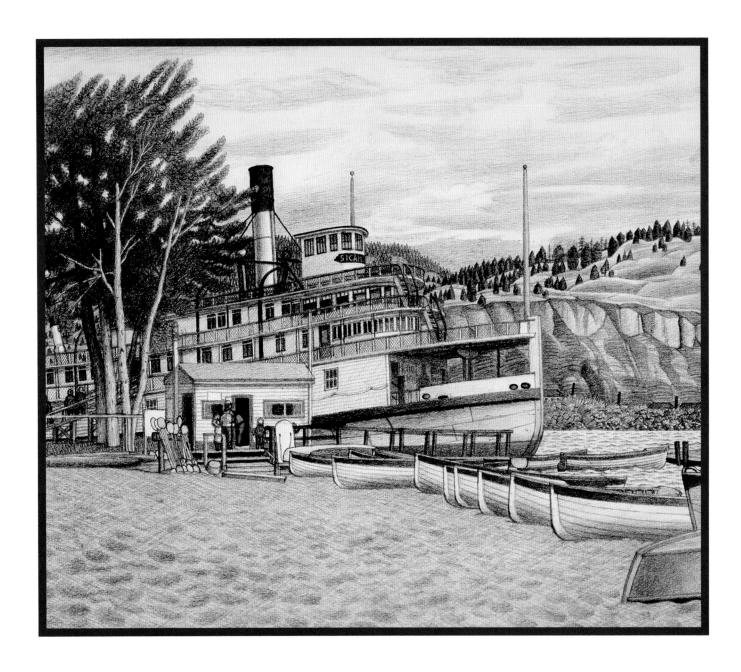

Museum Ship, Penticton, B.C.

1959 graphite cartoon, 45.7 x 53.34 cm

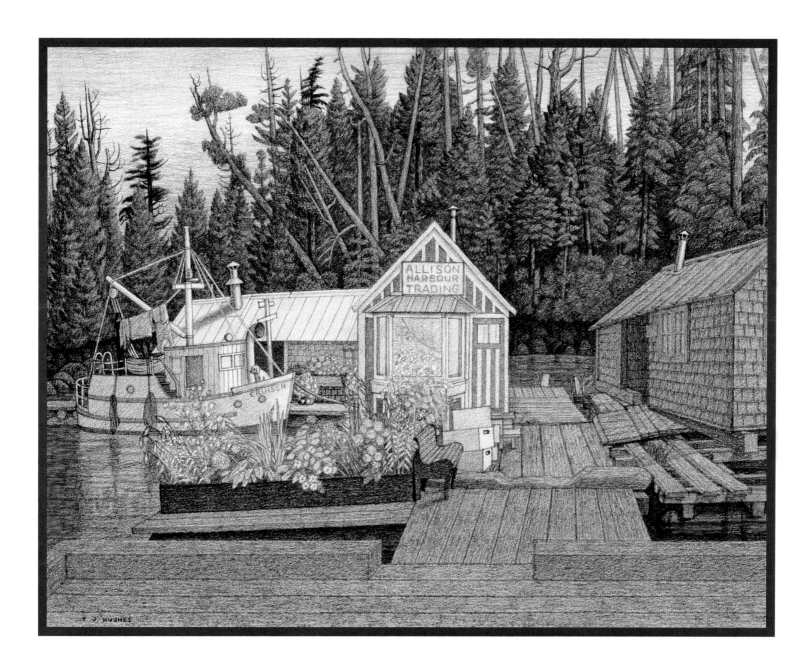

Allison Harbour

1955 graphite cartoon, 38.1 x 48.9 cm

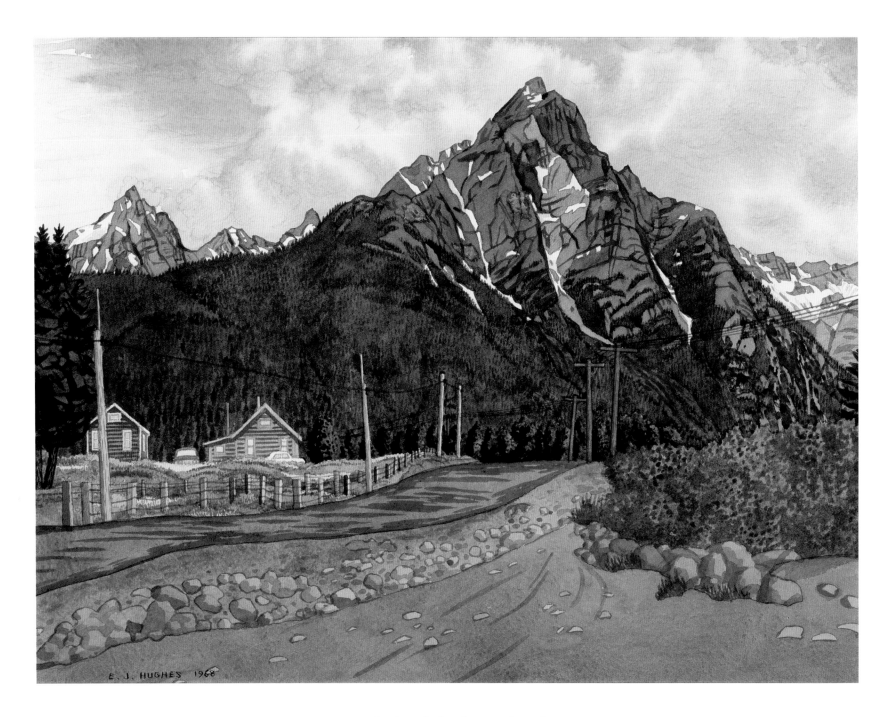

Mount Rocher de Boule near Hazelton

1968 watercolour, 45.72 x 61 cm

Aware that Hughes' watercolours were scarce and that I could not afford the oils, Moreault provided a more reasonable alternative. He suggested that I begin acquiring E.J.'s pre-1961 cartoon drawings. I believe I was the first client—or at least one of the first—to be afforded this opportunity by the Dominion Gallery.

Until 1961 Hughes normally completed a large detailed graphite drawing, known as a "cartoon," as the interim step between the initial sketch and the finished oil painting. These cartoons, "in which the graphite is applied so heavily that the velvety blacks resemble those of a lithograph," truly stand by themselves as finished artworks (Young, p. 43). At least for one critic, the cartoon—*Steamers*—has greater appeal than its oil counterpart, *Coastal Boats near Sidney, B.C.*

Following Moreault's advice I acquired four great cartoons at various intervals over the next seven months. I first purchased the 20″ × 30″ *Steamers* (page 2), which depicts a typical coastal ferry scene. This drawing was to serve as the prototype for *Coastal Boats near Sidney, B.C.,* one of Hughes' better-known paintings, presently in the collection of the College of Physicians and Surgeons of B.C.

The cartoon *The Bastion, Nanaimo, B.C.* (page 4), completed in 1950, is a bit more Teutonic than the earlier *Steamers.* Little or no distortion is introduced to soften the impact. The Bastion stands out like a lonely sentinel confronting a harsh world.

The 1955 *Allison Harbour* cartoon (page 7) reflects Hughes' more delicate style of the early 1950s. Here the accent is more engaging, without undermining the impact of the draftsmanship. It's a cozy and warm picture. Yet its static quality still generates an almost mystical aura. It is indeed a modern *nature morte,* mesmerizing and disturbing the viewer with its innate tranquility.

The last formal graphite cartoon I acquired from Michel Moreault during this period, *Museum Ship, Penticton, B.C.* (page 6) is the epitome of refinement and elegance. The subject matter, an old paddle-wheeler, captures the boy in the artist. It is a light and refreshing drawing that gave rise to an equally charming oil painting, now part of the alumni collection at the University of Western Ontario.

During this brief acquisition period I also acquired two watercolours, which, with the graphite cartoons, constituted my entire Hughes collection for the next ten years.

The first watercolour, *Mount Rocher de Boule near Hazelton,* like many other of Hughes' inland scenes, is to be appreciated for its languorous temperament. Yet it generates a mesmerizing echo. The interior topography of British Columbia does not seem to overly stimulate the artist's emotions of E.J. Hughes. Such works are to be treasured, in the words of Henri Matisse, "for their soothing and even emollient effect at the end of a long day's intellectual activity" (Russell, p. 385).

The second watercolour, *Maple Bay* (overleaf), is the antithesis of *Mount Rocher de Boule.* An array of warm rich colours and soft curves, it vibrates on sight. It is soothing, yet alive within its well-disciplined parameters. Not surprisingly, it was included as the only representative Hughes watercolour in Jane Young's 1983 retrospective exhibition catalogue.

According to Ms. Young, who arranged this first nationwide exhibition of E.J. Hughes' works, "*Maple Bay* demonstrates Hughes' skill as a colourist. The framing of the motif and the cropping of the image renders the latter water-

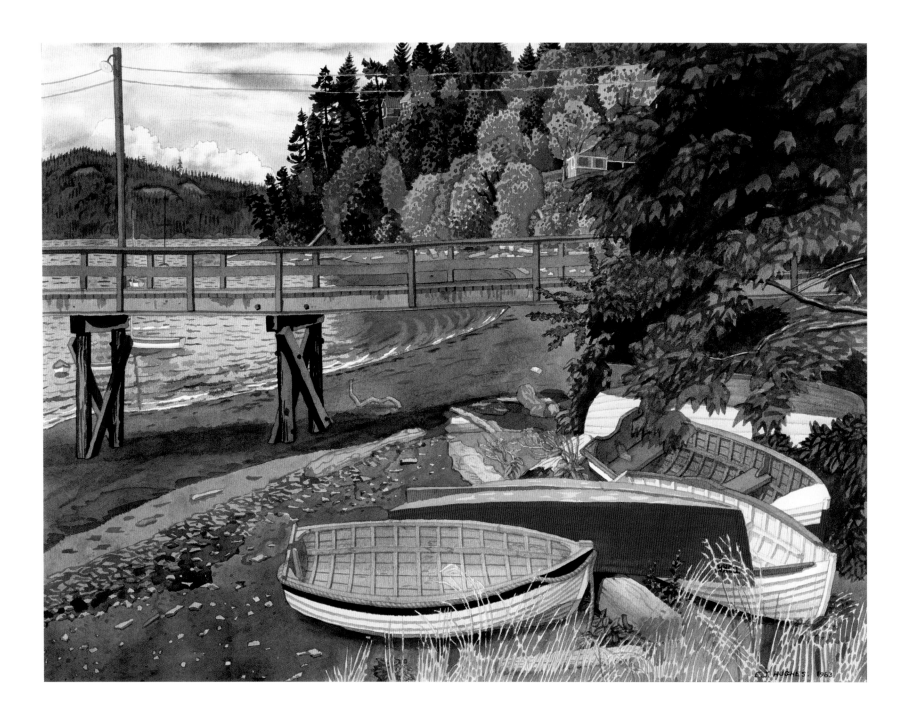

Maple Bay

1963 watercolour, 48 x 50.8 cm

colour a vignette of harmonious form and luminous colour. Hughes used the curves of the boats and railings of the wharf as the dominant compositional features in a motif where other painters may have been tempted to emphasize the curve of the beach and the hillside" (p. 59).

Interlude: Smith, Koerner, Kurelek

With one notable exception—a drypoint of Siwash Rock (page 23)—I did not acquire any other Hughes until 1980. During this period my aesthetic education continued through my acquaintance with three other significant Canadian artists.

Gordon Smith, a gracious and sensitive individual, is perhaps the modern-day aesthete. He seems, now as then, to glide over the mundane, the pedestrian and the inconsequential in day-to-day life. He conveys a message both as a person and as an artist. His personality supplements and complements his art. He uplifts his audience. In paintings such as those found in his West Coast Series, Smith invites the viewer to observe the world with serenity and confidence.

As a result of our occasional get-togethers, I acquired an oil and a silkscreen of his 1960s Harbour Nocturne Series. Subsequently, I was fortunate to purchase one of his acclaimed Long Beach watercolours.

John Koerner, a member of the great Vancouver philanthropic clan, introduced me to abstract art. John, like Gordon Smith, is the quintessential gentleman. His fluid style generates an ever-changing montage. Colour, significant form and a kaleidoscope effect stamp his work. Two vibrant oils, one unsigned, were acquired as a fortunate consequence of a valued personal relationship with this highly respected Vancouver artist.

William Kurelek, unlike Gordon Smith or John Koerner, was concerned with the more basic fabric of human life. His work exudes a haunting mysticism. Kurelek preached as he painted. The medium is the messenger. His abrasive scenes provide a poignant reminder of our transitory status on earth.

I met William Kurelek in the basement of his home in East Toronto some eleven months before his death in 1977. While we did not meet again, this single visit had a lasting effect upon me. His persona was as disturbing as his paintings. Courteous, almost timid or reserved, he appeared impatient to return somewhere. He gave the impression that he had either seen or could see things not seen by others. This was not a frivolous man. He seemed dedicated or obsessed with the ultimate consequence of life.

After our meeting at his studio I departed with two quite different examples of his work. The first was a 1949 pencil sketch of his sister, Nancy. It embodies a warmth and softness not associated with Kurelek. The other, a small oil, with a dark bluish overcoat, is more in accord with Kurelek's other work. An isolated and lonely church in the middle of a cold winter's night seems to reflect this stoic artist facing the cruelties of life.

Becoming acquainted with Smith, Koerner and Kurelek has been as fulfilling to me over the years as the aesthetic pleasure I derive from their art.

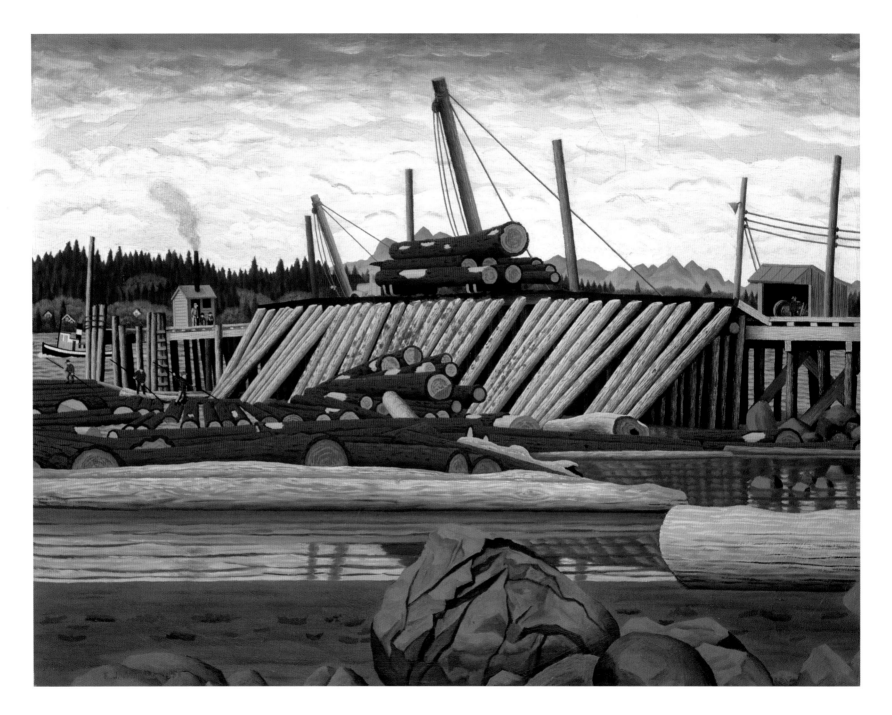

Unloading Logs, Comox Harbour

1953 oil on canvas, 50.8 x 66.04 cm

From *Comox Harbour* to *Shawnigan Lake*

Rather by accident, my interest in E.J. Hughes was revived by a Torben Kristiansen advertisement for the sale of a 1953 oil painting. On January 14, 1980, I purchased my first E.J. Hughes oil, *Unloading Logs, Comox Harbour*, from this Vancouver dealer. After an interlude of ten years, this purchase marked the beginning of a new acquisition program.

Unloading Logs, Comox Harbour may be classified as one of Hughes' forest industry paintings. To some critics these industrial subjects are not as aesthetically stimulating as his more natural coastal scenes. This particular 1953 oil painting, however, represents one of the more vigorous examples of its kind. While lighter in tone than Hughes' earlier canvases, it still exhibits a strong—if not heavy—brush stroke. The painting is vivid and alive as it portrays the simplicity of bygone days.

It is notable that this acquisition, like the other Hughes purchases, did not elicit any particular reaction from friends and acquaintances. A Hughes was not a decorative necessity. The Massons evoked more interest. Although a few Vancouverites owned the odd painting, there were no truly dedicated Hughes collectors.

My next acquisition was distinctly monumental. It represented an opportunity yet to be duplicated. Sometime in December 1982, while dropping in to say hello to Michel Moreault at the Dominion Gallery, I noticed a majestic ferry scene, without doubt an early E.J. Hughes. This rather large 1952 oil painting, *Steamer in Grenville Channel, B.C.* (page 1), was reproduced in the catalogue for the Hughes retrospective exhibition directed by Doris Shadbolt in 1967. Unfortunately, the painting was somewhat pricey. Always sensitive, Michel did not press the matter, and the painting, despite its provenance, remained in the stairwell of the gallery.

Three months later, fortified by Monique's gentle prodding, and with Michel's encouragement, I acquired the painting, though only after some memorable negotiations with Dr. Stern. It is a decision I have never regretted.

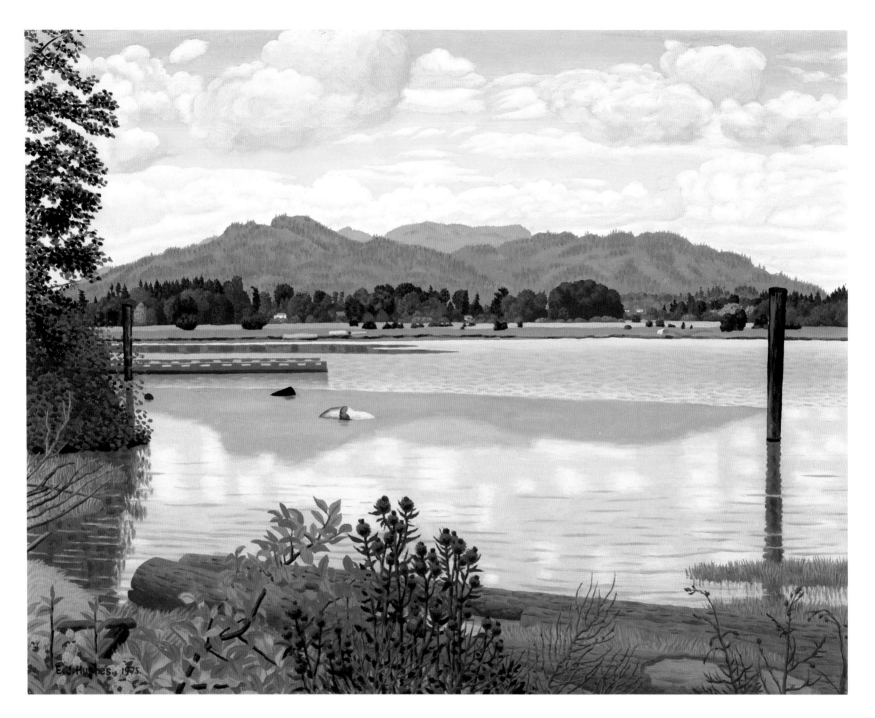

Cowichan Bay and Mount Prevost

1975 acrylic on canvas, 63.5 x 81.28 cm

E.J. Hughes is perhaps best known in British Columbia today for his ferry series depicting the CPR fleet that served Vancouver Island and the B.C. coastal community. Reference to them as "steamers" smacks of Dr. Stern. In my experience no one in B.C. has ever referred to these ships as anything other than ferries. It is therefore doubtful that E.J. Hughes would have referred to them either as steamers or as coastal boats. Obviously these ships did not look like ferries to Dr. Stern. However, that is exactly what they were called on the West Coast during the '50s and '60s. In fact, the *Steamer in Grenville Channel* was probably the *Princess Adelaide* ferry.

Steamer in Grenville Channel is truly a majestic painting. It is undoubtedly the most arresting of the ferry series. It commands respect. It is more than just a grand depiction of a small sturdy ship confronting the harsh and sombre coastal waters. It hints at mysticism. It conjures the imagination. It allows for a variety of interpretations. It titillates, yet at the same time pacifies the emotions. It is disturbing at times while serene at others. Upon reflection it is a subtle piece of art. Seductive for the moment, perhaps even theatrical, it evokes a myriad of sensations upon a more careful and sensitive scrutiny.

As might be expected, *Steamer in Grenville Channel* was well received by all members of the family. My daughter Jean was particularly captivated with the locale as she had sailed extensively in these northern coastal waters. For Jacqueline, Monique and Paul the appeal was its commanding visual impact.

My next acquisition was not so dramatic or, initially, as seductive. Having proclaimed my interest in E.J. Hughes to one and all, it was not surprising that Douglas Udell telephoned from Edmonton to offer me a 1975 canvas. After some initial hesitation and following a bit of friendly persuasion from Douglas and Michel Moreault, I acquired my first post-1973 Hughes, *Cowichan Bay and Mount Prevost*.

Hughes' work is generally segregated—on the market at least—into either the pre- or post-1973 period. Albeit oversimplified, the contention is that the pre-1973 work is identifiable by strong vivid colours and heavy brush strokes while the post-1973 acrylic paintings are characterized by softer pastel colours and more delicate draftsmanship. If one compares the 1952 *Steamer in Grenville Channel* with the 1975 *Cowichan Bay and Mount Prevost,* the distinction between the periods is all too obvious.

As a rule, collectors prefer the pre-1973 paintings while the critic and the aesthete sometimes promote the post-1973 works as reflecting E.J. Hughes' maturity as an artist.

A number of theories have been advanced over the years to explain this rather dramatic change in E.J. Hughes' style. Although the shift was clearly evident in 1973, some claim it coincided with the 1974 death of his beloved wife, Fern. Hughes' own explanation is that Dr. Stern asked him to lighten up his paintings because his clients were finding them too severe. This explanation is somewhat tenuous, as Hughes' paintings were selling well at the time. Without professing any expertise, my personal theory is less contentious. It suggests that the change in style merely reflects the decision of a mature sixty-year-old artist to switch occasionally from oil to the softer and less striking—but possibly more permanent and certainly more convenient—acrylic paint.

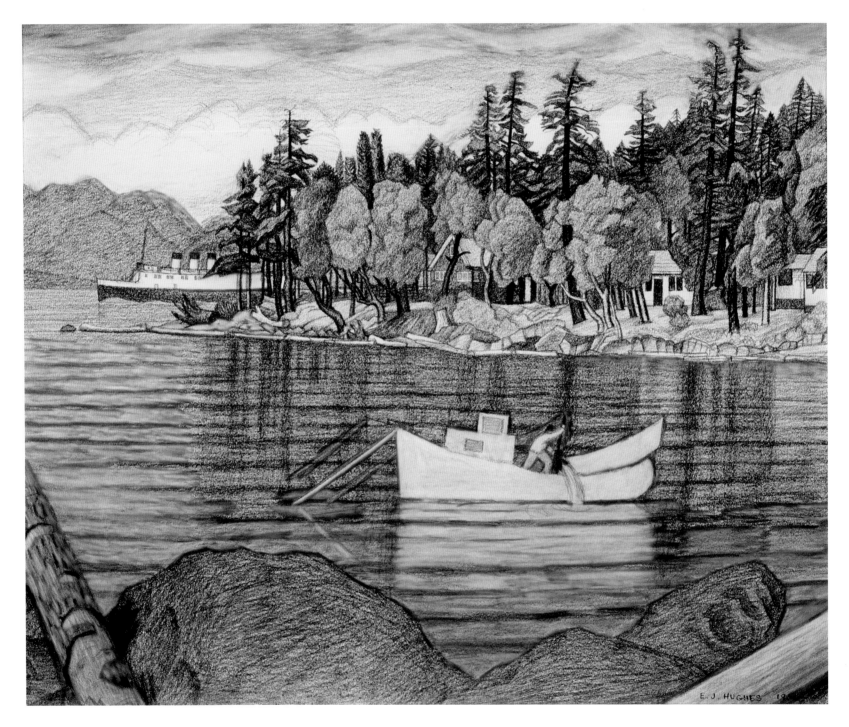

Taylor Bay, Gabriola Island

1951 graphite cartoon, 36.83 x 45.72 cm

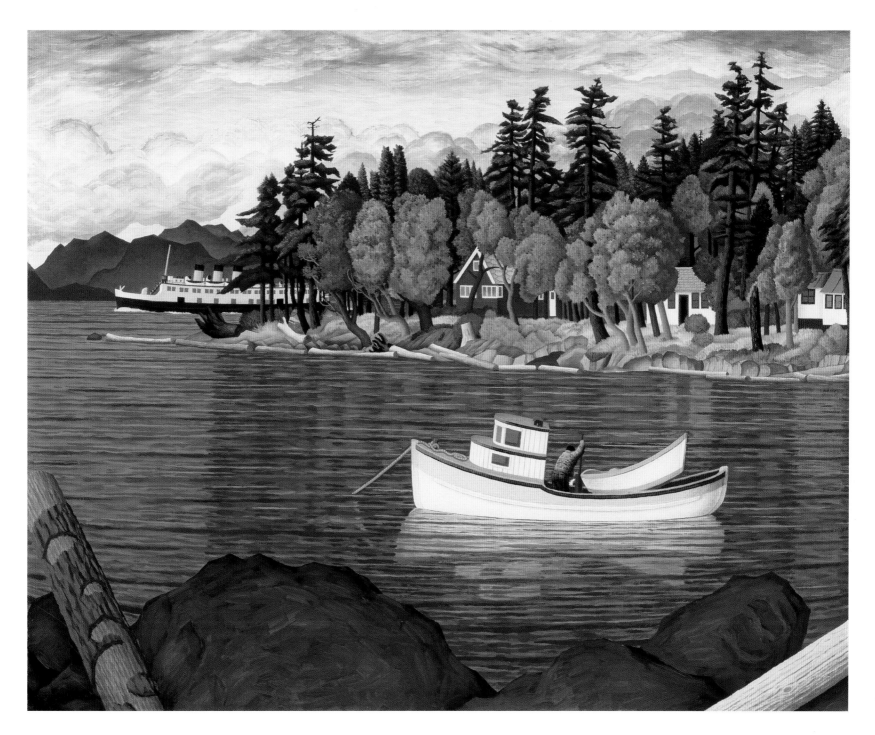

Taylor Bay, Gabriola Island, B.C.

1952 oil on canvas, 62.55 x 76.2 cm

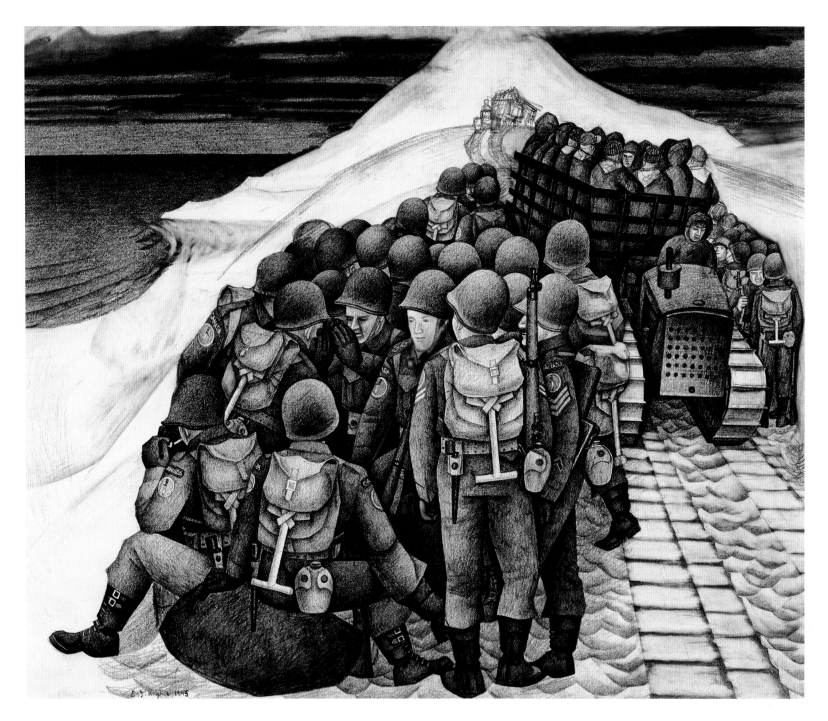

Ten Minutes Rest during the March on Kiska

1945 graphite cartoon, 48.26 x 57.8 cm

Cowichan Bay and Mount Prevost is almost the antithesis of *Steamer in Grenville Channel.* The latter is immediately seductive while the former—at best—merely teases at first glance. Initially, *Cowichan Bay and Mount Prevost* will arouse mixed feelings. While *Steamer in Grenville Channel* overwhelms, *Cowichan Bay and Mount Prevost* soothes the intellect. They do not belong together. Each detracts from the other, as is usually the case when comparing a Hughes of the 1950s with one completed after 1973. Yet when they are placed together, the subtle impact of the 1975 canvas is favourably accentuated by contrast. With its light pastel colours and its softly defined features, *Cowichan Bay and Mount Prevost* invites both speculation and contemplation. You can mentally disrobe before this painting. You can think or you can feel. It stimulates the imagination or it pacifies the mind in a gentle way. It stands by itself as a piece of reflective magic. It is sheer Mozart in contrast to Wagner.

Thanks again to Michel Moreault, I was fortunate in January 1985 to acquire a much-sought-after 1946 oil painting, albeit of comparatively modest proportion. *Above Cooper's Cove* (page 27), an 8½″ × 10⅝″ oil on board, although identifiable with this distinctive period, is simply too small to convey the heavy-duty message of Hughes' larger paintings from this era. While not a cheerful piece, it deftly captures the mood of a quiet, grey coastal winter day.

A minor detour later in 1985 brought me back to E.J. Hughes' cartoons. At Michel Moreault's suggestion I acquired the World War II graphite cartoon *Ten Minutes Rest during the March on Kiska.* This 1945 drawing is as strong, intense and meticulously drafted as any of Hughes' other early cartoons. Yet the distinctive curvature of the troops softens the scene to provide a rather elegant twist to this military composition.

Hughes' prolific war production, unfortunately embalmed in the vaults of the Canadian War Museum, aptly illustrates the folly of segregating his work into either a pre- or post-1973 genre. These wartime paintings clearly reflect a distinct style. The 1943 *Signalman and R.C.D Armoured Car in Harbour,* with its soft delicate colouring, for example, simply cannot be arbitrarily lumped into the pre-1973 category. One can only hope that this wartime cache will eventually be exhibited in all parts of Canada.

In September 1988, I acquired two drypoint prints from Michel Moreault to expand and complement the range of the collection. The 1935 *Hopkins Landing, B.C.* (overleaf) was transformed some seventeen years later into the oil painting *Hopkins Landing, Howe Sound.* The second drypoint, the 1936 *Trees on Savary Island* (page 21), with the previously acquired *Siwash Rock,* are typical of Hughes' early work.

These three prints, which originally sold at $2.00 each, reflect an exceptional sense of delicacy and superb drafting ability for a twenty-two-year-old artist. The graceful linear style generates a light, floating mystical sensation. They provide a clear indication of things to come. Discipline and style are characteristics that were to reappear in the future.

The embodiment of E.J. Hughes' unique talents may be found in his 1952 creation *Taylor Bay, Gabriola Island, B.C.* (page 17). Completed when Hughes was thirty-nine years old, this painting integrates and synthesizes the essence of Hughes' signature. The majestic B.C. ferry, an idyllic coastal island and the lonely fisherman epitomize his art. All of the components are there. Undoubtedly this is the work of an artist at peace with himself. Hughes had finally reached

Hopkins Landing, B.C.

E. J. Hughes, 1935

Hopkins Landing, B.C.

1935 drypoint, 17.78 x 22.86 cm

Trees on Savary Island

1936 drypoint, 20.32 x 25.4 cm

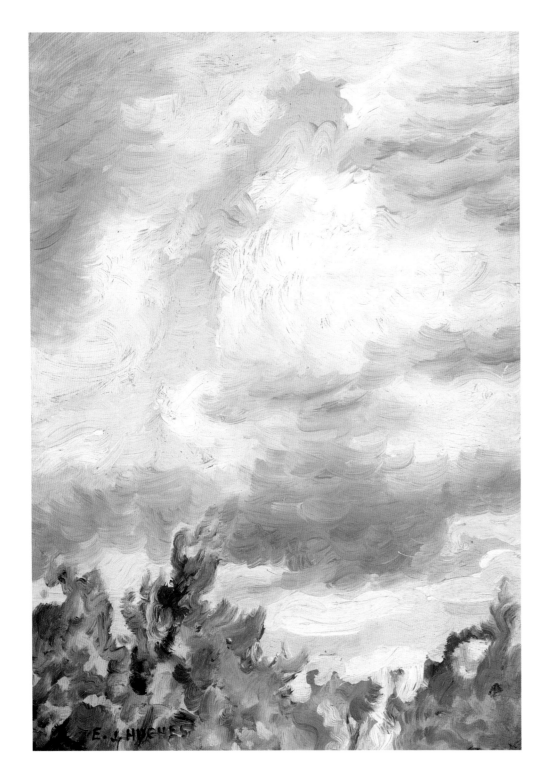

Ottawa Sky—Study

1941 oil on board, 13.65 x 10.5 cm

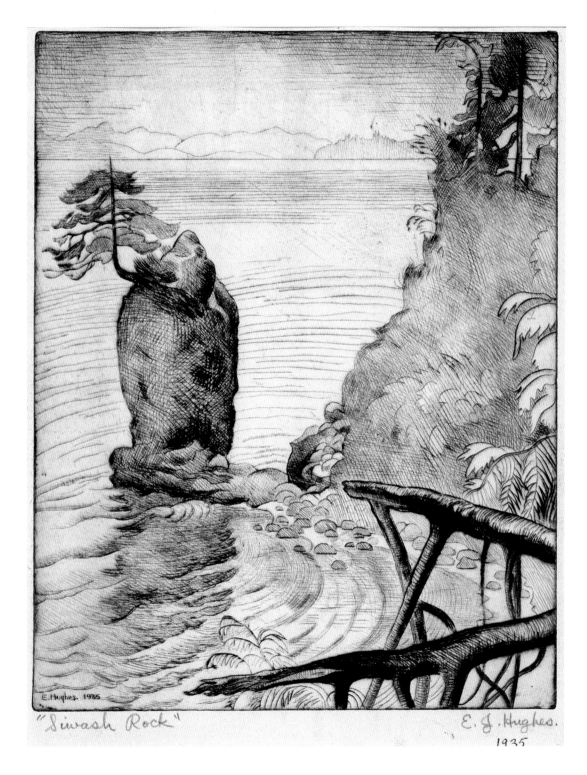

"Siwash Rock"

E. J. Hughes.
1935

Siwash Rock

1935 drypoint, 20.32 x 25.4 cm

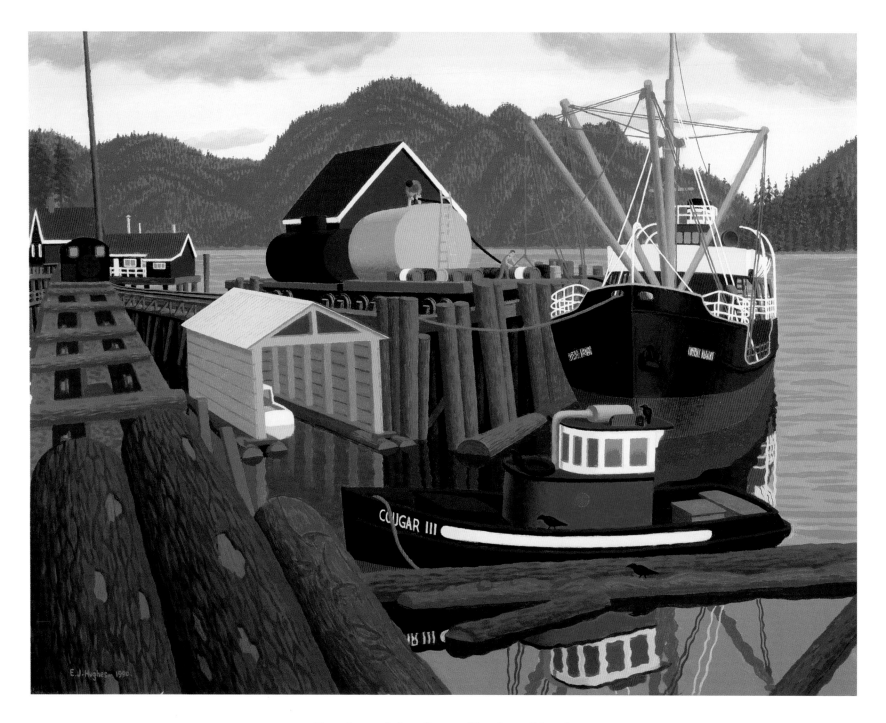

Cumshewa Inlet, Queen Charlotte Islands

1990 acrylic on canvas, 63.5 x 81.3 cm

his goal. "I am deliberately painting what is picturesque," he once stated. "I really believe if I work hard at it and am really sincere about it, I can make that picture be art." *Taylor Bay, Gabriola Island* provides clear evidence to support this claim. Both the oil and the accompanying cartoon (page 16) justified their presence in Dr. Stern's private collection. I am indebted to the executors of Dr. Stern's estate for allowing the quintessential Hughes to return to British Columbia.

A quiet Saturday afternoon with Mel Scott at his charming early Vancouver home in January 1990 to view his father's work proved rewarding. Charles H. Scott, a gifted artist in his own right, served as the principal of the Vancouver School of Decorative and Applied Arts in the 1920s. This was at the time when both Fred Varley and Jock Macdonald were on staff. Camouflaged among the many works by Charles Scott, two early Hugheses were to be found. Presumably they were acquired while E.J. Hughes was attending the art school between 1929 and 1935.

During our tour of the inventory, Mel Scott offhandedly pointed out the first of these two Hugheses. I doubt very much if I could have recognized it by myself. It was a rather watery brownish-green oil painting on board. If the colours were subtle, the subject matter, a partly sawed log, was boldly depicted. Undated, it was probably completed in Hughes' early years at the art school. Sensing my interest in Hughes, Mel Scott was kind enough to offer me this important historical piece when I left that afternoon with a few examples of Charles Scott's work.

The oil sketch was subsequently given to the Surrey Art Gallery to commemorate the late Jane Young's contribution to Canadian art. As the organizer of the 1983–85 E.J. Hughes Canada-wide retrospective exhibition and as the author of its authoritative catalogue, she certainly deserved this modest token of appreciation.

The second oil sketch, which both Mel Scott and I missed during the course of our January meeting, was detected by David Heffel some months later while he was viewing Grace Melvin's work. This untitled work (overleaf), executed on a very rough piece of 12″ × 15″ plywood, is signed E.J.H. and dated '35. It is an interesting and informative piece. Depicting what seems to be a north-looking view from Savary Island on a partly cloudy day, Hughes adroitly captures the ethereal effect of the sunrays filtering through the clouds. It is delicately and simply drafted. Yet it conveys a strong feeling of isolation and remoteness. Here, however, the harshness of the main theme is mellowed by the filtering sunrays. It portends a mysticism that was to reappear in later works.

In the spring of 1990, I acquired another experimental work by E.J. Hughes at the Joyner auction in Toronto. Referred to simply as a sky study (page 22), this 1941 oil sketch is primarily of pedagogical interest as reflecting the development of Hughes' distinctive cloud treatment.

An impromptu visit to the Dominion Gallery in September 1990 led to a startling discovery. Confronting me was a brash new Hughes with a rejuvenated tonality reinterpreting an old theme. It was an arresting and commanding piece. Suggestive of his post-war work, this new creation was certainly not identifiable with any of his post-1973 acrylic paintings. Here, in an almost sterilized atmosphere, Hughes develops an extraordinarily hard-edged version of his well-known Imperial Oil tanker motif. This is definitely not a painting to intermingle with the Fragonards and the Watteaus in the Louis XV salon!

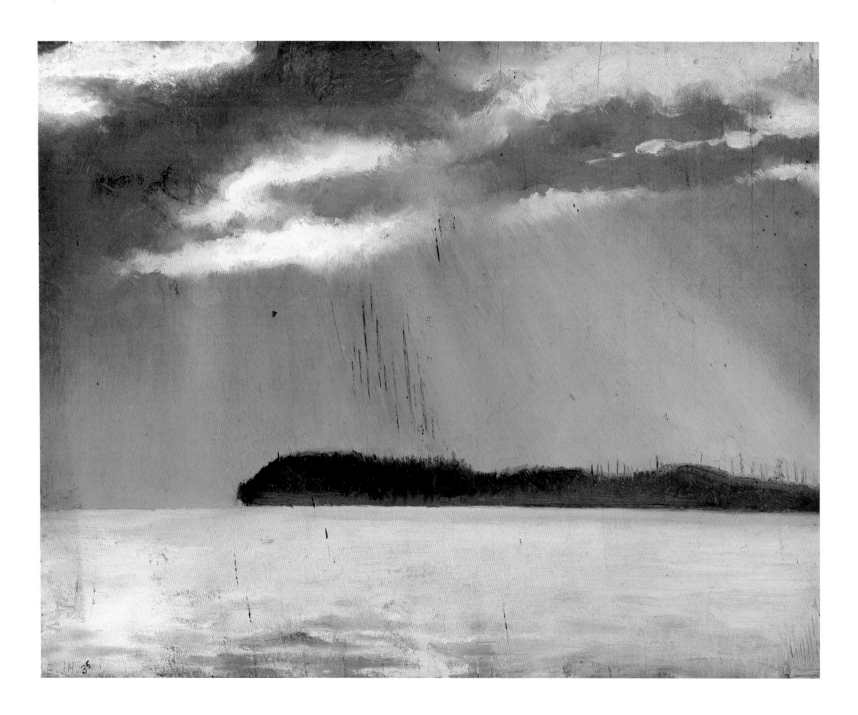

Looking from Savary Island

1935 oil on board, 30.5 x 38.1 cm

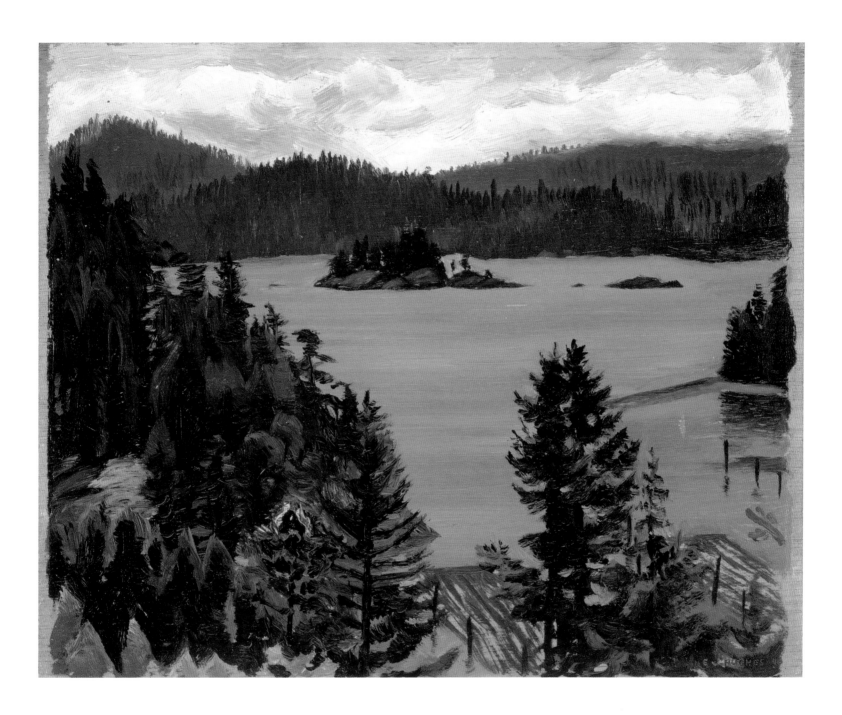

Above Cooper's Cove

1946 oil on board, 21.59 x 27 cm

West Coast of Vancouver Island —1958 pencil, 22.86 x 29.21 cm

The particularly vibrant *Cumshewa Inlet, Queen Charlotte Islands* (page 24) was executed in 1990 when Hughes was seventy-seven. Only time will tell if it marks the development of a new style—one that gives the appearance of a reconciliation between the equally distinctive pre- and post-1973 strategies. In the interim, *Cumshewa Inlet, Queen Charlotte Islands* will generate a modicum of introspection. Indeed, it invites a definite commitment for or against. Is it to be considered an accident, an isolated foray into the past, or is it indicative of a new direction for the artist? Hughes himself is more ambiguous on this issue when he indicates in a note that "this painting was reproduced from an old pencil sketch obtained in 1953 during my sketching trip up the coast of B.C. on an Imperial Oil tanker . . . Sometimes it is a welcome change to paint from an old sketch like this as most of my recent sketches are of Vancouver Island." Whatever the outcome, *Cumshewa Inlet, Queen Charlotte Islands* electrifies our non–Louis XV living room.

In the fall of 1990 David Heffel gave me my first Hughes linocut print. This twenty-eighth example out of an edition of sixty, entitled *The Old* Empress of Japan *Figurehead at Stanley Park* (page 33), was completed in 1939. It is soft and pleasing to the eye. It is to be cherished as much for its historical as for its aesthetic interest.

There is little doubt that Margaret gradually became committed to our Hughes collection. For Christmas 1990, she gave me the meticulously annotated pencil sketch of *Takakkaw Falls*. I returned the favour with the 1971 *Shawnigan Lake (Rose Island)* watercolour (overleaf). It is a graceful reminder of her summer holidays at the Owen/Dowler family cottage on the east side of the lake where Hughes and his wife, Fern, lived for twenty-one years.

The minutely annotated *Takakkaw Falls* is a virtual road map. It will guide if not dictate the style and structure of the final product, be it a watercolour or a painting. As such it is a worthy aesthetic and historical document. The sketch evidences Hughes' ingrained discipline and illustrates why the artist can rely on this type of blueprint years, and even decades, later.

The *Shawnigan Lake (Rose Island)* watercolour, with a profusion of sumptuous soft leaves gently fanning the shore of the lake, is an enchanting piece of art. As with *Maple Bay,* it satisfies the intellect while it caresses the senses.

To cap this magnificent bounty, David and Robert Heffel gave the family a well-delineated pencil sketch titled *West Coast of Vancouver Island.* It is another commendable example of Hughes' compositional acumen.

So with the passing of Christmas 1990, the first twenty years of my journey with E.J. Hughes came to an end. The elusive goal remained: to acquire a large-scale 1940s Hughes.

Takakkaw Falls

1963 pencil, 30.5 x 22.86 cm

Shawnigan Lake (Rose Island)

1971 watercolour, 50.8 x 61 cm

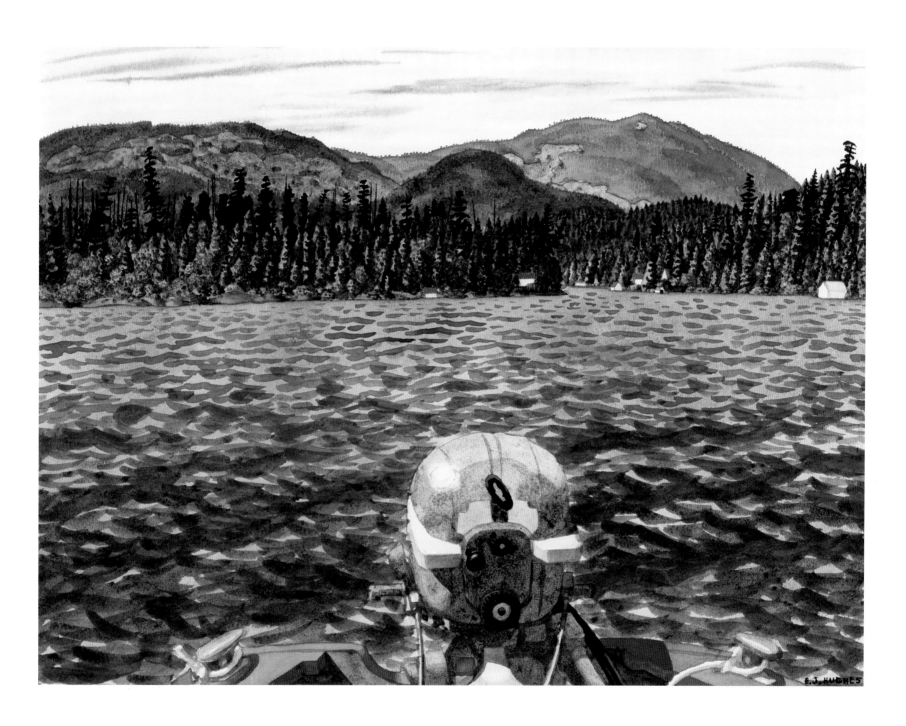

Entrance to West Arm (Shawnigan Lake)

1968 watercolour, 38.1 x 45.72 cm

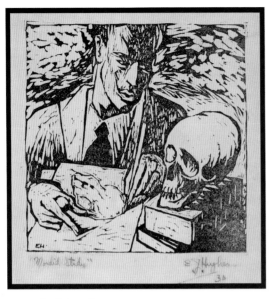

Morbid Study—1933 linocut, 25.4 x 27.94 cm

Both Sides of the Lake

Peter Ohler is a virtuoso in the art world of Western Canada. He makes you forget that you have to defray the costs of the acquisition. He is enthusiastic, highly knowledgeable, a skilled professional. He is a master of the human psyche. The painting is merely the by-product of the purchase and sale experience. He flatters the ego in the subtlest of ways. Not only do you acquire a masterpiece, but you simultaneously feel that you are one of those rare, knowledgeable, shrewd and insightful collectors: All in all an elegant finesse by a maestro nonpareil.

On Saturday, March 16, 1991, at approximately 12:20 p.m., I met Peter Ohler for the first time. Exactly twenty-two minutes later I walked out of his offices on 44th Avenue and East Boulevard in Vancouver the proud owner of a first-class Hughes watercolour and a provocative 1933 linocut print.

Part of Peter Ohler's great reputation, like that of the late Kenneth Heffel, is attributable to his ability to obtain extraordinary works of art. Over the years, he has acquired and disposed of some great early Hughes paintings. This is the principal reason that prompted me to become acquainted, however belatedly, with this West Coast art dealer.

My sole mission at this time was to acquire a 1947 or 1948 Hughes. I was soon sidetracked from this objective after I had settled down in Peter's comfortable studio. Quite by chance I noticed an extraordinary small late-1960s watercolour of Shawnigan Lake. Peter quickly redirected my attention to an early linocut appropriately titled *Morbid Study*. This macabre print portraying a man looking at a skull perhaps reflects Hughes' youthful recognition of the ultimate end.

Having completed this preliminary transaction, we then turned to the unexpected watercolour. It was unusual both in its format and its intensity.

The 15″ × 18″ watercolour, aptly described *Entrance to West Arm (Shawnigan Lake)* (previous page), depicts a well-known area of Shawnigan Lake where Margaret's family has maintained a summer home for three generations. We now had both sides of the lake covered!

With the engine casing of an early outboard motor in the foreground, this charming watercolour reflects the agitated water of Shawnigan Lake against the soft mountaintops of Vancouver Island. Constrained by this unusually small format, the vivid blue tones are accentuated to provide an even more forceful impact than otherwise might have been achieved in a larger format.

In brief, *Entrance to West Arm (Shawnigan Lake)* is a first-class example of E.J. Hughes' superb draftsmanship and strong sense of colour.

The Old Empress of Japan *Figurehead at Stanley Park*

1939 colour linocut, 22.22 x 30.16 cm

A Log Dump at Royston, Comox Harbour
1948 pencil, 26.67 x 36.83 cm

The Forty-Year Commemorative Exhibition

On April 27, 1991, a beautiful sunny Saturday morning, my mother and I attended the timely commemorative exhibition *E.J. Hughes, R.C.A/A.R.C.—40 Years with Galerie Dominion.* The exhibition was an appropriate event to mark Hughes' four-decade-long association with this renowned Montreal gallery. It was organized mainly to display a relatively large selection of his more recent paintings. It was not intended to be, nor did it provide, a retrospective exhibition of his work.

Once in the gallery, I renewed acquaintance with Stephen Jarislowsky, who had reserved one of the paintings to add to his impressive Hughes collection. In addition to being one of Canada's more successful money managers, Stephen is one of Hughes' more important patrons. The acquisition of the 1951 masterpiece *Arbutus Trees on Gabriola Island* shortly before the exhibition undoubtedly qualified him as the pre-eminent Hughes collector.

For the occasion, Michel Moreault published an instructive catalogue that included Pat Salmon's insightful commentary on each of the paintings in the exhibition.

I was therefore pleased when Ms. Salmon, after hearing my name, came over and introduced herself. We spoke about our favourite artist for the next thirty minutes. Ms. Salmon then introduced me to Hughes' sister and her husband, Zoe and David Foster from Moncton, New Brunswick.

During the course of our conversation, Ms. Salmon confirmed that she was holding up publication of her Hughes biography for the sake of discretion. Apparently Hughes has some rather well-defined opinions of his fellow Canadian artists!

Before parting, I suggested and Ms. Salmon agreed that we should next attempt to arrange a rendezvous either in Duncan or Vancouver, to allow me the opportunity to finally meet Mr. Hughes.

Parenthetically, my mother with her ever-engaging personality made quite an impression on everyone at the gallery. It was in this forum, according to Ms. Salmon, that my mother declared: "Jacques had a picture on the wall long before he had a carpet on the floor."

I had initially decided to avoid acquiring anything at this exhibition. Budgetary constraints dictated that I conserve my funds for an early Hughes painting that I had understood might be made available within the following three to six months.

Notwithstanding my resolve, my mentor, Michel Moreault, directed my attention to *Ladysmith, B.C.* (page 42), a 1982 canvas that had been reproduced in Jane Young's retrospective exhibition catalogue. A rather rustic painting, it caught my attention when I first saw it in that exhibition.

Michel Moreault insisted that this was an important work that should be part of the collection. Ms. Salmon echoed Michel's sentiment, as she was perhaps anxious that this work return to British Columbia.

After some reflection, I asked Michel to put a blue dot on the painting indicating that I would let him know in the next few days whether or not I would acquire it. As usual, Michel felt confident that I would make the proper decision.

At the airport on my way to Miami to attend Monique's graduation from the University of Florida, I telephoned David Heffel to report on the *40 Years with Galerie Dominion* exhibition. David took the opportunity to tell me of a Montreal collector willing to dispose of a 1961 Hughes entitled *Old Baldy Mountain, Shawnigan Lake* (page 78).

While flying over Toronto on my way to Miami, I was grateful to have a few days to determine how to deal with this financially vexing, yet exciting, scenario. Eventually, economic rather than aesthetic considerations dictated that I acquire the Shawnigan Lake piece and let *Ladysmith* "go"—for the time being.

The Heffel Gallery has always maintained a keen interest in E.J. Hughes' work. It was its founder, Kenneth Heffel, who acquired and sold Hughes' most widely acclaimed masterpiece, *Indian Church, North Vancouver, B.C.* The gallery has organized numerous exhibitions of E.J. Hughes' paintings, watercolours and sketches. And it has played a vital role in bringing Hughes' work back to British Columbia. It is the hub of the secondary market. Not surprisingly, Heffel's February 1992 Hughes exhibition provided an engaging avenue for another acquisition. I was completely won over by *Looking South over Shawnigan Lake* (page 70), a simply exquisite work. Now we had the lake covered from *all* sides!

Trees, Sooke Harbour, B.C.

1951 oil on canvas, 76.2 x 60.96 cm

Meeting the Artists in Vancouver and Tokyo

Paul and I met E.J. Hughes for the first time in the lobby of the Hotel Vancouver on Friday, October 2, 1992, at 12:30 p.m. The meeting had been pre-arranged. Ms. Salmon had telephoned me the previous Wednesday to advise that she and Hughes would be coming to Vancouver and that it might be possible to *accidentally* meet at the Hotel Vancouver.

Paul and I arrived at the hotel at noon to meet our guests. After waiting for them for about ten minutes, we decided to sit at the middle table of the lobby bar to make our presence all too conspicuous and unavoidable. Within minutes, Ms. Salmon and Hughes appeared and inevitably—as planned—joined us for lunch.

One can easily and justifiably describe E.J. Hughes as a "gentle man." He is soft-spoken, highly sensitive and classically mannered—a *bona fide* Victorian gentleman.

While we were having lunch, he confided that it was unfortunate his wife did not benefit very much from the years in which his income grew more than was necessary to meet their day-to-day needs. He added, however, that his mother, who had died only two years before, had been very much aware and proud of his financial and artistic achievements.

During our conversation at the hotel, he expressed how pleased he had been to visit London and Paris with his sister Irma and Pat Salmon, all courtesy of Dr. Stern. Presumably, this kind gesture was Dr. Stern's way of thanking Hughes for his exemplary trust and loyalty over the years.

Hughes mentioned that during most of his career he had always referred to Dr. Stern as "Dr. Stern." However, in later years they had become good friends and Hughes called Stern "Max" while Stern called Hughes "Ed." There is no doubt in my mind that Hughes thought very highly of Max Stern. In fact, both Hughes and Pat Salmon have readily acknowledged that an artist can succeed more easily with the support of a competent dealer—such as Dr. Stern.

During our session together, he reiterated how often Dr. Stern made recommendations with respect to his work. For instance, Dr. Stern suggested that collectors preferred to see open skies and that Hughes should attempt to provide

as much open sky in his paintings as he could. These suggestions did not seem to offend Hughes. If anything, they were a welcome source of amusement and, though sometimes influential, seldom were they accepted.

As our three-hour lunch was coming to an end, I suggested that Hughes might wish to visit our home to look at some of his work. This was enthusiastically accepted by Pat Salmon, who, aware of Hughes' reluctance to bother people, pressed him to accept. After he thanked me profusely for having defrayed the modest cost of his lunch we walked over to the Hongkong Bank Building, to view two of his works that were hanging in my office.

We then proceeded home. During the course of the ten-minute ride, he mentioned that I should contact Ms. Salmon so that he could reciprocate what he called our "wonderful hospitality!"

Once at our house, Hughes seemed to be more interested in his newer paintings than in the work he had produced while a student at Vancouver School of Art. Yet he had a total recall of his early work. Even at lunch, without seeing the piece itself, he had a clear recollection of the 1933 linocut *Morbid Study.*

The one painting that seemed to particularly attract his attention was *Steamer in Grenville Channel.* Hughes was quick to admit that he had worked "months upon months" to achieve the desired sky effect. He was surprised to see that the colours appeared darker than the original tonality. He had felt that the piece was simply too light in colour when he painted it in 1952. He was rather pleased, however, to hear that many people considered this particular painting one of his *chefs d'oeuvre.*

Examples of Gordon Smith's work, as well as those of William Kurelek, readily caught his attention. He was particularly attracted to the pencil sketch entitled *Nancy My Sister,* which dated from Kurelek's early student days. He was unaware that Kurelek could draw so well—quite a compliment to Kurelek, as Hughes is one of Canada's finest draftsmen.

Regarding the cartoons in our collection, E.J. Hughes expressed his disappointment that he had abandoned this medium in the middle of his career. He appeared proud of these cartoons and gratified that they were displayed with the same prominence as his watercolours and paintings.

From such a normally modest artist, it was rather surprising to hear Hughes recall how well he had executed *Maple Bay.* He readily admitted that he had forgotten "how good" this watercolour really was. Otherwise he seemed to remember all of his work in our collection.

Hughes was most talkative throughout his visit to our home. I must admit that I was greatly impressed by his gentleness, his interest in his art, and his memory of the conditions under which each one of his works was executed.

On the tour, which took us to every floor of the house, Hughes was captivated by the number of family photographs—particularly of the children—exhibited throughout our home. During his visit he repeatedly mentioned how fond he was of Vancouver. Though he does not like crowds and noise, he seemed nonetheless to be very attracted to the beauty of the city.

Finally, before leaving, Hughes mentioned as an aside that his *Fishboats, Rivers Inlet* was declared by Jack Shadbolt to be a "semi-masterpiece" when the Shadbolts visited him and his wife in Victoria in the late 1940s.

Boathouses by Catalogue

As might be expected, I am always anticipating the arrival of a new art auction catalogue to see if another Hughes might be available. For those of us who were either too young or too impecunious to acquire the works of this artist when they first appeared at the Dominion Gallery, the secondary auction market provides a welcome opportunity to rectify a missed opportunity.

Unfortunately, the first owners of Hughes' paintings are altogether too reluctant to part with them, and understandably so. Moreover, as Hughes was never prolific, at least by modern-day standards, the secondary market is rather "thin." This makes it difficult for the latecomer to assemble a representative grouping of Hughes' work. Within these constrictions, the art auctions do provide an effective secondary market for those few works that become available from time to time.

As usual, when I received Joyner's 1993 spring catalogue, I immediately turned to the index to find that some three works by Hughes would be put up for auction in Toronto.

One particular painting piqued my interest. Entitled *Boathouses on the Beach, Ladysmith* (overleaf), this 1969 canvas appeared to be a classic mystical Hughes. It almost seemed to be a throwback to his 1950s work. I was immediately attracted to the painting. Genially nocturnal, like many of his earlier canvases, the overall composition was appealing.

Unfortunately, it was impossible for me to have a look at the painting or indeed to attend the auction. As it can be imprudent to buy from the catalogue, David Heffel kindly agreed to act for me since he planned to attend the auction in any event. He did a great job and the painting was knocked down in our favour.

Boathouses on the Beach, Ladysmith is one of those intriguing double-faceted Hughes paintings. At first glance it merely reflects a quiet and quaint scene: a row of boathouses on the seashore. After sitting in front of the painting for a short time, however, a certain *je ne sais quoi* begins to tease the mind. The whole scene is at a standstill. Except for a bit of red railing, there is nothing to divert the mind from the main theme of the painting. The atmosphere is simply too placid, too calm—indeed, altogether too disturbingly serene. What then is the message? To the cynic, the answer is perhaps that there is no hidden message: "you get what you see." This facile answer, however, is not reconcilable with the overall impact of the painting. There is an inner strength that must be recognized. It cannot be ignored or casually dismissed. The tonality is arresting. On close examination, the heavy brushwork by itself suggests a hidden force. The resonant luminosity of this twilight scene clearly establishes Hughes as a virtuoso in his profession.

In short, *Boathouses on the Beach* is a symphony of muted vibrations. While the painting may be considered quaint and placid, it cannot be dismissed simply as a decorative painting. I could attempt to proffer an interpretation to parade my depth of perception. The crux of the matter is that I have yet to discern the veiled message. Not that I have given up the challenge—and that is perhaps how Hughes may reveal his true intent: to manipulate the obvious to create a continuing challenge for the intellect. If so, Hughes has achieved his objective with a rare modicum of

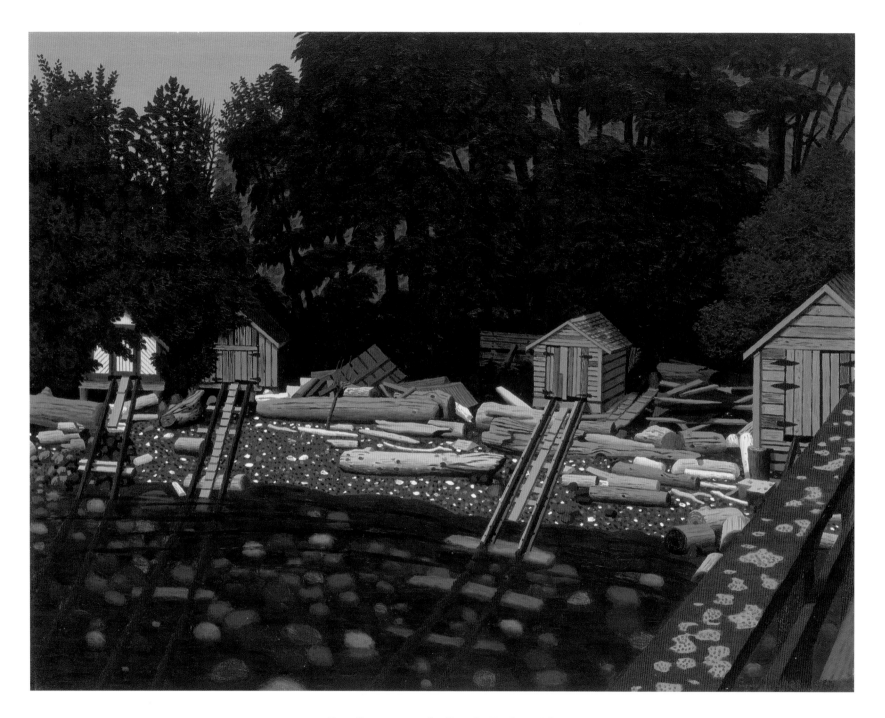

Boathouses on the Beach, Ladysmith

1969 oil on canvas, 63.5 x 81.28 cm

subtlety and *savoir faire*. Oh yes! I readily admit that the inner message may be more instinctively derived than consciously engineered. Even so, the challenge remains delicately camouflaged. Overall, a double-faceted painting: restful to the weary and spiritual to the alert.

After three years of constant deliberation, Michel Moreault finally persuaded me to acquire *Ladysmith, B.C.* (overleaf), a 1982 acrylic rendition of a 1948 pencil sketch. Since then *Ladysmith* has become one of my favourite paintings, though it would not be regarded as pre-eminent among Hughes' work. To the casual onlooker *Ladysmith* cannot be compared to *Steamer in Grenville Channel* or to *Taylor Bay, Gabriola Island.*

Why the belated appeal?

Essentially *Ladysmith* is a cheerful painting. It is restful yet it invites constant speculation about its camouflaged message. It has great juxtaposition of colours and tones—from soft beiges and browns to harsh blacks and reds. A masterpiece of subtle colour orchestration, the overall effect is one of quiet solitude and serenity. You have to look at it. You have to live with it for a while to appreciate it. This is not an instant seduction. Why then did I procrastinate for three years before acquiring *Ladysmith?* Initially the painting is not overly magnetic. It is a painting that needs space. It cannot be viewed hemmed between other Hugheses. It needs its own milieu. Time was required to sensitize my aesthetic judgment. *Voila!*

Finally, by accident rather than foresight, *Ladysmith* wound up in our bedroom at our beach house in Point Roberts. There it came alive within the knotty pine interior overlooking the San Juan Islands. Within this framework, *Ladysmith* imparts a therapeutic message. Here it can be appreciated and savoured. The experience taught me a lesson. Some Hugheses require time, space and the proper ambience to be truly appreciated.

The more energetic pieces, such as *Steamer in Grenville Channel* and *Taylor Bay, Gabriola Island, B.C.,* are immediately seductive. These quickly arouse the emotions. Others, such as *Cowichan Bay and Mount Prevost* and *Ladysmith,* require patience and contemplation. The end result may be greater satisfaction for greater effort.

All circumstances considered, the acquisition of *Ladysmith* was an instructive exercise. It proved to me that some paintings should not be dismissed at first glance. They require quiet observation and a proper setting to reveal their intrinsic quality.

Thanks to Michel Moreault's patience and loyalty, the painting that was first rejected became, upon disciplined reflection, a valued acquisition. With a little prodding from a good dealer, *Ladysmith* is now a cherished possession: better late than never!

In 1994, I acquired *Trees, Sooke Harbour, B.C.* (page 36), a 1951 classic Hughes. It was one of only two Hugheses in Dr. and Mrs. Stern's private collection. I had acquired the other, *Taylor Bay, Gabriola Island,* as previously mentioned, in 1982.

Trees, Sooke Harbour should be compared with *Taylor Bay, Gabriola Island* (page 17). They reflect two different stages of development. What motivated Dr. Stern, who died in 1987, to retain these two works from the hundreds of Hughes paintings he acquired as the artist's exclusive agent since 1951? According to Michel Moreault, Dr. Stern thought that *Trees, Sooke Harbour* and *Taylor Bay, Gabriola Island* represented the best of Hughes' art.

Ladysmith, B.C.

1982 acrylic on canvas, 61 x 91.44 cm

Trees, Sooke Harbour is an example of Hughes' early post-war period, having been completed in 1951 before he came under the influence of Dr. Stern. This early neo-primitive post-war stage is represented by such paintings as *Qualicum Beach* (1948) and *Abandoned Village, Rivers Inlet, B.C.* (1947). By the time Dr. Stern came into the picture, most of these works had already been acquired either by public galleries or by lucky collectors. Accordingly, *Trees, Sooke Harbour* might have been the most appealing post-war painting of this genre available in 1951 when Dr. Stern arrived on the scene.

The painting was likely begun a few years earlier than its 1951 dating, say in 1948 or 1949, as E.J. Hughes was in the habit of working on a few paintings at the same time. Moreover, he was inclined to let the odd unfinished canvas age for a while. A comparison of *Taylor Bay, Gabriola Island*, dated 1952, and *Trees, Sooke Harbour*, dated 1951, supports this conclusion, as the two paintings reflect two different styles. The *Sooke Harbour* composition, similar to other late-1940 pieces, is hard-edged and somewhat primitive, while the 1952 *Taylor Bay*—like other paintings of that later period—is more refined and contemporary.

In any event, if there can be some argument that *Trees, Sooke Harbour* is the best of Hughes' post-war era, there is no doubt that Dr. Stern's opinion with respect to *Taylor Bay, Gabriola Island* is fully validated—it is the best of Hughes. It features the artist's trademarks: the Gulf Island setting and the much-loved coastal ferry. The majestic painting truly authenticates Hughes' artistic maturity.

The Artist at Home

The time had finally arrived for me to meet my favourite artist at his home.

David Heffel and I left Vancouver very early Saturday morning, January 7, 1995, to board the ferry to Victoria. We first proceeded to Shawnigan Lake to meet with Pat Salmon at her home on the lake. With a little prompting she very proudly showed us her unique Hughes collection, which I could not help envying. A very small ink sketch particularly captured my attention: a detailed prototype for the majestic *Indian Church, North Vancouver*.

I was also attracted to a self-portrait sketch by Hughes that was matched with a sketch of his wife, Fern. The Salmon collection also includes an almost complete selection of the early Hughes etchings, a few of which luckily are duplicated in our collection.

In anticipation of our visit, Pat Salmon had thoughtfully prepared a small bundle of reference material for us. I was specially appreciative of a few copies of the Hughes Nanaimo exhibition catalogue. While we had lent a number of works to that exhibition, I had not previously seen the highly informative catalogue, so ably edited by Pat Salmon. It is, without a doubt, a must-read for anyone interested in Hughes' painting methodology.

After our tour of the collection we had to decide how to engineer a rendezvous with Hughes. As Pat Salmon had previously indicated, pre-arranging a meeting with Hughes was always a sensitive exercise. Her suggestion was that we

drive to Duncan for lunch and attempt to meet Hughes at one of his two favourite restaurants. We knew we were in luck when David spotted Hughes' Jaguar parked in the Hy's Restaurant parking lot.

Hughes seemed delighted to meet us at lunch. I can now more clearly appreciate why he is somewhat reluctant to meet people. Once he becomes interested in a discussion his whole personality begins to radiate. He speaks with equal passion on subjects ranging from the art of Vermeer to his long-time association with Dr. Stern.

It struck me as an appropriate occasion to give our coat of arms medallion to both Pat Salmon and Hughes. It was a small token of our gratitude. Initially, Hughes was a bit reluctant to accept the family *passe-partout*. Pat Salmon, however, appeared flattered, and I believe both were appreciative of the gesture.

After this brief exchange, we started talking about some of the paintings in the collection. Concerning *Steamer in Grenville Channel,* Hughes remarked that if I studied the sky panorama I would notice that it had been overpainted a number of times. Obviously, this aspect of the painting had proved to be a real hurdle for him to prompt such an immediate recall some fifty years later.

E.J. Hughes again talked longingly about his trip to Paris that was financed by Dr. Stern. Hughes very much enjoyed visiting the Louvre with Ms. Salmon and his sister Irma Hamilton from West Vancouver.

Following lunch, Hughes kindly invited us to visit his home; however, he did so only after making a profuse apology for the condition of his living room. Apparently, he was in the process of editing various personal letters and memoranda accumulated by his much-loved aunt, Sarah ("Bips") Shreeve, who had recently died.

Hughes' living-room wall boasted a number of works by local artists whom he had found worthy of encouragement over the years. He had a few works of his own—including a coloured reproduction of his famous *Sergeants' Mess* that appears in Jane Young's 1983 E.J. Hughes exhibition catalogue. He seemed to be very interested in W.J. Phillips' work, particularly since Pat Salmon had given him a Phillips woodblock print for his birthday.

During the course of lunch, Hughes did not seem to mind when I took a few photographs of him. Once we got to his home, all of us joined in a merry-go-round of photograph taking. He seemed to be as keen about taking pictures as we were. My only hope was that they would turn out—and they did!

I caught a glimpse of Hughes' personality when he started talking about cars. He displayed a youthful enthusiasm for automobiles generally but most specifically for his own Jaguar. This new car undoubtedly was the one thing, outside painting, that commanded his attention. His enthusiasm was contagious as we began discussing the performance of various automobiles. Hughes' memory again proved uncanny. On the basis of his one short visit to our home years before, he remembered to ask about Margaret's antiquated Jaguar.

I suspect Hughes may be reluctant to meet people because he gives too much of himself when conversing. He certainly becomes passionate when discussing matters of mutual interest. I can easily understand that if he is in the middle of a painting, such social excursions would be very distracting to his art.

As to his experiences during World War II, he readily admitted to being fully committed to the pursuit of craft as an official war artist. He seemed compelled to devote as much effort and energy to painting as the common soldier was devoting to winning the war. While the average soldier had the odd day off, he felt morally obligated to work every day of the week. The "work" he created during the war undoubtedly substantiates this claim.

Before we left I gave E.J. Hughes a forty-ounce bottle of Ballantine's on the basis that he might find the Scotch more enjoyable than the Barbeau medallion.

There is no doubt that Hughes is a very humane person. Without appearing unduly humble, he displays neither false pretension nor overbearing ego. Quite attuned to worldly matters, Hughes reflects a transparent *bien être* that is truly remarkable.

As we were leaving, Hughes, with perhaps some degree of envy, did again express how comfortable he found our family home when he had visited us in 1992.

There is little doubt that this January 1995 meeting with E.J. Hughes and Pat Salmon will remain for both David Heffel and me a special occasion to be fondly remembered for years to come. A Phillips woodcut forwarded to each of them is unfortunately the only visible evidence of our appreciation for such gracious hospitality.

Qualicum Beach in Japan

I first observed *Looking North from Qualicum Beach* (overleaf) in Jane Young's retrospective exhibition catalogue. But my interest in the painting was revived in Tokyo, of all places, in December 1993.

During a three-week business sojourn, I stayed at the Imperial Hotel located a few blocks from the centre of the Ginza, the locale of the more pricey Japanese art galleries. Whenever the opportunity presented itself, I would wander around in the Ginza to savour the disciplined opulence of this famous district.

One evening, returning from a book-buying trip to Maruzen, I was confronted by a startling exhibition at the massively fronted Nichido Gallery at 3-16 Ginza, 5-Chome, Chuo-ku. The exhibition consisted of some two dozen paintings reflecting a curious mixture of Western and Japanese styles.

The majority of the larger paintings depicted life-size groups of exquisitely concocted statuesque women amalgamating both Western and Japanese characteristics. It appeared as if the artist had fused the two races to create a most appealing group of women, which he set off against a majestic sandy beach background.

With some trepidation, recognizing the Tokyo art price structure, I ventured into the gallery to acquire at least a catalogue. Unfortunately, none of the attendants appeared willing to deal with an English-speaking *gaijin*. I was ready to depart empty-handed when an elderly gentleman approached me near the door with a catalogue of the exhibition. As I was offering to pay for it, one of the attendants finally appeared to inform me that the elderly gentleman was the

Looking North from Qualicum Beach (Low Tide at Qualicum)

1948 pencil, 50.17 x 60.96 cm

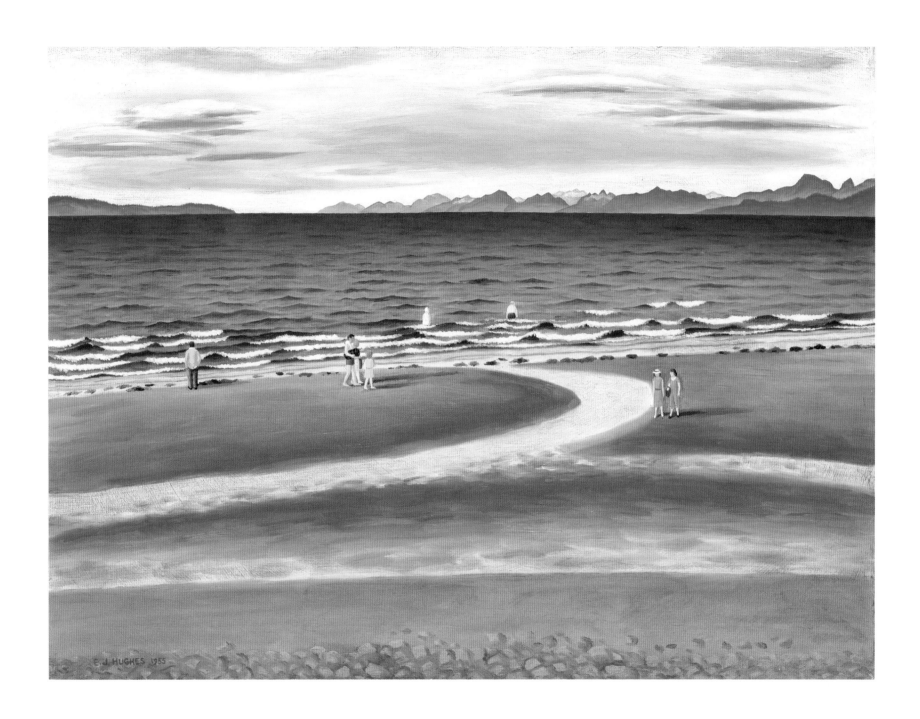

Looking North from Qualicum Beach

1955 oil on canvas, 45.7 x 61 cm

Cooper's Cove Study—Undated pencil, 29.21 x 21.59 cm

artist, who wished me to have the catalogue with his compliments. Thus began my odyssey with the Japanese grand master Kokuryo Tsunero.

At this stage, out of courtesy and inquisitiveness, I proceeded to the exhibition. I soon came across a large, imposing canvas, identical in composition to Hughes' *Looking North from Qualicum Beach.* I was startled, to say the least, at the similarity of the two paintings. It was simply mind-boggling that two artists living in two different worlds, some six thousand miles from each other, would choose an identical scene. While Hughes looked over the Pacific from the shores of Canada, Kokuryo-san did the same from the shores of Japan, with each artist breaking the foreground with a similar meandering creek emptying into the sea.

The essential difference between the two paintings is their size. Kokuryo's *Ebb Tide* measures 36¼″ × 46¼″, while Hughes' is about half that size. This difference in dimension has led me to speculate, from time to time, whether the scene might be deserving of a larger format to create a more imposing perspective of our own Pacific shores.

For reasons that were all too obvious, I could not afford to buy Kokuryo's museum piece. I did, however, acquire a smaller Japanese seashore scene entitled *Remainder of the Wind* that now hangs in my office. The painting was reserved initially for a loyal patron of the artist. Kokuryo-san, however, was kind enough to persuade the intended buyer to choose another work. The gesture allowed me to acquire the smaller painting, which, with some sense of self-delusion, I decided I could afford.

The overall experience developed into an interpreter-assisted friendship with Kokuryo-san and his wife that permitted me to visit their home in Yokohama in 1994 to view once again *Ebb Tide.* The painting remains in Japan.

With this background, I was intrigued when *Looking North from Qualicum Beach* appeared in Joyner's November 1993 auction catalogue.

Initially, the smaller format of *Looking North from Qualicum Beach,* at least in comparison with Kokuryo-san's larger work, made me hesitate to bid for it at the auction. And, if truth be known, the suggested price range was intimidating.

Fortunately for me, the painting did not sell at auction. Through a rather convoluted set of circumstances, I eventually acquired *Looking North from Qualicum Beach* from Gérard Gorce of the Waddington and Gorce Gallery in Montreal in June 1995.

Perhaps one day I will be able to acquire its Japanese counterpart!

Indian (Church) Study (page *x*), a small linocut given to me by E.J. Hughes, is an apt acknowledgment of a unique relationship. It is a most cherished possession. Executed in 1934, this cross-hatched print was an early study for Hughes' 1947 epic masterpiece *Indian Church, North Vancouver, B.C.*, currently part of Ron Cliff's distinguished collection. This gift coincided with the opening of a Hughes exhibition at the University of Victoria. The event was to commemorate the well-deserved bestowal of an honorary doctor of fine arts degree upon Edward John Hughes by the university on November 26, 1995.

Two weeks before convocation, Hughes, Pat Salmon and I met at the Empress Hotel for lunch before attending the official opening of the Hughes exhibition at the university. It was a leisurely European-style luncheon at what appeared to be one of the artist's more sentimental venues.

While it is often said that Hughes is a very reserved person, his presence at the exhibition completely refuted this allegation. He seemed to "shine" when surrounded by his creations, easily and willingly mixing with the crowd—proud and sharing of his art and of himself.

As on the previous occasion, when we met in Duncan, Hughes' reticence seemed to be more at the *prospect* of meeting people than at actually meeting them. I would guess that he recognizes only too well that he becomes too engaging when surrounded by people. The resulting emotional toll hinders his painting activities. As such, social affairs are a luxury to be enjoyed sporadically. He once mentioned that he would hesitate to live in Vancouver lest he be deluged by art school students wanting to visit "old Ed." Such interruptions, albeit complimentary, would be too emotionally disruptive: it is better for him to remain undisturbed and relatively unobserved in the safe haven of Duncan.

Together with my cherished *Indian (Church) Study,* this day in Victoria will always be fondly remembered—a great day, a great man and a great artist.

A week later, I received a handwritten note from E.J. Hughes acknowledging the lunch at the Empress with a commitment to reciprocate the gesture. That commitment was fulfilled on July 30, 1996, in Qualicum Beach.

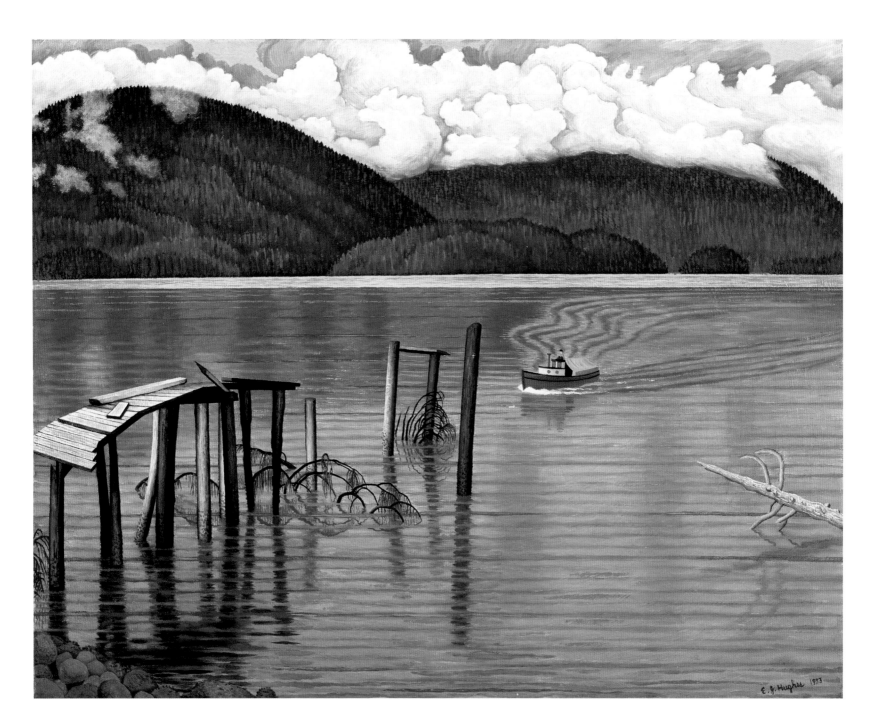

Rivers Inlet

1953 oil on canvas, 48.26 x 58.4 cm

From *Rivers Inlet* to *Saanich Inlet*

In early 1996, David Heffel offered me an undated watercolour entitled *Ottawa River at Ottawa* (page 104). As Margaret and I lived practically on the shore of that river during our first year of marriage, this watercolour had an obvious sentimental value. We certainly were familiar with the Eddy match plant facing Parliament across the river. It provided another perspective of Hughes' work in Ottawa during and shortly after the war. A reasonable price, coupled with a higher sentimental value, prompted the acquisition of this historic watercolour.

A visit to Montreal on May 29, 1996, was an occasion for two other acquisitions: the 1953 *Rivers Inlet* and the 1991 *Store at Allison Harbour II* (overleaf).

A week or so before my visit to Montreal, Michel Moreault intimated that he had a surprise for me. Indeed he did. Upon arriving at the gallery, I was confronted with the delicate *Rivers Inlet*. Hughes' sensitivity to nature is well authenticated in this 1953 charmer. The serene atmosphere is in sharp contrast to the assertive character of *Trees, Sooke Harbour,* which was completed in 1951 before Dr. Stern came on the scene.

Rivers Inlet provides a similar contrast to the 1946 masterpiece *Fishboats, Rivers Inlet*. The significant difference in intensity is only too vivid, though Hughes likely drew both sketches at the same time when he was fishing commercially in the area in 1938.

According to Jane Young "the relief from economic hardship" provided by Stern "may account for the lighter palette" after 1951 (p. 59). For whatever reason, there is a marked shift in style between Hughes' pre- and post-1951 paintings. My own suspicion is that Dr. Stern simply could not afford to have Hughes devote months on end to a single painting. The "economics of taste" now had to come into play!

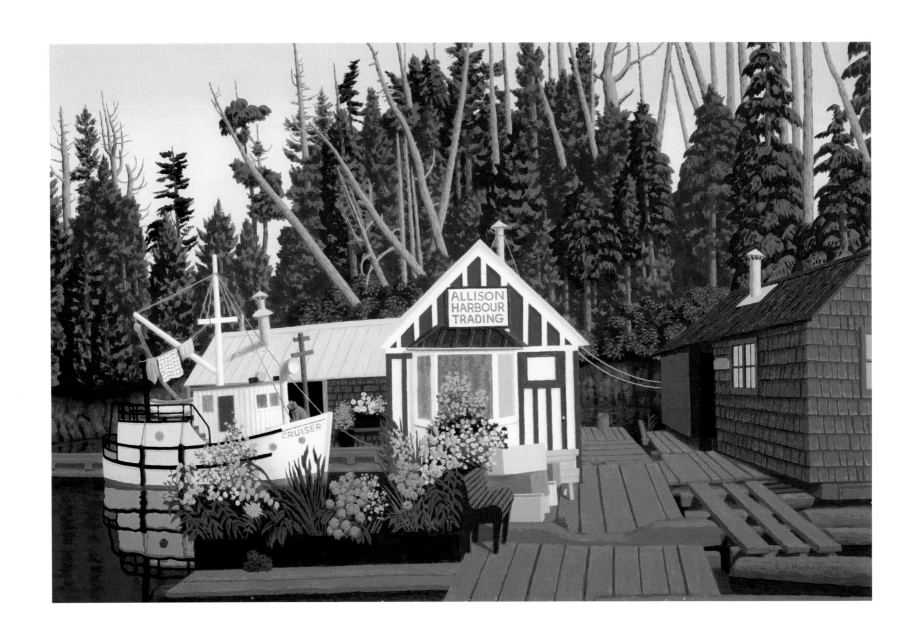

The Store at Allison Harbour II

1991 acrylic on canvas, 61 x 91.44 cm

In substance and in form, *Rivers Inlet* confirms Hughes' sentiment that "nature is so wonderful . . . I feel that when I'm doing my painting it is a form of worship." A debt of gratitude is owed to Michel Moreault for having maintained a long-term liaison with the previous owners to enable *Rivers Inlet* to return to British Columbia.

The Store at Allison Harbour II was a more controversial acquisition. As already noted, this 1991 acrylic is a second version of a 1955 oil painting of the same subject. To some collectors this type of duplication is frowned upon. Having seen the original oil in Senator Kolber's office in Montreal, when it was part of the Charles Bronfman/Cambridge Inc. collection, its acrylic counterpart appeared different enough to me to stand on its own. The contrast in medium, oil versus acrylic, and a different compositional perspective is sufficient to establish an aesthetic distinction between these two paintings. The contrast is as marked as the one that exists between a Hughes watercolour and an oil painting of the same subject. In any event, he is not the first artist to revisit an earlier composition "in order to lighten the tonality of the darker, earlier version," as noted by Jane Young, "so that the effect is more mid-afternoon than evening" (p. 15). As such, Hughes merely adopted a standard beatified if not canonized by Monet.

The controversy surrounding the acquisition of *The Store at Allison Harbour II* was further aggravated by the fact it was a substitute for another painting. The decision not to acquire *The South Thompson Valley at Chase, B.C.* marks the first occasion when Michel Moreault's advice was not ultimately persuasive. Judging from past experience, this decision may be regretted in the future. However, in this instance Margaret's influence was overwhelming. Perhaps our artistic judgment is not sufficiently refined! In any event, it was foolhardy to make a commitment solely on the basis of a photograph. As it turned out, the enhanced colour composition of the photograph proved out of sync with the subdued tonality of the painting.

The clincher in favour of *The Store at Allison Harbour II* is that it totally rejuvenated the entrance hall of our home to the universal satisfaction of the family. Location, as previously mentioned in the commentary on *Ladysmith,* may be a determinant in certain circumstances.

A decision made always entails a margin of error. Time is the only equalizer. Besides, *The Store at Allison Harbour II* provides a welcome element of cheerfulness and levity—two qualities never to be minimized.

Looking at the Sites

On Tuesday, July 30, 1996, I took the ferry from Tsawwassen to Nanaimo to again meet E.J. Hughes and Pat Salmon. What a day!

Pat met me with the Jaguar at the ferry dock at about noon. After an exchange of greetings, she informed me that we were going to Qualicum, at Hughes' request, to look at the site of a number of his Qualicum paintings. In particular, he wanted me to observe the actual vista he relied upon to create *Looking North from Qualicum Beach.* As previously noted, this was the painting I had acquired the previous year from Gérard Gorce, the well-respected Montreal dealer.

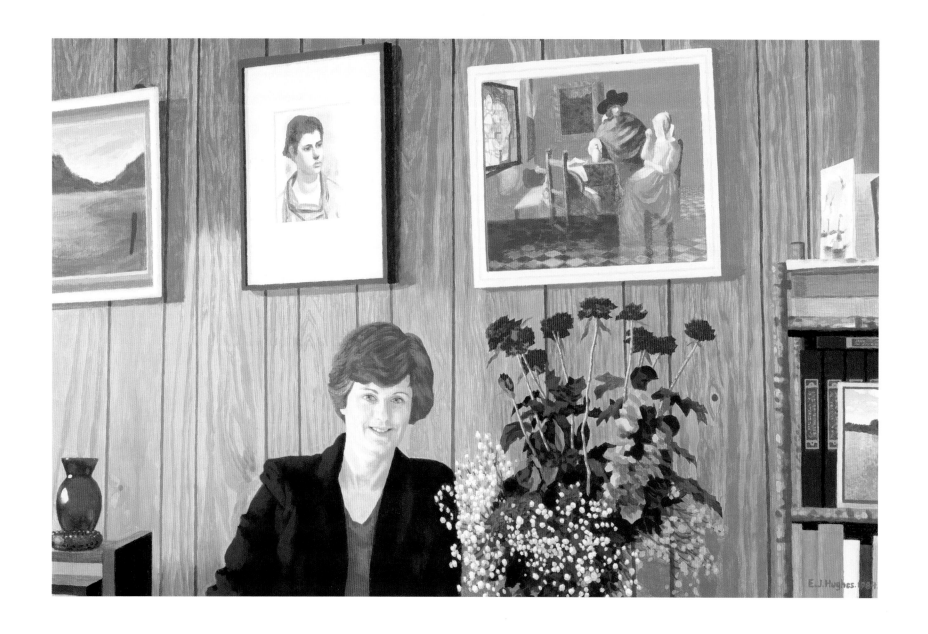

Mrs. S. on Heather Street

1984 acrylic on canvas, 63.5 x 81.3 cm

While the view of *Looking North from Qualicum Beach* is spectacular, there is no doubt Hughes reinterpreted it in his own distinctive vocabulary. To further appreciate the scene, we enjoyed a leisurely lunch at the Dutch Inn, "looking north from Qualicum Beach," all courtesy of E.J. Hughes.

After lunch, we drove to the Malaspina Hotel in Nanaimo, which was in the process of being completely renovated. The purpose of the exercise was to look at the murals painted by E.J. Hughes in 1938 in a number of large conference rooms at the hotel. Regrettably, the murals, which had been covered either by paint or by wallboard, were now only partially discernible. Fortunately, the Heritage Committee of Nanaimo is attempting to salvage whatever it can of these historical works.

By way of background, Pat Salmon gave me a detailed article that appeared in the *Times* of Nanaimo on July 25, 1996, which, supplemented by several of my own photographs, sadly records the deplorable condition of the murals.

After having cajoled the security guard at the Malaspina Hotel to let us look at the remains of the murals, we then visited the Bastion in Nanaimo. This remarkable landmark was the subject of the 1950 cartoon (page 4) that I had acquired years earlier from Michel Moreault at the Dominion Gallery.

From there we drove to Ladysmith, some twenty miles south of Nanaimo, to take in the panorama that inspired *Ladysmith*. It is worth noting that while the pencil sketch for this painting was drawn in 1948, it was not until 1982 that Hughes relied upon it to paint *Ladysmith*. Apart from its own aesthetic quality, this painting will no doubt become a valued historical record of this charming little town as it existed in 1948.

During our eight hours together, we discussed a number of subjects. At one stage Hughes pulled out a little hand-written notebook and summarized some of the criticisms of his works that have appeared in print over the years. I quickly reassured him that he should ignore this type of criticism as being uninformed. While perhaps not a perfect test, the marketplace has clearly passed judgment on his work. More specifically, the presence of his paintings in museums across Canada clearly speaks to the artistic value of his work.

Like all great artists, Hughes is concerned that his paintings will survive, be respected and be enjoyed by generations to come. He certainly expects, and justifiably so, that his art will become a permanent legacy to British Columbia.

On one occasion, I asked Hughes if he could be granted three wishes, what would they be. After a brief pause, he stated that his greatest wish would be to be allowed to paint until he was one hundred years of age. His second wish was that he with his friends and family would live on to enjoy life together. As to the third, he simply could not think of anything that he required or wanted. What a truly dedicated, generous and contented man.

Hughes is undoubtedly the least money-driven artist I have ever met. He is a genteel man free of the excess baggage that plagues most of us. His whole life seems to be dedicated to painting and to creating a legacy for all of us.

I greatly enjoyed the day. It is indeed a rare privilege to have had the benefit of spending so much time with Hughes in what has become a very personal and intimate relationship. And, as usual, Pat Salmon was a guardian angel to both of us. What a lady!

Stanley Park

1938 graphite cartoon, 21.59 x 30.5 cm

During this visit with E.J. Hughes and Pat Salmon, I was made aware that Michel Moreault of the Dominion Gallery was in possession of an intriguing 1984 painting entitled *Mrs. S.* (previous page). I surmised that it was a portrait of Mrs Salmon. It appeared that Michel Moreault was negotiating for the sale of this painting to the British Columbia Archives. I feared that if that sale were to be concluded, the painting would be forever entombed in Victoria. I immediately telephoned Michel, who agreed to hold the painting until I could visit Montreal to see it.

Mrs. S. is as historically important as it is technically challenging. It will become an autobiographical icon as it integrates a number of pivotal references to Hughes' personal and professional life.

With Pat Salmon centred in the foreground, Hughes duplicates an earlier sketch of his wife, Fern, and reproduces one of his favourite Vermeers. All the props are tied together with a bouquet of red roses—to commemorate his wedding anniversary—strategically placed next to Mrs. S., the pivotal figure of the painting. Finally, subtly inserted: a small painting that acknowledges Hughes' practice of acquiring the works of deserving young artists. On this larger than usual canvas, Hughes appears to sum up the important factors in his life: *hommage à mon épouse, à ma confidente, à Vermeer, et bonne chance aux jeunes artistes.*

What a delicate autobiographical declaration!

Recognizing the historical importance of this painting, both Hughes and Moreault agreed that henceforth the painting should be known as *Mrs. S. on Heather Street* to denote its setting at Hughes' residence in Duncan. Clearly, the painting provides an important biographical reference to our collection. It will constantly stimulate the imagination by challenging the viewer to discern the hidden technical finesse that Hughes introduces into the painting.

Mrs. S. on Heather Street is now comfortably settled in the library to provide a reflective atmosphere for the enjoyment of a good book and a fine Gloria Cabaña cigar (which by the time of this printing I unfortunately have had to give up).

An advertisement in the *Globe and Mail* by Ms. Aleida MacDonald in August 1996, offering a number of early drawings and sketches by E.J. Hughes, triggered immediate interest among collectors, including David Heffel. As the former wife of Ron MacDonald, an avid collector and, at one time, owner of Hughes' 1949 classic *Entrance to Howe Sound,* Aleida's paperwork collection was justifiably intriguing. After some direct negotiations, David succeeded in acquiring the whole collection, from which I chose two particular sketches.

Originally included in the collection was an early study of the famous 1941 *Sergeants' Mess.* Much to my dismay the sketch was inexplicably withdrawn from the sale.

My interest then shifted to the small, finely detailed 1938 pencil drawing of *Stanley Park*, the precursor of an old friend. A few years earlier, I had engaged in some particularly convoluted negotiations with Franklin Silverstone, the curator of the Bronfman/Cambridge Collection, to acquire a large oil canvas, *Near Third Beach, Stanley Park.* Frustrated with the never-ending bargaining process, and more importantly, influenced by Hughes' opinion that this painting was never finished, I gave up the chase.

Ferry Boat **Princess Elaine**

Undated pencil, 35.56 x 26.67 cm

The pencil sketch, on the other hand, was finished, and as such provided the key to understanding why its oil counterpart was regarded as never having been completed.

A comparison of the pencil sketch with the final oil painting reveals a much overpainted quasi-triangular "white sky" insertion. The paper sketch does not include this feature. It simply shows the undisturbed panoramic foliage. Apparently Dr. Stern considered the original version of this oil to be too dark. He suggested that Hughes should lighten it up—a task the artist unsuccessfully attempted to accomplish between 1946 and 1959. As a result, E.J. Hughes never considered this painting to be totally "finished."

Comparing the finished sketch with the unfinished painting, as reproduced in Shadbolt's Hughes exhibition catalogue, may provide an answer as to why E.J. Hughes was never completely satisfied with *Near Third Beach, Stanley Park.*

Looking at the pencil sketch, one cannot help but speculate on what the unaltered painting might have looked like. There is little doubt that the 1940 foliage in Stanley Park was extremely dense, allowing only filaments of sunrays through. The highly refined thin-line sketch accurately depicts the actual forest panorama. It conveys that "inside" feeling that one experiences when walking through a typical mature West Coast forest.

My second choice from the MacDonald collection was *Ferry Boat* Princess Elaine, a small, freely drafted pencil sketch of a famous Vancouver-to-Nanaimo CPR ferry. Here again Margaret was the final arbiter. The work was a fond reminder of the ferries she so often relied upon to get to the Owen/Dowler summer cottage on Vancouver Island. Undated, it provides an imaginative interpretation of this well-loved ferry, no longer part of the B.C. coastal scene. Hughes had the uncanny ability to depict these large utilitarian ferries with such grace that they now have become virtual idyllic icons.

The Heffel and Joyner Auctions

The second annual Heffel auction was held at the Wall Centre Garden Hotel on November 7, 1996. It was a tremendous success, although the selling prices were not as high as I had expected in view of a profitable season on the stock markets.

Nine works by E.J. Hughes were put up for auction, constituting one of the largest selections of Hughes' works ever offered by an auction house in Canada.

My first choice was a 1937 watercolour entitled *Totem Poles at Stanley Park* (overleaf). This is one of Hughes' most delicate creations. The subject matter is shrouded by an unusual greyish-orange complexion that dominates it. Superbly executed when the artist was only twenty-four, it confirms his drafting ability and his distinctive skill at manipulating colour. It suggests a strategy where the colour scheme itself provides the aesthetic message. The subject matter merely provides a framework for this noble experiment: an early indicator of Hughes' tactical acumen.

Secured in Hughes' homemade whitish oak frame, *Totem Poles at Stanley Park* was accompanied by the original sales invoice from Dominion Gallery. It had sold for $75 in 1953! Having recently read William Grampp's *Pricing the*

Totem Poles at Stanley Park

1937 watercolour, 37.46 x 24.46 cm

Priceless, I was intrigued to compare the rate of return on investment between this piece and Grampp's summary of the rate of return on *recognized* artwork. Grampp's most plausible study indicates a rate of return on art investments of 10.5 percent for the 1946 to 1968 period. Here, the Hughes watercolour generated a rate of return of 11.45 percent compounded over the 43-year period since 1953.

While it is fashionable to ignore the investment potential, any honest collector will admit that this factor is relevant, although perhaps not dominant when acquiring any artwork. On the basis of reasonably sound criteria, Hughes' works appear to qualify as a good investment.

My second choice at the auction was a vibrant oil painting entitled *Brady's Beach, near Bamfield, B.C.,* executed by Hughes in 1960. Here, however, my enthusiasm was more restrained. First, I was reluctant to deplete my financial resources lest I be prevented from "going the whole way" a week later at the Joyner auction for a 1952 painting that I much coveted. Second, another rendition of Brady's Beach I had seen at the Equinox Gallery in 1982, entitled *The Pacific Coast Near Bamfield,* appeared better suited for the collection. I lost the bid on *Brady's Beach* at $38,000 and the painting was "knocked down" at $40,000 plus the 10 percent buyer's commission.

My final purchase was a small 8½″ × 12″ pencil drawing entitled *Eagle Pass at Revelstoke—Study* (overleaf). This 1958 sketch is the predecessor of the more formal graphite cartoon executed in 1961. In turn, the formal drawing became the prototype for the oil painting now owned by the Vancouver Club. Having already acquired the cartoon, I deemed it only appropriate to acquire the sketch to unite the three works in British Columbia.

The November 15 Joyner auction in Toronto proved to be a more traumatic experience. Some months earlier, David Heffel had told me that Joyner would be offering an early 1950s Hughes. Examples of this period rarely come on the market and are therefore much sought after by collectors. Fortunately, a rare visit to Toronto in late August allowed me to meet Jeffrey Joyner and look at the painting—always a worthwhile exercise.

Cooper's Cove, Saseenos, B.C. (page 76) is a discreet piece of artwork. It is tranquil but subtle. Serenity is the message. It caters to the intellect rather than the emotions. Yet—unlike certain similar works—it possesses an inner strength generated by a strategic contrast between the melodious shades of brown of the mill site and lush multi-hued green foliage of the B.C. west coast. The aesthetic quality lies in the cleverly managed contrast in colours, absent of people and activity. It captures an unadulterated picturesque scene, inviting—if not challenging—the onlooker to respond.

Clearly *Cooper's Cove, Saseenos* had to be repatriated. The challenge was to determine how high a limit I should set on my bid. The situation was made no easier by the alleged interest in the painting. Fortunately, the auction forum was in my favour. E.J. Hughes' artwork is not as recherché in Toronto as it is in Vancouver. Furthermore, as pointed out by David Heffel, the omission of the traditional fishboat or ferry should serve to reduce the value of this painting. After much soul searching—and with minimal emotional bias—a maximum bid of $38,000 appeared a fair and reasonable price for this 1952 painting.

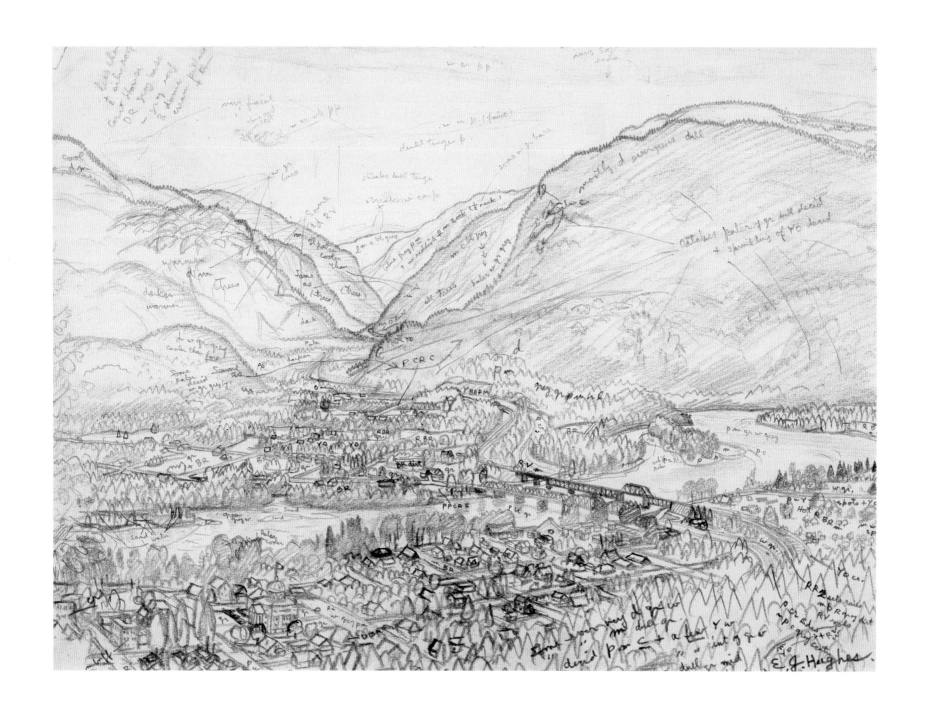

Eagle Pass at Revelstoke—Study

1958 pencil, 30.5 x 21.59 cm

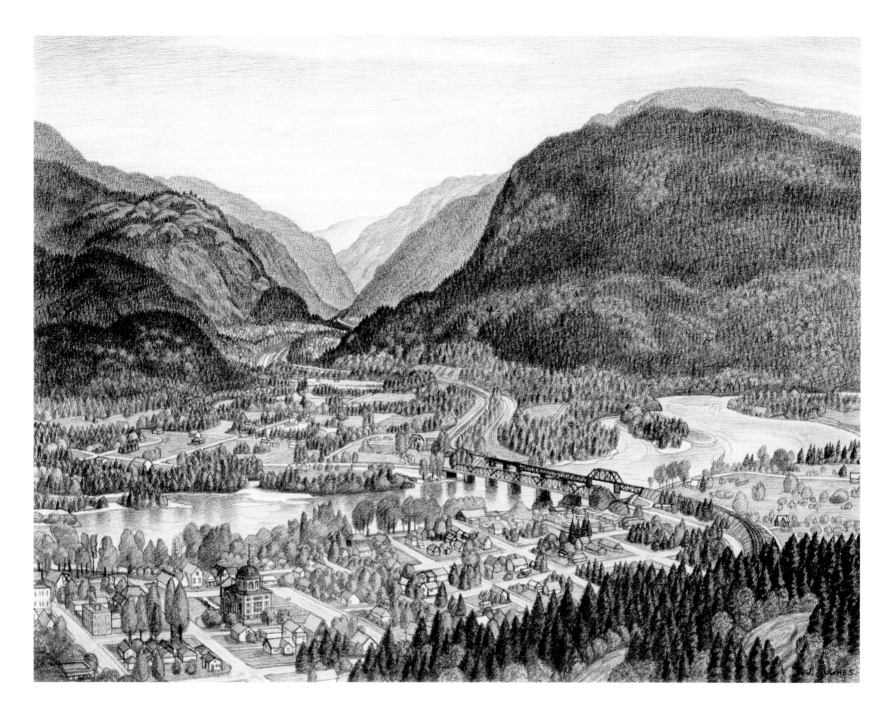

Eagle Pass at Revelstoke

1961 graphite cartoon, 46.99 x 59.69 cm

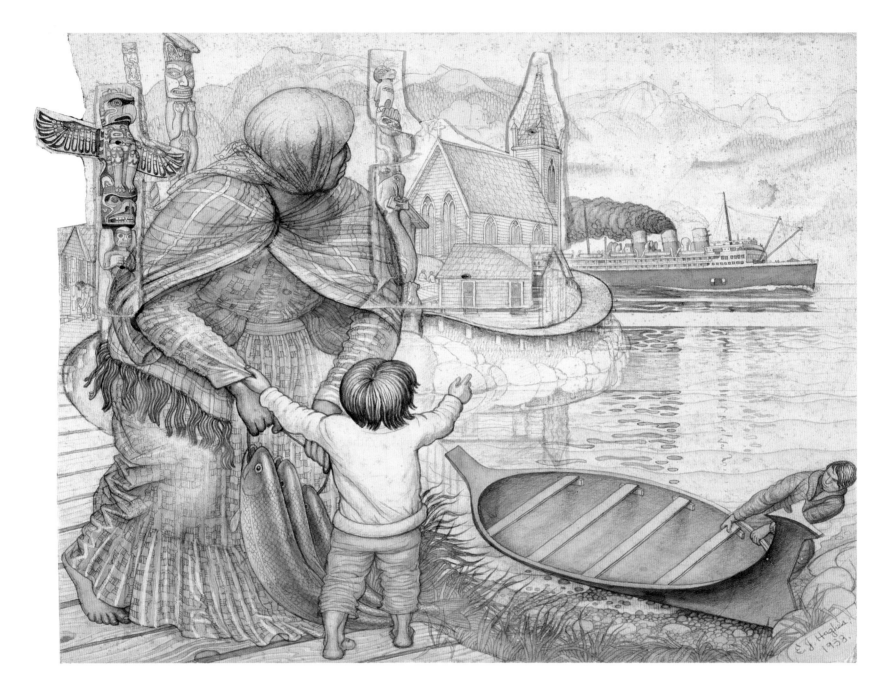

Indian Life

1938 watercolour, 13 x 18.6 cm

At 4:35 p.m. in Vancouver, a telephone connection was established with "Linda" on the Joyner auction floor. Momentarily, Lot 30, described in the catalogue as "Cooper's Cove, Saseenos, B.C., oil on board, signed and dated 1952 (20 × 23¾ inches / 50 × 61.9 cm) at $15,000–$18,000," came up for bid.

As expected, the top end of the estimate was reached within seconds. The bid proceeded quickly to $22,000, then paused momentarily at $23,000. Our bid of $24,000 was "knocked down" and the painting, at an aggregate cost of $26,400, became part of the collection. It was an exhilarating moment, particularly as this was my first attempt to bid at an auction by telephone. It was a happy experience all around as another Hughes was returned to British Columbia.

A Lucky Break

In 1939, the city of San Francisco staged the Golden Gate Exposition, presumably to counterbalance the importance of the concurrent New York World Fair. In preparation for this West Coast exposition, British Columbia's Minister of Trade and Industrial Development commissioned "The Brotherhood" of Hughes, Paul Goranson and Orville Fisher to design a series of murals for the exposition's B.C. Building.

While photographs of the finished murals are reproduced in Jane Young's 1983 exhibition catalogue, the actual murals appear to have been destroyed. Fortunately, E.J. Hughes had produced highly detailed drawings for his own four murals: *Tractor Logging, Hunting, Sport Fishing* and *Indian Life.*

Under unknown circumstances, John Avison, the noted CBC Orchestra conductor, acquired these drawings at a time when Hughes' art had yet to be recognized and appreciated by the public. Unlike works executed in his later life, none of these early drawings was signed by Hughes.

Sometime in either late 1994 or early 1995, Theodore Pappas, a rather discreet and little-known Vancouver auctioneer, held one of his unpublicized auctions at the Bayshore Hotel. Among a mass of various artifacts and memorabilia, a number of Hughes' unsigned mural drawings were offered for bid. Blair Dickson, an insightful bidder, acquired them for a modest price. Sometime thereafter, Dickson visited E.J. Hughes in Duncan, had the drawings signed, and eventually sold them to the Vancouver Art Gallery.

It did not take long for the story to circulate among the art circles of Vancouver. Many were distressed to have missed this golden opportunity. Others tried to negotiate with the new owner, who rightfully decided that the Vancouver Art Gallery was the proper depository. For me, it was a disappointment, as I did not possess any example of Hughes' mural works. *Que sera, sera,* as the song goes, and I accepted this permanent void in the collection.

Lo and behold, fate intervened!

On Saturday, May 24, 1997, I received a call from Pat Salmon, who informed me that Mr. Pappas had phoned E.J. Hughes to tell him that he had obtained a watercolour from the John Avison estate that he believed had been executed by Hughes for the Golden Gate Exposition in San Francisco. After a quick description of the work by Pat Salmon, I immediately referred to Jane Young's 1983 exhibition catalogue to trace the watercolour in question. I was soon convinced

The Seashore at Crofton

1998 woodblock, 56 x 71.12 cm

it could only be *Indian Life* (previous page). A phone call to Mr. Pappas seemed to confirm my conclusion. The final test would come the next day when I could actually examine this long-sought-after example of Hughes' mural work.

Promptly at noon on Sunday, May 25, 1997, I arrived at the Pappas auction sale at the Bayshore Hotel. I was soon confronted by Ian Thom of the Vancouver Art Gallery and my good friend David Heffel. We were all after the same prize. And what a prize it turned out to be!

As described by Jane Young, *Indian Life* contained "many of the motifs and compositional devices Hughes would develop in later years: a vista which opens diagonally into the distance with a white steamer to emphasize the recession, an Indian mother and child, totem poles, a rural church and distant forests in which each tree is uniformly drawn" (p. 31). In short, a Hughes icon. The greatest impact on me was the subtlety of the colouring and the exacting details of the composition, particularly of the garments worn by the mother. The gentle pastels—shades of mauve and green—intermingle throughout the overall arrangement to create an aura of intrinsic *délicatesse.*

There was little doubt in my mind that both Ian Thom and David Heffel coveted this magnificent historical piece as much as I did. The catalogue estimates ranged from a low of $3,000 to a high of $5,000. Recognizing the competition, I decided to adopt a more aggressive posture and fixed a limit in excess of three times the high estimate. Both David and I decided to exchange our respective top bids discreetly on a piece of paper to be revealed only after *Indian Life* had been knocked down. All three of us—Ian, David and I—were sitting together, on the assumption that we were the only serious bidders for this watercolour.

Unfortunately, there soon appeared an unknown bidder at the front of the room who seemed to be matching all bids. I kept up the pressure and fast pace as both Ian and David abandoned the chase. It was now a question of discouraging the other bidder. I eventually did with a bid of $7,500. I was simply overjoyed to have obtained this missing link in our collection and also—if you can believe it—by the fact that my self-imposed limit had been $16,000! David's limit was perhaps a more realistic $7,500, which was right on the mark. I shall remain indebted to him for vacating the field.

When settled safely at home, *Indian Life* assumed an even more commanding presence. It became a veritable magnet. It compels everyone's admiration. Margaret fell in love at first sight. We soon realized how lucky we had been to acquire this remarkable piece. The whole experience will not be easily forgotten. Indeed, I doubt if it could ever be duplicated. Thanks to Pat Salmon for the early alert. To the disappointed Ian Thom—he should remember that eventually all great paintings end up in museums!

Sometime in 1997, E.J. Hughes was invited to produce a limited edition woodcut for the Artists for Kids program. He readily agreed as the well-respected master printer, Masato Arikushi, was to assume responsibility for the production of some 100 issues of the 22″× 28″ woodcut. The resulting traditional Japanese-style print was crafted on hand-made hosho paper with 26 blocks using more than 120 impressions to create hundreds of colour variations.

The Seashore at Crofton woodcuts found a ready market at $2,000 each. To the delight of the artist, the endeavour was of significant benefit to the charitable organization.

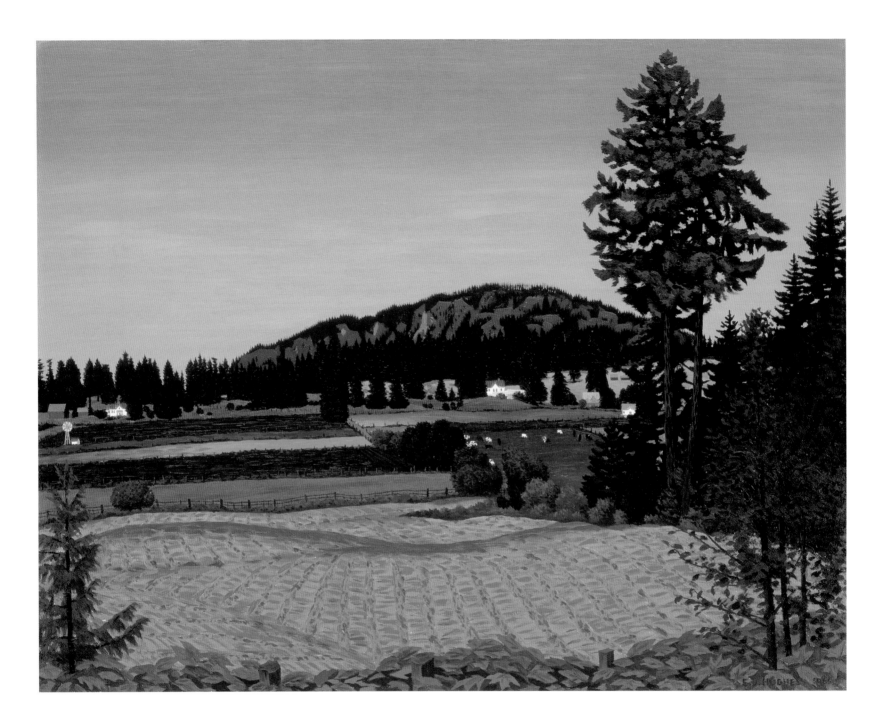

Farm near Cobble Hill, B.C.

1965 oil on canvas, 63.5 x 81 cm

E.J. Hughes generously provided me with the second of ten artist's proofs of this rustic work, which never ceases to intrigue grandson Bladen. It is a cherished addition to the collection. I doubt whether Hughes had used the medium since the 1930s when he produced a few linocuts such as *Morbid Study* and *The Old* Empress of Japan *Figurehead at Stanley Park.*

It is noteworthy that despite an almost insatiable demand for this type of print, Hughes has always been reluctant to exploit the medium. Merchandising, to put it mildly, has never been his forte. Monetary considerations have never influenced E.J. Hughes. His art is his life. So long as the financial rewards have been sufficient to support his modest lifestyle, he has been content to pursue his profession without much concern for money matters.

Spring Break

The first four months of 1998 were perhaps the most hectic I had experienced in almost ten years. It all began in March when I undertook a three-week business trip to London, Bad Orb, Birstein, Neuwied, Dubai, Frankfurt and Cologne. Upon my return to Vancouver and a few days before departing for two weeks in Tokyo, David Heffel invited me to his gallery. He was eager to show me a Hughes that he had recently received.

I was in a receptive frame of mind. It had been almost twelve months since my last acquisition—too long a period of restraint. Moreover, the added workload, coupled with a bullish stock market, generated a euphoric sense of financial well-being—a perfect set-up for any dealer. Not surprisingly in the circumstances, I rose to the bait when David informed me that the consignee, anxious for a quick sale, was reluctant to wait for the November auction.

Farm near Cobble Hill, B.C. is a bit of a whimsical painting that instantly appealed to me. It seemed more stimulating than the typical Hughes farm scenes I had seen in the past. The painting presents an obvious conundrum for the viewer. The issue is how to interpret Hughes' green-ribbed undulating field in the foreground. My first impression was that it depicted some sort of weedless plastic sheeting system. Alas, I was wrong! Pat Salmon later informed me that it merely represented a freshly raked hayfield at midday! I do not feel too embarrassed about my first interpretation, since I understand that Dr. Stern had a similar reaction when the painting first arrived at his gallery.

Overall, I find this 1965 painting rather refreshing. It is noticeably more exciting than a Hughes *paysage* such as the 1959 *Farm near Chilliwack* that was coming up for sale at a forthcoming Joyner auction. Between these two choices, I had little difficulty in giving the nod to *Farm near Cobble Hill.* So, after a few phone calls between David Heffel and the consignee, the painting was ours. I doubt whether the negotiation with David took more than ten minutes, which is all the time necessary for any transaction between a willing buyer and a competent dealer.

My next Hughes took even less time to acquire. Two days prior to my departure for Tokyo, Michel Moreault phoned to tell me that he had just received an extraordinary watercolour that I simply had to acquire. Since Michel had never before confronted me with such an ultimatum, I was startled by the unusual approach. He undertook to courier

Looking South over Shawnigan Lake

1962 watercolour, 21.59 x 26.67 cm

me a photo, which I received the next day prior to leaving Vancouver. As soon as I saw the photograph I called Michel to let him know that I would be only too delighted to add this *chef d'oeuvre* to the collection.

What a catch! What a friend! Michel was completely vindicated in issuing his ultimatum. *The Beach at Savary Island* (page 143) is the watercolour of the decade.

When I received Michel's photograph, I experienced a faint recollection of having seen the subject matter before. However, in my haste to prepare for my trip to Japan, I did not have time to pursue the matter further.

A few days after I returned from Tokyo, the little gem arrived safe and sound from Montreal. The real thing was even better than the photograph. I was overwhelmed. As Michel predicted, it was a pivotal addition to the collection. This watercolour was in fact the counterpart of the original 1952 oil now in the National Gallery in Ottawa. Recognizing that the 20″ × 24″ watercolour was painted in 1998 when Hughes was eighty-five years old, one can only conclude that this great Canadian artist was still in his prime.

The Beach at Savary Island embodies the inherent sense of serenity that permeates all of Hughes' great works. Contemplative and minimalist, it arouses the intellect. The impact is achieved by Hughes' inimitable treatment of the waves breaking on the beach. It is a truly great work of art.

The Annual Reunion

The seventieth anniversary of the family cottage at Shawnigan Lake in August 1998 provided an excellent opportunity to visit E.J. Hughes and Pat Salmon nearby in Duncan. Once again, we were all able to spend a few hours together at Hughes' home on Heather Street. Unfortunately, because of the festivities at the cottage, it was not possible for us to have lunch or dinner together. This disappointed Hughes, as his little black book indicated that this was his turn to invite me for dinner!

The first order of business was to hand over Hughes' honorary doctorate from the University of Victoria, which had been suitably framed by Bobby Ma at the Heffel Gallery. It joined Hughes' other honorary doctorate from the Emily Carr Institute of Art and Design, which he had received in 1997. E.J. Hughes, the artist, was pleased to be referred to as "Dr. Hughes" or, as he said, "Doctor, Doctor."

We next proceeded to review the recently assembled photo album of our E.J. Hughes collection. After years of deliberation, I had asked Jürgen Vogt to photograph the "works." This was long overdue. It also allowed me to provide Pat Salmon with a complete set of professional negatives to add to what I am sure is the best archive of Hughes' works. As might be expected, "Dr. Hughes" was fascinated with the album, which contained a selection of his work from 1933 to 1998. It was also a wonderful opportunity to obtain titles for a few of the older, formerly untitled works. Thereafter, the untitled coastal island, shown on page 26, was to be known as *Looking from Savary Island*. Similarly the untitled oil painting, appearing on page 22, was to be known as *Ottawa Sky—Study*.

Qualicum Beach 1998

1998 watercolour, 45.72 x 61 cm

During our visit, I was again impressed with Hughes' memory. He exhibited a total recall of the time, place and circumstances surrounding the execution of any given work, even after sixty years. What a memory for a man of eighty-five. He still was of the opinion that the title of *Morbid Study* was too morbid.

My next objective was more controversial. In 1996, as previously mentioned, I acquired the 1937 watercolour *Totem Poles at Stanley Park*. It had never been signed. Judging from the note on the back there was no doubt it was a Hughes. In any event, the authenticity was acknowledged by the artist. The issue was whether I should now ask him to sign it. Obviously the artist's signature neither detracts nor adds to the aesthetic value of a work of art; however, the public, myself included, places a value on the signature of the artist. Perhaps this is too déclassé for the aesthete. Nonetheless, it does serve a purpose. It provides a footnote for the casual observer who is not familiar with the artist's style.

As *Totem Poles at Stanley Park* was the only unsigned work in the whole collection, I asked Hughes whether he would consider signing this charming watercolour. Without hesitation he took my fountain pen and signed the painting: now this unusual Hughes will be readily identified.

As Pat Salmon and I took our leave, Hughes repeated that next time we met, lunch or dinner was on him. I regretted that we did not have more time together, since E.J. Hughes is one of the few people who can divert me from business matters. I cherish Hughes' artistic dedication and intellectual honesty—so refreshing and rejuvenating in this cynical world.

During the course of my May 1998 visit to Duncan I had inquired of Pat Salmon whether Hughes might undertake a watercolour version of the much-admired *Qualicum*. This was an imposing oil painting donated to the Vancouver Art Gallery by Elizabeth Nichol. The precedent having been established when he painted the watercolour version of *The Beach at Savary Island,* I felt somewhat confident that Hughes would at least consider the suggestion. A few days later, Pat informed me that Hughes had accepted the challenge.

Some six to eight weeks later, Michel Moreault telephoned to advise me that *Qualicum Beach 1998* had arrived at the gallery in Montreal. Rather surprisingly, Michel was not as enthused with this watercolour as he had been with *The Beach at Savary Island.* In any event, since I was going to Montreal to attend a Laurentian Bank directors' meeting, it was agreed that a final decision be postponed until I saw the painting at the gallery.

Notwithstanding Michel's reservation, I quickly fell in love with this reinterpretation of *Qualicum.* As usual, with a minimum of discussion, it became a welcome addition to our collection. For those of us living in British Columbia, *Qualicum Beach 1998* affords a sentimental journey to our coastal shores. It is a peaceful work, no less vibrant in watercolour than it is in its original oil format.

Replicas, reinterpretations and duplications of any work by an artist are sometimes denigrated by the so-called cognoscenti as being, in the grandchildren's parlance, a bit of a "cop-out" on the part of the artist. The original is the only one to reflect any aesthetic achievement. Any reinterpretation or duplication in a different medium of an original work is adjudged as an inferior product. I do not propose nor am I qualified to engage in such esoteric debate.

Saanich Inlet

1990 acrylic on canvas, 101.6 x 81.3 cm

74

A careful and attentive look at both the oil and watercolour versions of *Qualicum* will persuade even the most ardent critic that each version has its own cachet, conveying its own distinct message. Yes, I would like to have acquired the oil, but I am more than content to have had the opportunity to acquire the watercolour.

E.J. Hughes' pencil sketches have always fascinated me both for their artistic merit and for their historical value. From a technical point of view, these sketches aptly reflect the artist's discipline in delineating his composition. They represent the crucial first step in the evolution of the final painting. As pointed out by Jane Young, these sketches were sometimes allowed to age, as in the case of *Ladysmith*, when the 1948 sketch was relied upon to produce a 1982 canvas.

Late in 1998, I was fortunate to obtain three of these early sketches.

On one of his occasional visits to the gallery's warehouse, Michel Moreault retrieved a surprisingly revealing sketch of Fern Hughes. The portrait, *The Artist's Wife in an Armchair* (page 80), speaks for itself. Hughes certainly captured an intriguing personality. As usual, first appearances may be deceiving. On closer scrutiny, the sketch invites imaginative speculation as to the final message!

The November 1998 Heffel auction afforded me the opportunity to acquire the original sketch of the 1953 oil *Unloading Logs, Comox Harbour* (page 12). This 1948 study, with the less sophisticated title *A Log Dump at Royston, Comox Harbour* (page 34), is simpler than the finished oil. This is unusual, for Hughes normally fashions the composition as laid out in his sketches. In this case, Hughes changed the original artistic "script" from a "log dump" to the "unloading of logs," presumably to create a more stimulating composition and to allow a more appealing title!

As mentioned earlier, Michel Moreault was able to acquire *Rivers Inlet,* a much-sought-after 1950s Hughes, from its original owner in Montreal. While I failed to obtain the formal cartoon of this piece, Michel was kind enough to give me the more informal pencil drawing that preceded it. Undated, *View of Rivers Inlet* (page 82) was executed in 1937 when Hughes was engaged in commercial fishing in Rivers Inlet. It is a charming study that complements the later oil version.

Together these three additions afford an interesting historical perspective of E.J. Hughes' art.

In May 1999, after eight years of deliberation, I finally acquired *Saanich Inlet,* a truly majestic acrylic painting I had first seen at Hughes' 1991 commemorative exhibition. That I was able to do so after such a delay is largely due to Michel Moreault's patience and loyalty. As can be deduced from my *Journey with E.J. Hughes,* Michel was not only a provider of Hughes' works but also a valued architect of the collection.

As I noted earlier, the Dominion Gallery organized an exhibition of Hughes' work in April 1991 to commemorate their forty-year partnership. In retrospect, this exhibition proved to be a fruitful source of acquisitions. The commemorative catalogue depicts both the *Cumshewa Inlet* canvas that I had already acquired as well as *Ladysmith,* which I had bought more recently.

As I entered the Dominion Gallery—in a somewhat less than acquisitive mood—I was struck by a larger than normal canvas, *Saanich Inlet.* It occupied a prestigious position in the show, though the painting was not included in the catalogue as it was not finished at the time of publication.

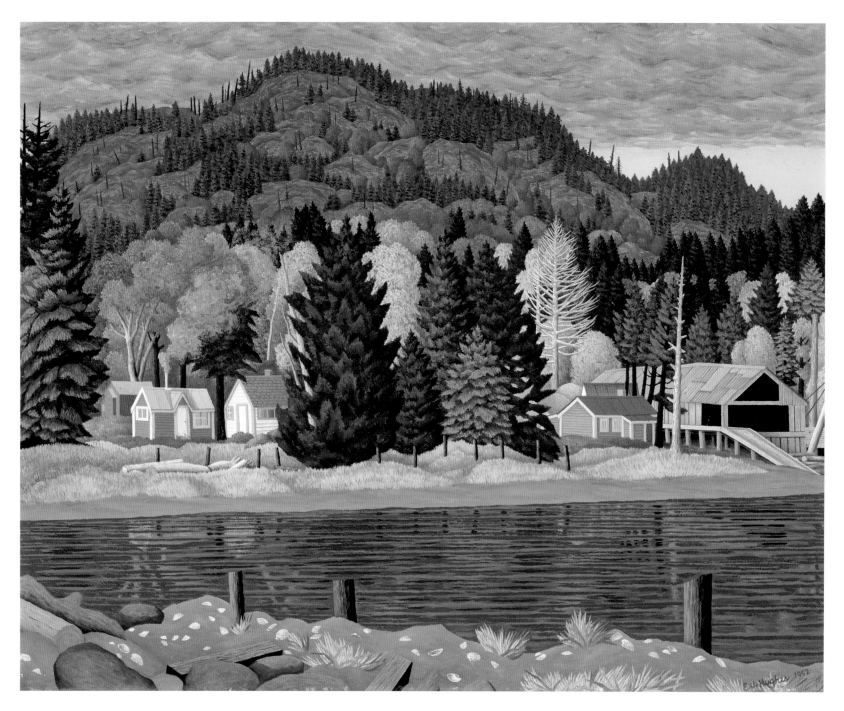

Cooper's Cove, Saseenos, B.C.

1952 oil on canvas, 50.8 x 62.55 cm

Surprisingly, the painting did not generate much interest. Yet it offered a striking bird's-eye view of Saanich Inlet. Perhaps if the painting had been done in oil rather than acrylic it might have more readily seduced the casual viewer. As it is, the all-powerful and commanding scene is well tempered and muffled by the softer acrylic tone.

Despite my initial attraction to *Saanich Inlet,* I left the exhibition uncommitted. I was more concerned with whether I should acquire *Ladysmith,* as recommended by Michel Moreault, or *Old Baldy Mountain, Shawnigan Lake* (overleaf), as suggested by David Heffel.

My initial interest in *Saanich Inlet* never wavered, and whenever visiting Michel I made a point of inquiring whether the painting was still available. If Michel was not overly impressed with the painting, he recognized that I was committed to acquiring it sooner or later. Michel's less than enthusiastic posture may be attributable to what I might call an eastern bias against the all-intrusive topography of the west coast of British Columbia. Like the typical English country squire, he seems to prefer the smoother, softer, undulating terrain of the eastern provinces. Wisely, he realized that I would eventually give way to my better judgment, and fortunately for me he kept the painting in his inventory.

Finally, in May 1999, I decided that *Saanich Inlet* should join the collection. It is truly a magnificent painting. Depicted on an unusual 40-inch-long canvas, the Z-shaped Saanich Inlet as seen from the top of the Malahat Highway is soothingly captivating. The soft acrylic tone, as previously mentioned, provides the perfect antidote to the otherwise aggressive coastal landscape. Pat Salmon is to be complimented for suggesting this theatrical site to E.J. Hughes.

While I relished the acquisition of Saanich Inlet, I nonetheless felt sad that this was one of the last original E.J. Hughes paintings in Michel's inventory. Soon the secondary market would be the only source of the artist's work: an omen, perhaps, of the final stage of my journey.

Anno Domini 2000 (revised 2005)
Vancouver and Point Roberts

Old Baldy Mountain, Shawnigan Lake

1961 oil on canvas, 61 x 91.44 cm

Revisiting the First Edition

In my original monograph I intimated that E.J. Hughes had abandoned the use of oil for acrylic sometime in the early 1970s when he adopted a softer colour tone in his paintings. *Cowichan Bay and Mount Prevost,* a 1975 acrylic, was my authority for the proposition. Although the exact wording can be parsed to circumvent that interpretation, my understanding of the situation was erroneous. Yes, E.J. Hughes did use acrylic paint in 1975, but he did not abandon oils until 1983, as pointed out in Ian Thom's *E.J. Hughes.* I stand corrected. Not a big deal, perhaps, but a significant error in the curriculum vitae of the artist. As Hughes' oils are often preferred to his acrylic paintings, the wrong cut-off date might also be of financial relevance in the marketplace. So now the record has been set straight.

On the subject of correction, a rather misleading assertion, gaining credence by repetition, should be realigned. E.J. Hughes was never a professional commercial artist, nor was he ever employed as such, as were most of the members of the Group of Seven—the notable exception being Lawren Harris. (Fred Varley was employed by the Grip Engraving Company and Rous and Mann, a printing establishment in Toronto; Tom Thomson, Franz Johnston, Frank Carmichael and Arthur Lismer also worked for Rous and Mann.) Jane Young in her 1983 catalogue, for instance, suggests that Hughes "formed a partnership with his art school friends Goranson and Fisher to establish a firm of commercial artists" (p. 25). This allegation supports a veiled reference (sometimes not so veiled) that Hughes started his professional life as a "commercial artist." By itself the assertion is not alarming. Are not most artists interested in the disposition of their art in the marketplace? To that extent there is a commercial element, but that does not make an artist a *commercial* artist, a pejorative term reserved normally for a draftsman employed to produce a given illustration or design for advertising or other commercial purpose.

With one possible exception—*The Farewell*—which was commissioned by his uncle, albeit without pay, Hughes' artistic independence was never compromised. Yes, he was retained to execute four murals. But here, like Matisse, who was retained by Dr. Albert C. Barnes to paint a mural in his museum/college of art in Merriam, Pennsylvania, Hughes was solely responsible for the aesthetic composition of the work. As to the alleged partnership with Paul Goranson and

E. J. Hughes.

The Artist's Wife in an Armchair

1938 pencil, 27.94 x 21.9 cm

Orville Fisher, this was no more than an informal arrangement—even less so than that of the Group of Seven—to promote their art. Even Jane Young herself stipulates that the association was merely a fraternal brotherhood—indeed, the Western Canada Brotherhood—modelled on the English Pre-Raphaelite Brotherhood. It was no more commercial than could be said of any artist trying to sell his paintings or of an artist's arrangement with an art dealer to obtain commissions for his work, whether on a wall or on canvas. Surely an artist who seeks to make a living selling his art is not to be denigrated to the status of a commercial artist.

Another fallacious assertion purports to establish that E.J. Hughes was aesthetically manipulated by his dealer, Dr. Stern—an assertion that relies on the exception to prove the rule. Certainly Dr. Stern made suggestions. And Hughes was always deferential to his one and only dealer. Yes, Hughes undertook to paint a Royal Canadian Mounted Police officer, and yes, Hughes cut a couple of inches off the skyline of *The Car Ferry at Sidney, B.C.* But if this is all the evidence that is available, the argument is spurious. A handful of altered canvases is of little consequence when compared to the remaining 500-odd paintings executed by Hughes during his association with Dr. Stern.

I always find it amazing when one generation attempts to pontificate on events of an earlier period without understanding the *Zeitgeist* of that generation. Dr. Max Stern did introduce E.J. Hughes to the realities of the art market in Canada. As Emily Carr so sorely experienced, buying paintings was not the *passe-temps* of choice for the average Canadian in the 1950s. The *populus* had yet to be gentrified. This would not occur for another decade or two, and then the accent would shift to abstract art. So to make a living as an artist in the 1950s was almost impossible, particularly in British Columbia. To accommodate the tepid demands of the marketplace, Stern suggested that Hughes shift from a museum to a living-room format. Hughes, equally sensitized to the need to make a living—however modest—doubled his output of paintings from three to six a year. Unlike Balthus, Hughes did not have the option to devote one or two years—or perhaps even three—to complete a painting. Yes, as he often admitted to me, few of his paintings were ever "finished" according to his standards. *Near Third Beach, Stanley Park,* after some thirteen years in gestation, for instance, was still considered an unfinished painting—to achieve perfection, time is never finite. So the strict production regimen may not have been as detrimental as is often alleged. Though *Near Third Beach* might have been better left alone!

As to the softer palette introduced in the mid-'70s, I am a biased observer. I find these works' subtlety enticing. Whether because of age or the fact that I am surrounded by a number of the more robust 1950s pieces, I am partial to the pastel tone work of E.J. Hughes. These paintings generate a serenity that is contagious. Intellectually they are as effective as his paintings from the 1960s. "More with less" is a not unwarranted observation. I agree that the 1950s pieces are seductive. But the later pastels may provide a more challenging aesthetic message. Perhaps you cannot truly appreciate the softer-hued post-1973 works until you have thoroughly "digested" the more robust paintings of the earlier periods.

Whatever the reasons for change in palette tonality, it is absurd to attribute the switch to Dr. Stern, as he found it more difficult to sell this genre of painting than the artist's earlier work. In suggesting such a modification in style he would have been acting against his own financial self-interest—a motive that cannot be easily ascribed to the good

View of Rivers Inlet—1937 pencil, 50.17 x 60.96 cm

doctor. This stylistic realignment aptly supports the contention that while the artist humoured Stern, Hughes was always the sole captain of his artistic destiny, monetary inconvenience notwithstanding.

Another jab by the one-eyed observer is that Hughes' work is merely photographic. Fortunately, that contention is passé, if for no other reason than that no one would pay the amount that a Hughes fetches on the market were it simply a photographic reproduction. Yet Toronto art critic Sarah Milroy recently attempted—albeit inferentially—to link Hughes' paintings with Jeff Walls' photomontage—an intellectual stretch that would verge on the *malhonnête*. In any event, any professional photographer will confirm that Hughes' perspective is totally at variance with that of a photograph.

An addendum to my original manuscript is also warranted to amplify on the provenance of *Cooper's Cove, Saseenos, B.C.* (page 76). Upon being reframed in early 2004, the stretcher—the wooden frame upon which the painting is stretched—was revealed. As with most early Hughes paintings, a time and sequence code is provided on this wooden frame. It indicates the artist started preparing the canvas in 1946, applied a white lead coating in 1949, and dated the work as of May 1952. As previously noted, a drawn-out gestation period was not unusual for the artist. The point of interest is to speculate as to when Hughes actually painted this piece. From Jane Young's private working papers, some ten oil paintings are dated as having been completed in 1951, and thirteen in 1952. Yet it is difficult to conceive that Hughes executed thirteen paintings in one year, including *Cooper's Cove, Saseenos,* in this early period in his career, when a protocol of three to five canvases a year had governed in the prior years. On a probability basis one can extrapolate that *Cooper's Cove,* given its provenance, was *substantially* completed probably before 1952 and possibly before 1950. Idle speculation, perhaps, but a possible rationale for the number of canvases that are dated in the early 1950s.

Jeff Joyner was thoughtful enough to enclose the original bill of sale when he sent me *Cooper's Cove,* which I had acquired at his auction in Toronto. The painting had been sold initially to Mr. and Mrs C.N. Wells of 582 Lansdowne Avenue, Westmont, P.Q., for the princely sum of $375, which, together with a 5 percent tax, totalled $393. Now, to satisfy the curiosity of the collector/investor, what was the rate of return from 1954 to 2005? On a compound basis, this paint-

ing would have given rise to a 10.5 percent compound before-tax rate of return. On a current value of $125,000, the rate of return, surprisingly, is a more positive 11.8 percent. Not a bad investment for anyone who prefers to look at a Hughes rather than at a share certificate of Exxon Mobil.

To the art cognoscenti, my whole travelogue with the artist appeared amateurish and somewhat biased as a critique of Hughes' art. To this charge, I plead guilty. I *am* an amateur, hopefully in the eighteenth-century sense of that word. And, as clearly set out in the prologue, the monograph was never intended as theoretical critique. Objectivity was neither intended nor provided. My *Journey* was an emotionally driven exercise. It is, and was meant primarily to be, a family homily. Its dubious claim to fame is solely as a case study on how a collection is assembled. It is a personal overview. As can be discerned from the text, I much enjoyed the task. *A Journey with E.J. Hughes* is my story on how and why I acquired his art; it is not proffered as a professional critique of his oeuvre. For that, thank God, we have Ian Thom's detailed and insightful thesis—*chacun à son métier.*

A few observers, particularly after the E.J. Hughes exhibition in Vancouver, have suggested that I should have elaborated upon my experiences in the marketplace. How did I proceed and what did I learn from my dealings with owners, art dealers and auctioneers in assembling the collection? In essence, how does one buy paintings? Once bitten, twice shy prompts me to stipulate that my thirty years' limited experience in the marketplace does not make me an expert in the field. The inimitable Ken or David Thompson of Toronto would be a far more astute advisor. But since they have yet to pronounce themselves on the subject, I have summarized a few useful guidelines in a stand-alone essay at the end of this book.

One of the startling discoveries following the publication of *A Journey with E.J. Hughes* was the reaction and the non-reaction of those who acquired a copy. I cannot speak for all those who might have read it. Not too many acknowledged doing so. This was not unanticipated. I always thought that the attraction was the reproduction of E.J. Hughes' work. I was well served merely by reliving my journey. The commentary was an add-on as an anecdotal primer for the younger family members. The most laudatory opinion was that the book was well presented and that the reproductions were appealing. On that basis alone I felt justified in having undertaken the travelogue.

It introduced even the non-reader to Hughes' art, which was and still is a commendable objective. The text is superfluous to that objective. Yet a surprising number of people not only read the book but took the time to write to me about their reaction to the commentary. A few of the letters I received were from busy corporate CEOs. Female readers showed an acuity that was enlightening. These letters were as gratifying as they were unexpected. Overall the project was well received for its visual impact. As to content, its impact is more difficult to judge, but if the commentary did not edify, it did not harm anyone either, and in most cases the price was adjusted accordingly.

Trees, Savary Island, 2004

2004 watercolour, 61 x 50.8 cm

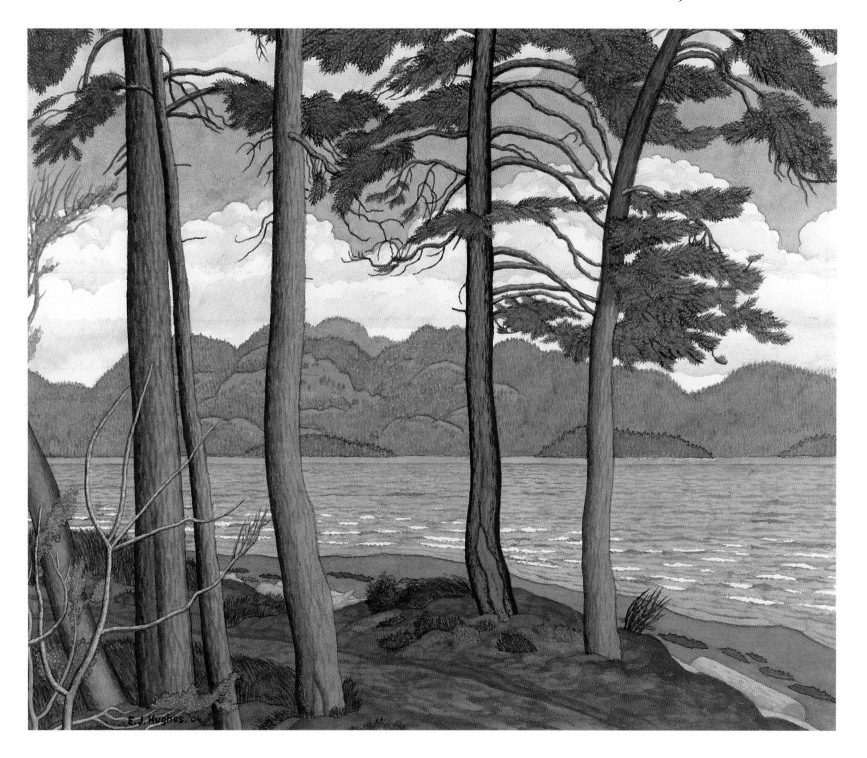

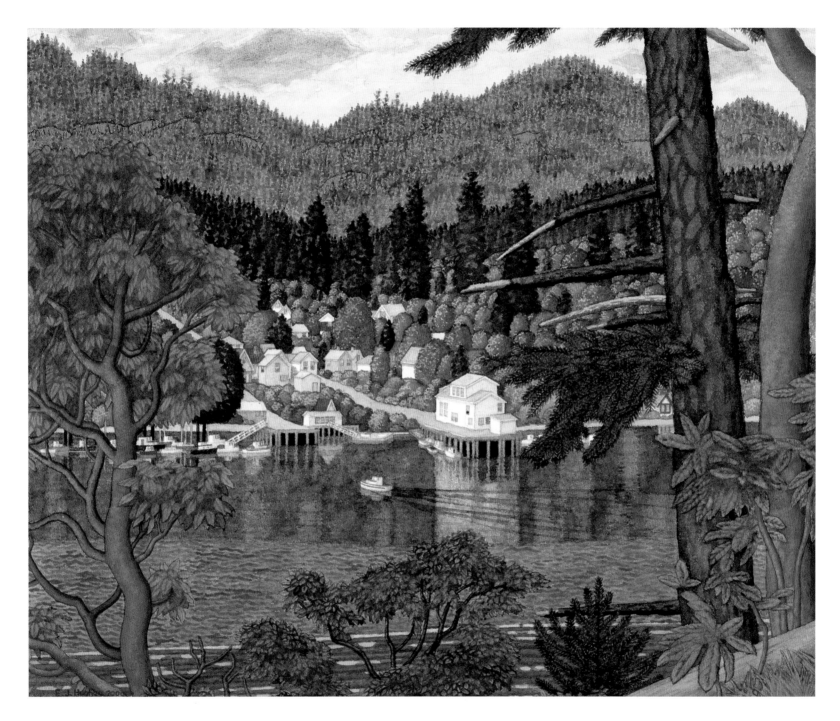

Wharves at Chemainus, 2000

2000 watercolour, 45.72 x 61 cm

From *Near Second Beach* to *Ship with a Blue Hull*

How could I have neglected to include the delicately enticing linocut *Near Second Beach* in my original manuscript? Perhaps the vexations of finalizing the text for the printers diverted my attention. I acquired this subtle little piece while editing and re-editing the text—some thirty drafts, necessary to convert my stylistic legalese into readable English. Writing the script was facile, editing it exhausting, and publishing it utterly frustrating. I have great admiration for those who venture into this arena. This is not an easy undertaking for the amateur. The ordeal may explain, though not excuse, my oversight.

Near Second Beach (overleaf), one of only four linocuts, was produced by E.J. Hughes in 1936. It is an elegant rendering of this secluded beach, with which I became familiar less than a decade later. E.J. aptly contained the intimacy of this seashore enclave. Less ebullient than its counterpart, *Bridges on Beaver Creek,* the linocut *Second Beach* captures a particularly refined bit of seashore. The mood is tranquil and serene. Yet it illustrates Hughes' subtle ability to suggest less to achieve more. He undermines the obvious to generate a distinctive aesthetic atmosphere. He sidetracks an immediate impact to compel a more careful look that delivers the "goods."

Both linocuts were included in the November 1998 Heffel auction. Though I was initially drawn to *Bridges on Beaver Creek,* I was soon challenged—if not totally absorbed—by the *Near Second Beach* linocut. I bought it, but why? Herein the inevitable question: why does a collector choose one example of an artist's work rather than another? In this case I simply found the subdued—though complex—message of *Near Second Beach* to be more satisfying. It soothes rather than challenges the intellect—a desirable quality at my age.

Near Second Beach—1936 linocut, 24.13 x 29.8 cm

In my pursuit of E.J. Hughes' sketches and paintings over three decades, there were only two works I especially regretted not acquiring. In each case the oversight was due to a lack of perception rather than of money, though the latter was always a consideration. The first painting was a 1952 oil, *Wharves at Chemainus;* the second, a 1951 piece, *Englewood.* Each depicts a typical historical coastal scene—one a small village and the other a sawmill site.

I first noticed W*harves at Chemainus* in an auction catalogue, though it was *Englewood,* which I seen previously seen at the Dominion Gallery, that directed my attention to it—for reasons that are too obvious if you compare the two works. Still I was not sufficiently motivated—or intellectually sensitive—to attempt to acquire the painting at auction. And a missed opportunity in the case of a Hughes painting is a forgone opportunity. Ever so gradually I began to appreciate my error in judgment. A second chance did not appear likely. So began an intermittent period of recrimination. Though it did not keep me up at night, the oversight was a bit irritating.

As I was in the throes of finalizing what I hoped would be the final draft of *A Journey with E.J. Hughes,* I met with Pat Salmon and E.J. for lunch at our favourite restaurant in Duncan, the Dog House, as rightly famous for its cheerful staff as for its homemade pies—each of which justifies the trip there. While enjoying the atmosphere we began to reminisce about lost opportunities. I happened to mention that I still regretted having failed to acquire what I now considered to be two great Hugheses. Without the appearance of any ulterior motive, Pat inquired as to which ones. Having typically forgotten the names of the paintings, I proceeded as best I could to describe their subject matter. Pat, forever knowledgeable, quickly recognized the paintings—*Wharves at Chemainus* and *Englewood.* She readily agreed with my reassessment of these two works and for good measure commiserated with me at my loss.

Some six to eight weeks later, I was met by Pat and Ed at the ferry terminal at Departure Bay for one of our luncheons at the Dorchester Hotel in downtown Nanaimo. As we approached the Jaguar, Pat, with a whimsical smile, opened the trunk to reveal *Wharves at Chemainus, 2000,* a captivating watercolour rendition of the oil painting. It was like an apparition—an *Erscheinung*—at least to the extent I could conceptualize the experience from my early Catholic

schooling. Here, the essence of this great composition had been reincarnated in a softer, lighter and more delicate rendition of the original work. I was completely taken aback. The void had been filled, the oversight corrected, the collection rebalanced—what an endowment! A perfect substitute: a watercolour version of the original oil painting.

By the spring of 2002, E.J. Hughes, forever devoted to my cause, undertook to remedy another gap in the collection. He produced the watercolour counterpart of the forsaken oil rendition of *Englewood* I had originally seen at the Dominion Gallery in the early 1980s. I remember the experience as if it were yesterday. It had a mesmerizing impact upon me. The painting oozes mysticism—like a vision from *Wuthering Heights.* It disturbed me, yet it captivated my mind. The message was more cerebral then tactile, as Berenson would put it. I should have bought the work then and there. Though tempted, I did not. It was not long, however, before I began to realize that I had overlooked a very resonant piece of work. This was a quintessential mystical Hughes.

Taste does not develop overnight. From sweet light wines I progressed to full-bodied dry reds—picturesque, yes, but with an intellectual kicker, please! As the years went by I became more and more dejected. I even phoned the Vancouver owners to ascertain their intentions, only to be apprised that the painting was going to the Vancouver Art Gallery—an unassailable position. So, as Kenneth Thompson is reputed to have said, "You can't always get what you want." In this case, though, I obtained one hell of a substitute.

As contrasted to its oil counterpart, the watercolour rendition of *Englewood* (overleaf) is a melodious and lithe rendition of this intriguing coastal sawmill site—a Monet as opposed to a Goya. Comparing the two works, one cannot help but appreciate the artistic ability and aesthetic sensitivity of E.J. Hughes. The same subject but an entirely different tonality emerges in the watercolour to generate a completely different mood. Where the oil is harsh and hard-edged, the watercolour is gentle and supple—one confronting and the other mollifying the viewer. The two works should be seen together, if for no other reason but to appreciate the virtuosity of this great West Coast artist.

E.J. Hughes' largesse was aptly confirmed when he introduced *Wharves at Chemainus* and *Englewood* into the collection. As I had missed the opportunity to acquire the oils, he provided an equally satisfying substitute in watercolour. This compassionate gesture obviated any remorse over a lost opportunity. How fortunate to have been so generously treated. The experience remains a cherished memory in my journey with E.J. Hughes. For it is not only about works of art but also entails an emotional and intellectual liaison with this great man, this great artist.

Adieu to the Dominion Gallery

Above the Yacht Club, Penticton, B.C. (page 136) is one of those charming Hugheses that caress the senses and pacify the intellect. It radiates serenity. The painting is the perfect antidote for the exhausted Bay Street executive, inviting the weary and the tired to relax and absorb the curative magnificence of nature. It seductively invites you to pause and assess where you are going with your life.

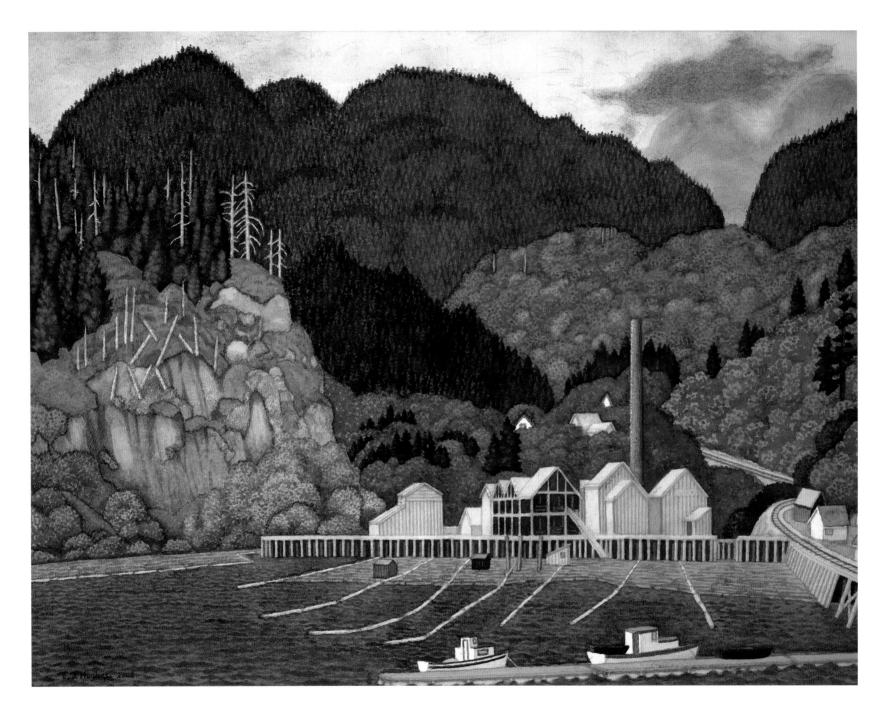

Englewood

2002 watercolour, 50.8 x 61 cm

In this sensual 1991 acrylic, E.J. Hughes reflects a passionate fervour not normally exhibited in his "out of town" paintings. He clearly related to his subject matter. The water of Lake Okanagan and the boats at the yacht club were undoubtedly the catalyst for this unusual off-Island vigour. Notwithstanding the painting's inherent attributes, I was rather ambivalent about it, much as I was initially about *Ladysmith* (see page 41). Maybe I was sidetracked by another Hughes? Fortuitously, I woke up a few months before the Dominion Gallery closed its doors.

It was indeed a sad occasion when the trustees of Dr. Stern's estate decided in late 1999 to close this venerable art emporium after seven decades of purveying art to the Canadian and American public. Montreal will never be the same. It was the last remaining link to that city's pre-eminence as a national art centre—a long-delayed finale. Toronto was now the undisputed art centre, its provincial dealers totally oblivious to the Québécois art collector. No matter, for the francophone community was never fervently committed to acquiring paintings from outsiders (they talk, but don't buy), particularly when dispensed by a non-francophone dealer such as Dr. Stern. Truth be told, it was primarily members of the Jewish community who bought Hughes' work, particularly when first shown at the Dominion Gallery.

In the fall of 1999 I joined Michel Moreault to bid adieu to this venerable establishment that had been such a shelter to me. It had served me well for more than three decades. A chance to visit the Dominion Gallery was the highlight of any journey to Montreal, particularly when my mother was no longer residing there. As we commiserated together over the loss of this cultural refuge, we began to look over the remaining Hughes inventory. All of a sudden, *Above the Yacht Club, Penticton, B.C.* caught my attention, as if for the first time. I was captivated. Why had I overlooked this distinctive Hughes before? Even now, I cannot quite explain it. Why does one at first disregard a painting only to "see" and appreciate it at a later date? Is it a maturity of taste, a more fecund purse or the realization that a work might become unavailable? Who knows? The reason is psychologically driven. Whatever the cause, I bought the work. It was the last painting I acquired from the Dominion Gallery—a worthy *salut* to Dr. Stern.

As an aside, the reproduction of *Above the Yacht Club, Penticton, B.C.* in Ian Thom's widely acclaimed book does not do the painting justice. The colour of Okanagan Lake—the heart of the painting—is significantly more vivid than in the colour reproduction. As I found out in the first edition of this book, reproducing a painting in colour is more of an art than a science. The tonality can never be perfectly matched. As in many other areas it's a question of trade-offs. In this case the foreground perhaps benefits to the detriment of the lake portion of the work. Also, costs play a part. A photographer cannot spend hours on end with a curatorial staff to elicit a perfect reproduction in print. Time is of the essence; so is money! In any event, a less than perfect colour print may still be more informative than a black and white rendering—at least, I hope so.

To commemorate the publication of my *Journey*, Pat Salmon and Ed Hughes presented me with an enticing pencil sketch, *Above Maple Bay, Mount Maxwell* (overleaf), in the spring of 2001. It is a sentimental keepsake, a reminder of a memorable regatta weekend with two avid sailors—Beverly Justice and Dick Vogel—when we were in our early twenties. I have since devoted much time to obtain the watercolour counterpart of this drawing, so far unsuccessfully, though

Overlooking Finlayson Arm—1963 pencil, 27.3 x 34.3 cm

I am still in pursuit. The work is one of those "atmospheric" Hugheses. The subject matter is schematically manipulated to provide a sense of arresting containment. The sketch is another example of the artist's ability to make a pleasant scene into a work of art—composed and timeless.

Merry Christmas, 2001

Not often does one receive an unexpected gift of high value, aesthetically and monetarily. Such was my fate on Christmas Eve 2001 when David Heffel delivered the panoramic *Harbour Scene Nanaimo, B.C.* (page 128) to our Vancouver home. A personally designed greeting card accompanied this strikingly bluish-toned painting, which immediately commanded attention. As blue, of almost any shade, is Margaret's favourite colour, the painting, with such a proliferation of hues of that addictive colour, was an immediate hit with her and, needless to say, with the whole family.

In this painting Hughes manipulates his blue paint as a chemist would mix his curative ointments. The result: an *éclat* of colour that becomes the message. It overpowers the work. Yes, the ferry and the prancing tugboats are attractive to the eye, but it is the tonality that governs. A brilliant experiment. The blue on blue creates a pervading colour mood, with the boats being merely a sideshow to provide content to the painting. Compare it with an earlier work—*Nanaimo Harbour* (see Ian Thom's book, p. 161)—where the focus of the painting is upon two of the larger-sized coastal ferries. In *Harbour Scene Nanaimo, B.C.* Hughes minimizes the impact of the ferry to achieve his rhapsody in blue. What a composition!

This munificent gift was to acknowledge the very few, and not so precious, hours of my semi-retirement that I had devoted to develop a tax-efficient business disengagement. As I was much indebted to the donor's family for their support during my active legal career, I never expected any recompense for this bagatelle, regarding the matter as a means of repaying past patronage. Obviously, the beneficiary judged the matter on his, rather than my own, estimate of the *quantum meruit*. So, *Harbour Scene Nanaimo, B.C.* remains a very high net worth memento of an ephemeral consultation that was appreciated by one generous friend.

Meeting Varley

Shortly after the demise of the Dominion Gallery, Sotheby's was appointed to dispose of the gallery's vast inventory. This was to be accomplished as quickly as possible, with the aim to produce revenue for the always needy university beneficiaries. This noble objective, however, did not appear to mesh with the realities of the art market. Too much art at one time causes indigestion. The trustees overlooked this cardinal rule. Not well versed in matters of commerce, they adopted the attitude that "if it's worth so much, let's get rid of it," the quicker the better. This naïve enthusiasm was not met with a corresponding reaction on the markets. Various schemes were adopted, but none proved successful to accommodate the overnight bailout. In time, a more sedate modus operandi was adopted. The inventory, particularly of E.J. Hughes' work, was parceled out and introduced gradually to the marketplace. Unfortunately, the remaining works had become tainted in the process.

Above Maple Bay, Mount Maxwell—1986 pencil, 27.3 x 34.3 cm

One of the initial schemes involved selling a number of Hughes pencil sketches at auction on the Web under the Sotheby's banner. This was a minor disaster, though it allowed me to meet Christopher Varley, the doyen of the private art dealers in Canada. At the time I was looking for the sketch of *Saanich Inlet,* the painting I had acquired in 1999. Although I did not find it on the Sotheby's Web site, another sketch—*Overlooking Finlayson Arm*—looked appealing. I found it difficult to ascertain the subject matter clearly on the Web—not a good omen for an art auction. Still, the sketch looked like a justifiable gamble, if a moderately expensive one.

I won the bid and then the fun began. Though Sotheby's was the official auctioneer, they in turn had appointed Chris Varley as a subagent to effect the sale. All well and good except that Sotheby's was supposed to process the sale. Here everything got fouled up. The tripartite arrangement was simply too demanding upon Sotheby's, which, perhaps wisely, abandoned this market venue. After a number of e-mail exchanges, Varley and I resolved the matter. I got the sketch and hopefully Chris got part of the proceeds, though I doubt sufficient to compensate for his frustrations. Notwithstanding this precocious *accouchement,* the sketch became a valued part of the collection.

Rivers Inlet 2002

2002 watercolour, 50.8 x 61 cm

Finlayson Arm is a particularly delicate rendering of a popular site along the Malahat Highway on Vancouver Island. The subtlety of the draftsmanship becomes apparent on close scrutiny. It is Hughes' cachet. A simple scene is interpreted to create an "arrested impulse." What, but for Hughes, would be seen as a nice little sketch becomes an aesthetic work with an ongoing resonance, albeit a discreet one. In time these pencil sketches will generate the popular interest they deserve—hopefully first here, in British Columbia.

All's Well That Ends Well

It is well known within the art community that I longed to acquire a pivotal pre-1950 Hughes to anchor the collection. This was a bit of a pricey undertaking, as few of these paintings are still available on the market, the majority being in museums. Though examples of these works appeared on the market from time to time, financial constraints meant I could only afford one such acquisition. After evaluating all the privately owned paintings, I concluded that the *place d'honneur* should be granted to *Fishboats, Rivers Inlet,* a truly majestic 1946 painting—the largest of Hughes' works.

Choosing the work was much easier than acquiring it. The painting had been purchased by Mrs. Keith Porter in the early 1950s soon after the artist had disposed of his inventory to Dr. Stern. Knowing my interest, David Heffel arranged for us to meet Mrs. Porter in the early 1990s in Toronto to have a look at this classic early Hughes. I was awed by the painting. It synthesized the youth, energy and passion of E.J. Hughes. Confronted by such a *chef d'oeuvre,* I did not even try to entice Mrs. Porter to sell it when she inquired as to the current market for Hughes paintings. The conflict was too great and certainly too apparent to allow for an unbiased opinion. Instead I suggested that in her place I would keep on cherishing the painting. The sortie did not, however, mollify my desire to acquire it if it ever came on the market. Though a few works representative of this era came on the market in the ensuing years, I refrained from depleting my resources, always awaiting—for more than ten years—the appearance of the missing link.

I kept E.J. Hughes and Pat Salmon apprised of my travails regarding *Fishboats, Rivers Inlet,* and we revisited the subject on numerous occasions. E.J. often reminisced about his arduous fishing experiences in that area in the 1930s. This was not a vocation that he cherished. It was only a means of survival made necessary by the general economic depression of that period. Both were keen to support my campaign to repatriate this icon to British Columbia. Hughes did intimate, at a luncheon in Nanaimo in August 2003, that he always intended for that painting to be hung in a public gallery—a message there, I suspect!

As the years went by, Pat Salmon and E.J. must have suspected that my chances of acquiring *Fishboats, Rivers Inlet* before I departed this world were diminishing, if not evaporating entirely. Both appeared to share my disappointment. In late August 2001, my son-in-law Jim Allan suggested, as he often did, that we fly over to Shawnigan Lake for lunch with E.J Hughes and Pat Salmon. A flight on the venerable Beaver and lunch with two of my favourite friends was too good an opportunity to pass up. After lunch at the Galley on the shore of the lake, Pat guided me to her Jeep Cherokee

Hopkins Landing, Howe Sound, 2002

2002 watercolour, 50.8 x 61 cm

and, without any further ado, presented me with *Rivers Inlet 2002* (page 94)—yes, a watercolour adaptation of *Fishboats, Rivers Inlet.* I was spellbound. Though I had been unsuccessful and would probably fail to obtain the oil, I would now have the endearing watercolour to fill the void in my collection. What a propitious substitute!

In keeping with Hughes' style at this stage of his career, the 2001 watercolour version of the 1946 oil is considerably lighter in tonality. This is a nimble piece of work. Whereas the oil painting is severe and somewhat ominous, the watercolour is bubbly and cheerful. Though the subject is the same, the message is different—one solemn and stern, the other lively and supple. Again, the two should be compared to appreciate the artist's virtuosity. Hughes is truly a brilliant strategist—a quality that is not often appreciated, as most of us are blinded by the facade of his paintings. By an adroit juxtaposition of colour and tonality, he relied on the same subject to create two distinct works of art.

With the introduction of *Rivers Inlet* into the collection, as with a few similar additions, Hughes not only allowed me to satisfy a goal but also provided me with the chance to acquire substitutes for works that were beyond my reach when they were first introduced on the market. What an opportunity for a collector.

Following the Sketch and the Drypoint

Howe Sound is Vancouver's magic corridor, which has justifiably seized the imagination of B.C. artists over the years. It is the near-perfect template of the West Coast. Perceived from the shores of Spanish Banks, in Vancouver, the sound (more an inlet, really), extending to the tidelands of Squamish some thirty miles away, is a virtual aesthetic tunnel—a stunning combination of snow-capped mountains and sculpted islands (Bowen, Gambier, Hutt) anchored in the blue-grey water of the Pacific Ocean flowing through the Strait of Georgia. It continually diverted my attention from my studies while I attended law school, which then faced this grand piece of nature. To some the panorama might have been the only redeeming feature of this institution!

It is not surprising that E.J. Hughes reacted to the grandeur of Howe Sound, though unlike others, he chose Hopkins Landing, rather than Spanish Banks, as his viewpoint. An unfettered perspective from Spanish Banks probably appeared too simplistic, if not too repetitive. Hopkins Landing on the Sunshine Coast was more challenging. It also afforded the opportunity to introduce an element of humanity into this otherwise divine tableau. Beginning with a sketch and then a drypoint print in 1935, Hughes completed the oil painting some seventeen years later, in 1952—not exactly a quick gestation, but so typical.

As reproduced in Ian Thom's *E.J. Hughes*, the finished work, *Hopkins Landing, Howe Sound*, is no less than the scenic wrapped in the sombre. The subject is clearly appealing. But the tonality of the painting supplies its strength and character. It is the conduit for the message. It provides the painting with a solemn echo. As to the message, Hughes is typically noncommittal—is the black cloud a hint that this idyllic bliss is always to be followed by the proverbial tempest? The artist is too honest to allow sheer beauty to stand unreservedly. A modicum of real life must be introduced to provide an earthly equilibrium. Always the artist, sometimes the preacher—that's Hughes.

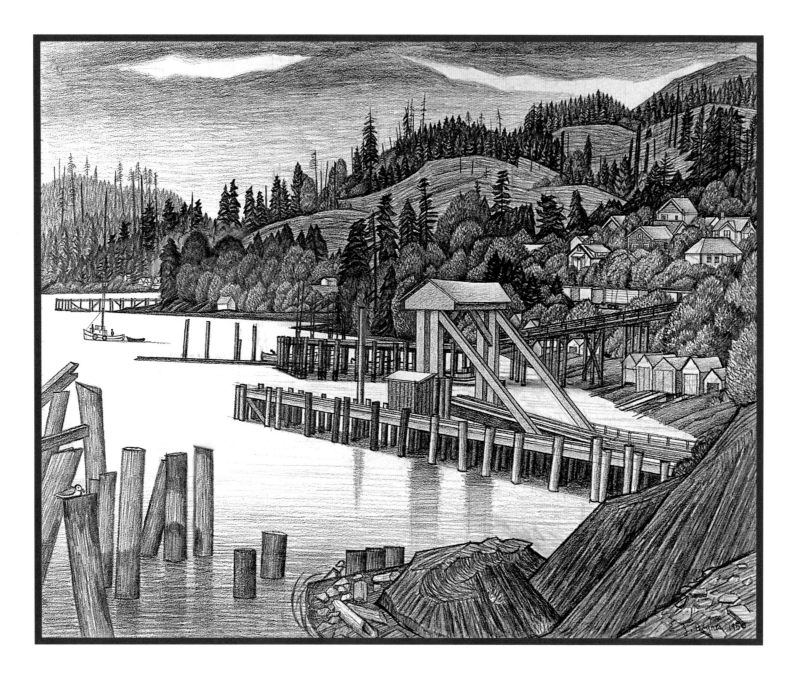

Wharves at Ladysmith, B.C.

1955 graphite cartoon, 38.7 x 47.62 cm

The original oil came up for sale surreptitiously at a little-known auction house—Iégor—in Montreal in December 1999. For reasons that are too obvious, no Montreal dealer alerted me. Notice would be given, albeit after the sale. The painting was knocked down for $54,000, then a rather high price for a painting of that format. Rumours started to percolate, and I became dejected that I had missed the opportunity to acquire this classic Hughes.

The sale of *Hopkins Landing, Howe Sound* generated more interest after than before the auction. The sales catalogue, with a highly seductive reproduction of the painting on its cover, began to appear in various centres throughout the country. Everyone was in awe. The collector, of course, was mortified by having been left out of the ring. Hughes, the creator of this little gem, was no less affected. Motivated by fond memories of the initial strategic exercise, he undertook a watercolour counterpart to the oil painting. *Hopkins Landing, Howe Sound, 2002* (page 96) duly appeared on the shore of Shawnigan Lake on a glorious spring afternoon to the enchantment of a grateful collector.

Again, the oil and watercolour versions must be compared to appreciate Hughes' artistic dexterity—same subject, yet two different messages. To use the parlance of my grandson Jeff, Hughes had mellowed out. Nearing ninety, did he see the world more complacently? Had the angst of youth now disappeared? The hard edge is gone, replaced by a softly sensuous new tonality. Colour, as orchestrated by Hughes, is the alchemy—what *Merriam Webster's* dictionary defines as "a power or process of transforming something common into something special." Indeed, E.J. is the ultimate alchemist.

A Cartoon Well Framed

Oh, those stimulating cartoons! I can't resist them. *Wharves at Ladysmith, B.C.* immediately caught my attention when I leafed through Heffel's May 2002 catalogue. This was a definite buy. Upon arriving at the auction I immediately noticed the erudite Andy Sylvester of Equinox Gallery, who I presumed was similarly inclined. The marketplace was to be the equalizer. I started to bid aggressively. Soon the bid went beyond the upper estimate of $5,000. I kept the pace. Finally the auctioneer's hammer went down and the cartoon was mine—what a relief. Only when I was leaving did Andy declare: "Jacques, you were so determined that I couldn't ruin your evening by joining the bidding." His was an unusually compassionate gesture in the art world, but then Andy Sylvester is the uncommon gentleman in the business.

As an added bonus, *Wharves at Ladysmith* was in its original handmade bleached white oak frame, which suitably enhanced the cartoon. It provides a time reference within which to fit the subject matter. Initially I believed the frame had been made by the artist, but Pat Salmon disputed this attribution. Though I have persevered, I have yet to ascertain who crafted this artistic frame—another all-too-common instance where the gifted craftsman remains unknown and unappreciated. The cartoon is signed, but the frame is not. Each complements the other. Yes, the cartoon can stand

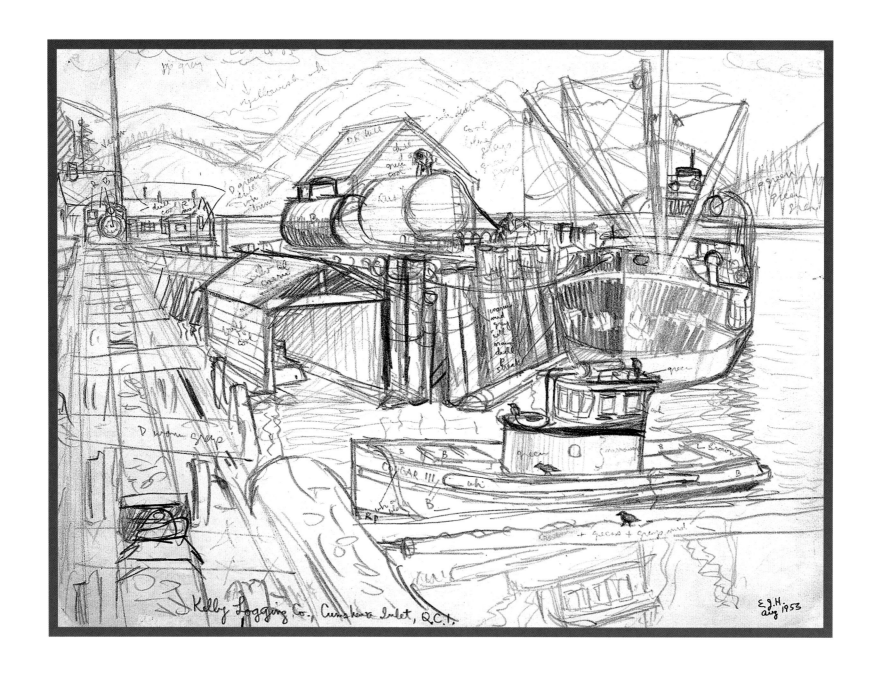

Kelly Logging Co., Cumshewa Inlet, Q.C.I

1953 pencil, 22.23 x 30.5 cm

alone better than the frame, but the frame is an integral part of the aesthetic ensemble. Is a book less worthy without acknowledgment of authorship? Clearly not, yet its impact will be restricted, its echo tempered.

Such an anonymous work hinders the intellectual intimacy between the reader and the author. Fame and fortune may override the necessity of authorship for some artists, but is the unknown craftsman simply destined to oblivion? Commonality of practice is an explanation, not an excuse. During the past decade frames have come to be appreciated as works of art, as validated by an active auction marketplace. Surely it is time for the frame makers to sign their work, for a signature provides a valuable provenance. How much more interesting it would be to know that a certain Roger Graves of Chemainus made the frame in 1950. More to the point, how fulfilling it would be for Roger's progeny to share in the glory.

Wharves at Ladysmith joins six other cartoons in the collection. However, it is noticeably smaller than the others, being only 15¼″ × 18¾″. I can only deduce that Hughes wanted to compress the subject for greater visual impact. It's a knockout. The missive is compact and forceful. There is no camouflage here. This is not a misty Turner. It is frontal. In your face, in the parlance of *Vanity Fair.* Alone on a wall above the fireplace, it will keep you captivated. It does not need a mate; this is a stand-alone work. Black and white to accentuate the mood, colour being avoided lest it detract from the impact. How interesting it would be to compare the cartoon with the oil counterpart. Although I have only seen a black and white reproduction of the oil in Doris Shadbolt's E.J. Hughes catalogue, I assume that the painting maintains a solemn mystical tone, even if the main wharf has been repositioned to soften its impact. As for the cartoon, it is remarkable how Hughes can manoeuvre a simple heavy graphite crayon on paper to create such a powerful message. The artist is as accomplished technically as he is talented aesthetically—an enviable combination.

The cartoons of E.J. Hughes are stunning, but the pencil sketches are no less engaging. Here, levity and fluidity govern. These studies, though not as imperious as the cartoons, are subtly vibrant. The gravitas of the cartoon is abandoned for a more impulsive grasp of the moment. At Heffel's fall 2002 auction I was particularly attracted to the pencil sketch *Kelly Logging Co., Cumshewa Inlet, Q.C.I.,* as it was the model for *Cumshewa Inlet, Queen Charlotte Islands,* the rather feisty painting I had acquired in 1991 (see page 24).

Here again, Andy Sylvester was generously accommodating. Knowing that I sought this 1953 sketch to match the painting, he discreetly abstained from bidding while giving me the nod that the field was all mine. As the pencil works have yet to be appreciated—and hence valued—as dearly as Hughes watercolours or oil paintings, the acquisition cost was unduly reasonable. As in many other instances, the sketch was readjusted slightly in the canvas version. From the delicate pencil drawing, how can one explain the hard edge of the painting? The scene may be almost the same, but the message is different. One is deftly compelling, the other acutely harsh; one is subtle, the other intrusive. The pair provide a stimulating and ongoing contrast—the yin and the yang of E.J.'s oeuvre.

Ship with a Blue Hull, Cowichan Bay

1982 acrylic on canvas, 81.3 x 101.6 cm

The Unappreciated Pastels

Beginning in the 1970s, E.J. Hughes began to experiment with a new tonality—the delicate pastel shades. This was quite a cross-over from his stronger hard-edged signature. Colour, however, remained the creative tool. From the renowned *Indian Church, North Vancouver, B.C.* (1947) to *Beside the Koksilah River* (1980), Hughes employs colour to achieve the desired mood, though the gestalt remains identifiable. A Hughes is a Hughes, irrespective of the colour tone.

These lighter-palette paintings, which can be identified, for ease of reference, as the pastel works, were not readily accepted in the marketplace—a situation that still exists today. I can sympathize with the reaction, as it reflected my own initial response. After a bit of introspection I began to "get the message." Maybe it was a question of age or perhaps of a more discerning eye. In any event, I started looking and gradually began to appreciate the not-so-obvious attributes of these pastels, though I failed in my first attempt to add one to the collection.

In May 2001, Joyner's offered Hughes' *Cherry Point near Cobble Hill, B.C.* at auction. As reproduced in the catalogue, this painting, to put it kindly, appeared rather pallid—not the first time a catalogue reproduction did not do justice to the artwork. Moreover, the scuttlebutt intimated that this larger format painting (38″ × 51″) had been bleached by sunlight, which accounted for its anemic appearance in the photograph. A bit reluctantly I gave up the chase. Not totally unexpectedly, the painting failed to meet the reserve estimate and was "bought in"—the trade jargon to signify a graceful exit from the auction.

A short time afterwards, the painting reappeared in Matt Petley-Jones' gallery on Granville Street in Vancouver—a more auspicious forum than Toronto. Even at first sight, I could not accept that the painting was sun bleached. Yes, the colour tone was very subdued—soft and muted—but the overall composition was simply too enticing to discount the colouring as other than the original tonality. You had to look at it, and then the delicate bouquet of the composition made its appearance, as Hughes intended. On reflection, the genie came out of the bottle. Gentle, intimate, serene, yes, but sun bleached, I doubted it. Every few days I would drop in at the gallery to neutralize the initial bias. The more I saw the painting, the more I admired it. Just when I had decided to acquire it, Matt told me that it had been sold the day before—woe to the procrastinator! I should have ignored the gossip and bought it as soon as it appeared in Vancouver (a lesson I should have learned by this point).

A few months later I was given another chance to make up for my initial inertia. Sotheby's spring 2002 catalogue was the conduit. Still in the process of liberating Dr. Stern's vast inventory, Sotheby's was offering another intriguing Hughes pastel, *Ship with a Blue Hull, Cowichan Bay*, a large—32″ × 40″—acrylic canvas. This time, I purged my mind of past prejudices and began to carefully analyze the painting. Every day for a period of about four weeks, I paused to study the painting, trying to appreciate every delicate nuance. I was determined first to ascertain and then to understand Hughes' strategy. Eventually I began to read the libretto of this work. Within days of the auction I decided that

Ottawa River at Ottawa

1950 watercolour, 60.96 x 50.8 cm

this was a remarkable Hughes—an intriguing example of the pastel series. As it turned out, I was the one-eyed man in the land of the blind. The crowd had yet to wake up. I acquired the work with little competition at a price that was unconscionable—which proves one of two things.

To understand *Ship with a Blue Hull, Cowichan Bay,* it helps to compare it to a light opera. This is not a show-stopper. Rather, it is a gentle aria. The theatre of it all is subservient to the tune E.J. Hughes is composing in the enticing foreground. Like a corps de ballet, this overture is introduced to subdue the impact of the freighter intruding on nature. The delicate flora—budding thistles and bleached sea grass—ushers in the *pièce de résistance,* the ship with the blue hull, so strategically situated as to soften its pivotal role. Here Hughes resists the temptation to accentuate the vessel, which, unlike a coastal ferry, is not especially pleasing to the eye. Above all, the new pastel protocol engenders the visual message. It sets the mood. It casts the spell.

The tone recalls Édouard Vuillard's 1899 *First Fruits,* so prominently displayed at the Norton Simon Museum in Pasadena, California. For whatever reason Hughes set aside the robust and opted for a softer, more genteel palette to create a new genre. Understandably, admirers of his earlier, more forceful work were a bit disconcerted. The contrast was too great to absorb overnight. How difficult it is for an established artist to reorient his public. In Hughes' case, the earlier works were so addictive that the new ones—the pastels—were unjustifiably denigrated. In time though they will become very fashionable and recherché. I can guarantee it!

As I noted earlier, an initial impression is often corrected upon further reflection. If I was too naïve to appreciate the delicate message of *Cherry Point near Cobble Hill* early enough, I seized the moment with *Ship with a Blue Hull.* As to the future, I hope I am still in the avant-garde—it's so much more rewarding aesthetically and, might I add, also financially.

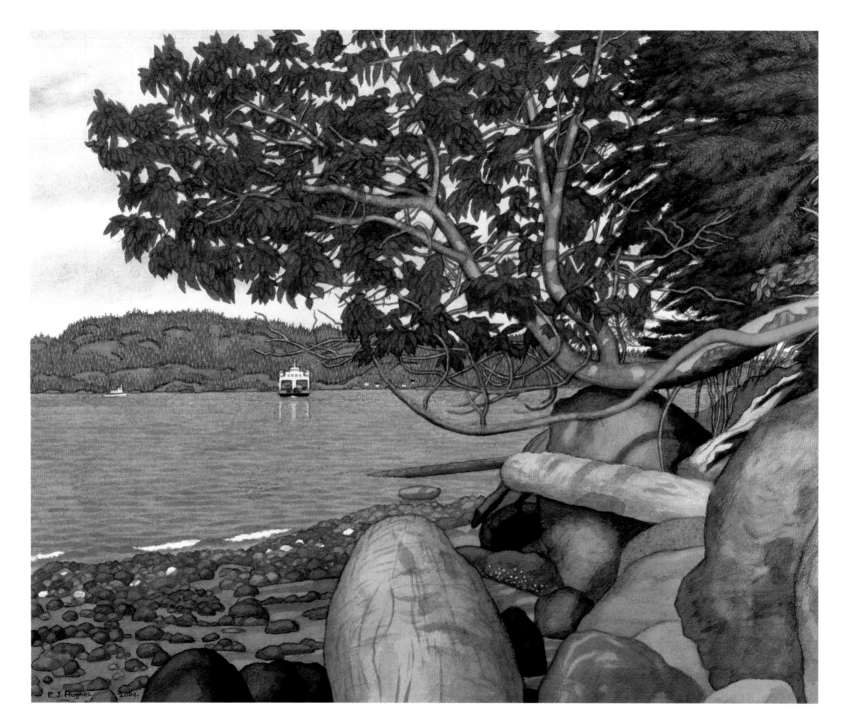

The Seashore near Crofton

2002 watercolour, 50.8 x 61 cm

From *The Seashore* to *Painter's Mother*

In her E.J. Hughes 1983 retrospective catalogue, Jane Young, from multifarious alternatives, chose a 1973 painting—*An Arbutus Tree at Crofton Beach*—for the cover illustration. It was a surprising choice, as some of Hughes' early works were better known and appreciated. Presumably, the intent was to introduce and promote the artist's more recent and softer tonal work. It was a worthy choice, for it captured the essence of this new style. The painting is a quintessential B.C. scene seen through a mellow lens. Charming, seductive and perpetually captivating, it commands attention. I always admired it.

It was with this background that my interest in Crofton Beach was revived in the fall of 2002. Following one of my luncheon rendezvous with E.J. Hughes and Pat Salmon in Nanaimo, I was confronted with a startling watercolour rendition of *The Seashore near Crofton*. It was an apt variation of a previous theme—the 1973 *Arbutus Tree*. In the newer work the artist relied on an even more subtle format. The freighter is omitted, and the ferry is realigned in the foreground to accentuate its impact, but not to overshadow the pivotal arbutus tree. The sub-theme is delicately introduced without undermining the role of the ferry. The coup is accomplished by a juxtaposition of the props. The derelict barge is eliminated and the rocky foreshore restructured to guide the eye to the diminutive ferry. In the 2002 piece the ferry is the aesthetic prima donna. Standing alone, it provides an element of mysticism akin to that found in Hughes' 1952 painting *Steamer in Grenville Channel*. Where is *this* ferry going?

(The Farewell) Above the East Coast—1951 oil on canvas, 53.3 x 66.04 cm

Once in a while gratitude must prevail! *The Farewell* is an extraordinary Hughes. It is one of a kind—the only specific commission the artist ever undertook. The job: to replicate the front page of an edition of the *Saturday Evening Post,* the popular magazine of the 1950s. Yes, that was it: the talents of one of Canada's greatest artists were commandeered to copy a magazine cover. No less than his uncle, Alex MacLean, who financed his art school studies, was deserving of such beneficence. The painting was to recall the establishment of the family in Canada, when grandfather MacLean left Scotland to work in the coal mines of Cape Breton Island prior to settling in Nanaimo, B.C., where he assumed a managerial position at the Dunsmuir colliery.

This family heirloom was apparently returned to the Dominion Gallery sometime after the death of Alex MacLean. As E.J. Hughes had not provided any title to this painting, it was probably Dr. Stern who named it *The Farewell.* Hughes would prefer to call it *Above the East Coast,* which entitlement, if the artist's choice governs, should now be applied to the painting.

Although *The Farewell* was exhibited often by the Dominion Gallery, Dr. Stern chose not to sell it, hoping perhaps that another family member would claim it. Following the demise of the gallery, the painting was finally put up for auction at Sotheby's on June 5, 2002. This, in the parlance of the day, was not a painting I was ready to die for. But it provided an interesting biographical footnote. At the bottom of the painting just below his signature, E.J. inserted "Copy from Sat Even Post." The artist wanted to set the record straight. This was not his creation. This was not his concept of an artistic experience—it was kitsch. It may be the only one of the much-sought-after 1950 Hugheses that will not invite mass hysteria. It is biographical, showing honesty and gratitude—two noble characteristics. A historical perspective always helps in understanding the artist, which may explain why I value *Above the East Coast.*

The Oil versus the Watercolour

Throughout his life E.J. Hughes executed both oil and watercolour renditions of the same subject. Sometimes the watercolour preceded the oil, and sometimes the oil preceded the watercolour. Each medium has its own attributes, the variables being tonality and perspective. Different pricing standards also govern, the watercolours being significantly less expensive than the oil paintings.

Parenthetically, this pricing differential has always intrigued me. Why is it that an oil painting normally commands a price five to ten times more than that of a watercolour? Yes, it takes longer to execute an oil painting. But a watercolour requires greater skill—mistakes cannot be corrected as easily. The work on paper is said to be less permanent, yet oil paintings do destabilize in time. Still, the marketplace favours the oil over the watercolour. Is the depth of tone and perspective of the oil painting more charismatic? Or is it simply that the collector prefers a canvas to a paper backing? History confirms this bias. Renaissance works on paper are not as seductive as the oil paintings of that period. Yet Hans Holbein the Younger could instill a powerful message in his drawings (see *Portrait of a Scholar or Cleric*). Honoré Daumier and Thomas Rowlanson were indeed the *grands maîtres* of that medium. Oil and canvas were not essential to their art; paper, gouache charcoal and graphite sufficed. Their watercolours were as vibrant as any oil painting. Even Vincent van Gogh's ink and black chalk *Portrait of Joseph Roulin* cannot be viewed—other than in size—as subservient to his radiant oil paintings.

Watercolour painting reached its apogee in the second half of the eighteenth century, the "English Watercolour Episode." During this era the medium was never so well exploited as by Girtin, Cotman and Bonnington. Yet critical acclaim did not seem to translate into financial reward, penury being the common fate of the artist—great art, yes, but great prices, no. The watercolour, then as now, was never accepted as the equivalent to an oil painting. The English watercolourists were barred from exhibiting at the Royal Academy, their work usually referred to pejoratively as "drawings" rather than "paintings" to infer a preparatory exercise, and priced accordingly.

The disparity in value reflects a cultural phenomenon, albeit with strong psychological undertones. The Japanese appreciate the more subtle works on paper. We in North America prefer the more aggressive oil paintings. Oil paintings reflect strength and virility, watercolours, gentility and diffidence. One is masculine, the other feminine—no wonder the appeal of paintings to the male monument builder! It is further argued in the marketplace that an oil rendering will outlast a work on paper. Whatever the reasons, if a premium is to be accorded for paint and canvas, a tenfold differential between oil paintings and watercolours is neither warranted nor deserved. To the sensitive and discerning eye the watercolour is an exercise in finesse—an artful stratagem to appease the mind. It is not subservient to its oil counterpart but an alternative art form that provides its own artistic perspective.

What better soliloquy than to introduce Hughes' *Mouth of the Courtenay River* (overleaf), that very masculine watercolour that dominates the senses. This is a solidly structured work, unlike those supple and nimble Bonningtons

Mouth of the Courtenay River

2003 watercolour, 50.8 x 61 cm

and Girtins of the British school. This is not a marshmallow piece. It is a powerful painting that depicts the majestic bond between man and woman in a tempestuous world. It sends an unusual message, as Hughes normally avoided the human element in his paintings. Here the fisherman and his young family, fragile and diminutive, confront the intimidating panorama of this British Columbia coastal scene—humanity pervades.

Executed in the spring of 2003, the watercolour *Mouth of the Courtenay River* is the counterpart to the 1952 oil painting of the same name. The difference between the two versions as usual is one of tonality and hence of atmosphere. The two works provide the perfect opportunity to evaluate the impact of an oil compared to that of a watercolour. Though the watercolour is lighter in tone, it is of equal resonance. The difference is in the mood that each painting generates. The impact of the watercolour is not weaker than that of the oil, but its accent is less invasive and more infusive. Does that difference warrant a 90 percent discount from the value of its oil counterpart? I doubt it. Stand twenty feet away, compare the two works without knowing which is the canvas and which is the work on paper, then decide for yourself.

The Painting and the Frame

Zeitgemälde is an apt description of *The Koksilah River at Cowichan Bay* (overleaf). This 1990 acrylic is the incarnate "picture of the moment." It is nature at a standstill. Hughes has that singular ability to immobilize the landscape. There is no movement—*rien ne bouge*. He encapsulates that "fix" on the countryside. No painterly artifices are introduced to distract the impact. Rather, the work is all about a moment in time—the Koksilah River at a standstill to allow the viewer to appreciate fully the tranquility of nature.

For years I have sought appropriate words to describe Hughes' distinctive serenity—that moment in time—so emblematic of his paintings. Paul Johnson, the author of *Art: A New History*, recently defined such an effect with panache and sensitivity. In describing the impact of Vermeer's *View of Delft* he finds that the artist depicted "total reality with a stillness and soundlessness which is almost palpable" (p. 383). Yes, this reality can be almost felt or touched. It palpitates. There is no better way to describe Hughes' strategy in this 1990 landscape.

A subdued work, *The Koksilah River* appeared in Sotheby's spring 2003 auction catalogue. I was nonplussed until Ian Thom suggested that I study the painting more carefully. This was no seduction at first sight. By underplaying the theme, Hughes was attempting to create the mood. He consciously avoided the theatrical to produce a deftly arresting sanitized vision. In time I began to get the message. I started to understand the mood, to appreciate the objective. This was not a painting to arouse passion as much as to engage the mind. Simply said, it is a cerebral piece of work, particularly in its new four-inch-wide ebony frame. Sit in a comfortable lounge chair, look at it and contemplate—yoga-like. It will transfix you. There is an inner power to the painting that can only be discerned upon reflection.

The Koksilah River at Cowichan Bay

1990 acrylic on canvas, 63.5 x 81.3 cm

Thanks to Ian Thom, I came to "see" the painting for what it was before others, which enabled me to acquire it at the auction with hardly any competition. The whole experience proves that a knowledgeable and impartial curator is an invaluable resource in fashioning an art collection. An impartial art historian is the partner *sine qua non* to the amateur. I only wish I had obtained that support earlier in my collecting career.

The *Koksilah River* acquisition engendered an acute proactive reaction to the function of a frame around a painting. The painting arrived from Sotheby's in the typical drab and shabby mock gold frame—the Dominion Gallery's trademark for Hughes paintings. Though the practice may have been justified in the early days, it should have been abandoned when Hughes' prices became more respectable. I can't understand how a twenty-dollar Mexican frame can adequately house a $50,000 painting. Yes, an inexpensive plain border frame can do the job, but a cheap fake gold leaf *encadrement* is appalling. It devalues the painting. It debases the integrity of the artist. (Not surprisingly, the frame in this instance substantially reduced the value of the painting at Sotheby's auction.) On the other hand, the "right" frame will enhance the work and allow its message to reverberate. Properly encased, the artwork can breathe and its impact can be accentuated. The frame is part of the aesthetic package. When properly integrated, the ensemble is greater than its parts—the frame has found its soul and the painting its halo.

For the next few months I cogitated on what sort of frame would enhance the gentle message of *The Koksilah River*. The problem today is that the typical frame shop can only offer manufactured moulding. It's a cut and glue affair. Your choice is limited to the standard fare, which is then cut and glued or stapled together. There are no village frame *makers* any more—what a shame! An ebonized baby grand piano in the living room provided the first clue—what about an ebonized black frame to match the shade of the trees and harmonize with the yellow tonality of the painting? A wide band would then serve to broaden the impact of the work. As it turned out, obtaining such a frame was easier said then done. Where to get a four-inch frame made and then where to have it ebonized?

My son-in-law Jim Allan, who had recently renovated his home in the Arts and Crafts style, provided me with the artisan—Ted Turner, a former harpsichord maker. Always welcoming a challenge, Ted bought into the project with vigour and enthusiasm. Within a week the four-inch frame was constructed and, in the absence of a better resource—now remedied—Ted proceeded to apply four coats of black lacquer. The finished product was stunning. It was as if we had reinterpreted the work. What had been a cramped and constrained affair was now an expansive scene—yes, serene, but imposing and gently authoritative. What had been boxed in was now allowed to breathe. What had been a veiled message was now an open letter for all to read, as the artist intended. Together with Ted Turner, the *ébéniste,* the whole collection is now in the process of being revamped. (I use the French word since the English counterpart—cabinet-maker—does not seem to apply to a creative frame maker.) At last, I have found another trade—frame designer!

Trees, Sooke Harbour

2003 watercolour, 50.8 x 61 cm

Kaali Meets Hughes

A favourite moment can be easily relived with fondness. A successful medical operation, a favourable legal decision, a profitable business venture, a sailing championship are all worthy subjects for the occasional recall. Not surprisingly, artists, like other professionals, reminisce from time to time about past accomplishments. The creation of a master-piece—yes, the artist will recognize it—is particularly amenable for periodic recollection. It was undoubtedly for this reason that E.J. Hughes decided to revisit Sooke Harbour.

In the early summer of 2003 Hughes reinterpreted *Trees, Sooke Harbour, B.C.,* a 1951 oil painting that served as the frontispiece of Ian Thom's *E.J. Hughes,* that *opus classicus* on the oeuvre of the artist. Again, in this new watercolour, the artist, although depicting the same scene, introduces a more vivid, less sombre atmosphere. Here Hughes bracketed an element of litheness that is not at all reflected in the original oil painting. Compare the two and *voilà la différence.*

Pat Salmon overwhelmed me with this tableau a few months later when Jim Allan flew us on his Beaver to Shawnigan Lake to have lunch with her and E.J. Hughes, who was soon taken with four-year-old grandson Kaali, who accompanied us.

For his part Kaali seemed surprisingly muted before this great Canadian artist whom he had previously "met" at the Hughes exhibition at the Vancouver Art Gallery. This memorable experience can now be recalled with ease by reference to the exhibition catalogue that the artist so graciously dedicated to him on the shores of Shawnigan Lake. The Hughes culture transcends yet another generation!

Hughes, Macdonald and Fisher

In 1928, Ione Macdonald decided to inveigle her classmates to commemorate their sojourn at the Vancouver School of Decorative and Applied Arts in an autographic album. Each candidate was given a page to make his mark for posterity. For decades the whereabouts of this historical manifesto remained unknown. Though remembered by a few, no one seemed to know whether it was still in existence. As some of the participants gained fame in the art world, the relevance of this historical document became more acute. All agreed that it would be unfortunate if this aesthetic record could not find its rightful place in the annals of the Vancouver art community. Alas, no one came forward with the missing link. That is, until it appeared on the Heffel Gallery's monthly—February 2003—on-line auction!

Its appearance was not altogether surprising, since things of value, sentimental or otherwise, are normally well preserved. A faithful descendant of Ione Macdonald anxious for the album to enter the public domain decided to put it up for auction. For the first time the next generation could look at and appreciate this eclectic compendium. Unlike the normal school autograph book, this album contains individual signature sketches—a *bona fide* archival depository, as valued for its aesthetic perspective as for its social connotation. Particularly noteworthy: a whimsically spiritual sketch by the nationally renowned Jock Macdonald, an English thatched-roof cottage scene by Orville Fisher and

The Class Album

Left: *A British 'Sopwith Camel' in Action—1917*
1931 cartoon, 15.24 x 9.52 cm

Right: *Sketch by Jock Macdonald*
1928–31 pencil, 15.24 x 9.52 cm

an altogether commanding graphic crayon rendering by Ed Hughes. (Why do you think I was so interested?) The remaining contributors, though not well known today, are to be recognized equally for creating this visual mirror of the time. The *ensemble* is the message.

Non-figurative art was obviously not in play at the Vancouver School of Art during this period. Here was an academy focussed on the well-established norms of drawing and painting, as so vividly rendered by Orville Fisher in his ink sketch. Abstract art was not in evidence either surreptitiously or overtly. The impressionists, expressionists and cubists had yet to make an impression at the school. The sketch album also authenticates the prevalence of women in the art school system. Attending art school was *the* viable alternative for those not interested in pursing a career in nursing or teaching, the only professional avenues available for women at the time.

Jock Macdonald's pencil composition is particularly significant. It introduces an element of creative imagination not otherwise present in the students' work. Macdonald had joined the teaching staff at the Vancouver School of Decorative and Applied Arts in 1926 and together with F.H. Varley did much to shift the aesthetic accent to a less representational mode than had anchored the school up to that time. Both are now acclaimed for their contribution to the development of our national style of painting. Macdonald's sketch is particularly revealing of the prevailing pedagogical bent. The simple line drawing reminiscent of Matisse and Picasso is an exercise in simplicity—less to say more. The imagination is given a bit of free rein: Is the professor issuing a dictate or is it the simple greeting (twirping) of a joyful bird? Whatever the interpretation, the message comes through—"Be happy!"

Ed Hughes' contribution is a telling autobiographical statement. The artist's fundamental *charactère* is already in evidence. Inherent discipline, superb draftsmanship, a hard-edged compositional style and meticulous accuracy were qualities firmly imbedded in E.J. Hughes by the age of eighteen. Look at the heavy graphite sketch, *A British 'Sopwith Camel' in Action—1917*, and you may easily discern the Hughes signature that was to govern for the next seventy years. It is amazing that Hughes had developed his own style by such an early age. Undoubtedly the school had an impact on his artistic development, but neither Varley, Macdonald nor anyone else on the staff had any influence on Hughes' individualistic imprint, which became so distinctive as to be recognizable at first sight. Hughes was his own man.

In the sketch, Hughes synthesizes a boyhood fantasy into a vibrant wartime scenario. "Google" it and you see that the plane—the revered Camel—has been replicated by Hughes with uncanny accuracy. Similarly, the German soldiers' garb would appear to have been drawn with the same meticulous care—commendable, but hardly art by itself. Yet the juxtaposition of the props generates the homily: war anaesthetizes humanity. The German soldiers (read humanity) plod on almost oblivious to the deathly armature of the British Sopwith Camel. That is art.

Steamer in Grenville Channel

Interpreted by Bladen Barbeau Allan, age 8

The Watercolour Version

On Saturday, March 27, 2004, Jim Allan and I met with E.J. Hughes and Pat Salmon at Shawnigan Lake. It was one of those warm sunny days that so aptly impart that invigorating sap of spring. The lake was placid and the environment almost at a standstill—a typical scene for an E.J. Hughes canvas. We all agreed to have lunch at Steeples, my sister-in-law Daphne Francis' restaurant, which we have always enjoyed both for the food and the ambience. E.J. looked in great form, his vigour belying his ninety-first birthday. We were chit-chatting casually when Pat expressed Hughes' disappointment with his one and only visit to the E.J. Hughes exhibition—at the Art Gallery of Greater Victoria—which had unexpectedly turned into a public relations calamity. It was agreed that another visit would be so engineered to allow the artist to savour his legacy undisturbed by the machinations of the gallery director.

Then came the denouement!

On the way back to the plane, Pat Salmon handed me *Trees, Savary Island, 2004* (page 85), the watercolour rendition of the original 1936 drypoint print and the subsequent 1953 oil painting of the same scene. This arresting piece monopolizes your attention. It commands you to pause. It sanctifies the beauty of British Columbia's coastal shores. Again Hughes has taken a simple scene and beatified a bit of nature for all of us to savour. Though I have admired and cherished Hughes' more energetic pieces—ferry boats and all—the softer, more delicate works have had a profound impact on me. Perhaps you need to digest the bolder paintings before you can appreciate the more subtle works. Maybe it's a question of age. Whatever the cause, at seventy-two, I seem to be more attracted to Hughes' subtler and more tranquil renditions of nature. As with all such works, *Trees, Savary Island, 2004* is the template for such a genre. This is a cerebral piece that mellows out the vicissitudes of life. It releases a captivating message—a mood—that makes you glad you are alive. Here Nature does not need any other accoutrements.

Hughes Interpreted by Bladen and His Classmates

March 31, 2004, will be always firmly imprinted in my mind. On that day I spoke—in French—to my grandson's Grade 3 classmates on the art of E.J. Hughes. What an experience! What feedback!

Madame Véronique Hamilton, Bladen's teacher in the French program at Quilchena School, had instigated a popular parent guest speaker program. The objective was to allow the class to benefit from a parent's or grandparent's experience that might be of educational interest. Bladen's father—Jim Allan—spoke on his latest trip to the Arctic, while I was invited to describe my *Journey with E.J. Hughes*. I was flattered though a bit nonchalant about what might be involved. What was so difficult about talking to some twenty children? So I readily accepted the invitation and put the matter to rest until a week or so before the "show and tell."

Well, when I got to thinking about the format of my presentation, I realized that this was no cakewalk. How do you keep the attention of an eight-year-old for forty minutes? How do you explain the aesthetic quality of a work of art?

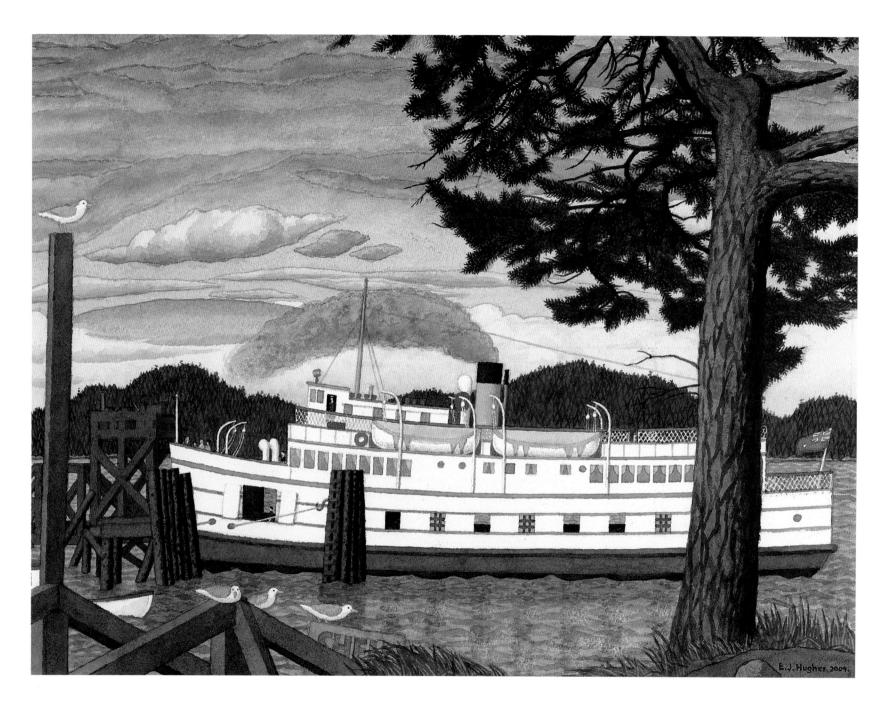

The Car Ferry at Sidney, B.C., 2004

2004 watercolour, 50.8 x 61 cm

How do you describe the emotional net worth of a painting? How do you explain the function and value of a picture on the wall? How do you attempt to do all this in a language that you have not spoken *courament* for years? Well, the first step was to pique their interest. A handout copy of my *Journey with E.J.* would serve the purpose. Moreover, it would provide an effective prop for discussion—a picture being worth a thousand words.

I initiated the discussion by asking the group to close their eyes and conjure what their house would look like without paintings or pictures on the walls—particularly in their bedroom. The exercise startled them a bit. They all agreed—though never before conscious of it—that the absence of art on the walls would be a downer—totally depressing. I was amazed by their insight and passion. Here was an alert and thoughtful group. The discussion was lively and committed. They understood and welcomed the challenge. They were eager to go on.

At this stage the intellectual gymnastics proved a bit more demanding. Introduction aside, my primary theme was to convey that a painting oftentimes has both an obvious and a less apparent message. The trick was to discern and decipher the undertone. After discussing a number of paintings in the book, we focussed on *Steamer in Grenville Channel*, illustrated on the cover. They easily interpreted what they saw. Next, with their eyes closed, they paused to see if they could detect the inner message emanating from the painting. This was the challenge. One or two of them suggested a forthcoming storm that would besiege the little ship. After a few hints and a little prompting, they agreed that the lonely ship could be interpreted as akin to a working parent facing the day-to-day travails of the workplace. The accent was not on accuracy of interpretation but rather on the attempt to read the inner meaning of a painting.

Anticipating that representational paintings hide their inner meaning well, I brought out an abstract by John Koerner to offer an alternative for discussion. Lo and behold, immediately hands shot up and a profusion of interpretation was forthcoming. Everyone saw a message, though none alike another. This was subjective interpretation—which is what it should be. Putting the aesthete aside, one person's opinion is as good as another's as to the meaning to be ascribed to a painting. I think I made the point! But I am still startled by the children's facility to interpret an abstract rendering, when their elders are so reticent to give voice to their emotions, preferring instead to intellectualize a non-figurative painting.

I left the class and grandson Bladen with a feeling of accomplishment. I think the students got the message, and, more importantly, they had a lot of fun doing it. It was worth the hours I had devoted to the task. Hopefully they will all look at paintings differently now.

The finale did not occur until a few weeks later, when Jean, Bladen's mother, handed me a booklet entitled *Le Grand-père de Bladen à l'école Quilchena, le 31 mars 2004*. It contained a drawing from each member of the class interpreting a Hughes painting to be found in my *Journey*. I was overwhelmed. What a memento. What a thoughtful gift. Here was proof that they *had* gotten the message. I still thumb through it and "read" the interpretation of the Hughes canvases. Though it was never the intention, this artistic homework proved to be a noble experiment on how an eight-year-old interprets a Hughes painting. (For an example, see page 118.)

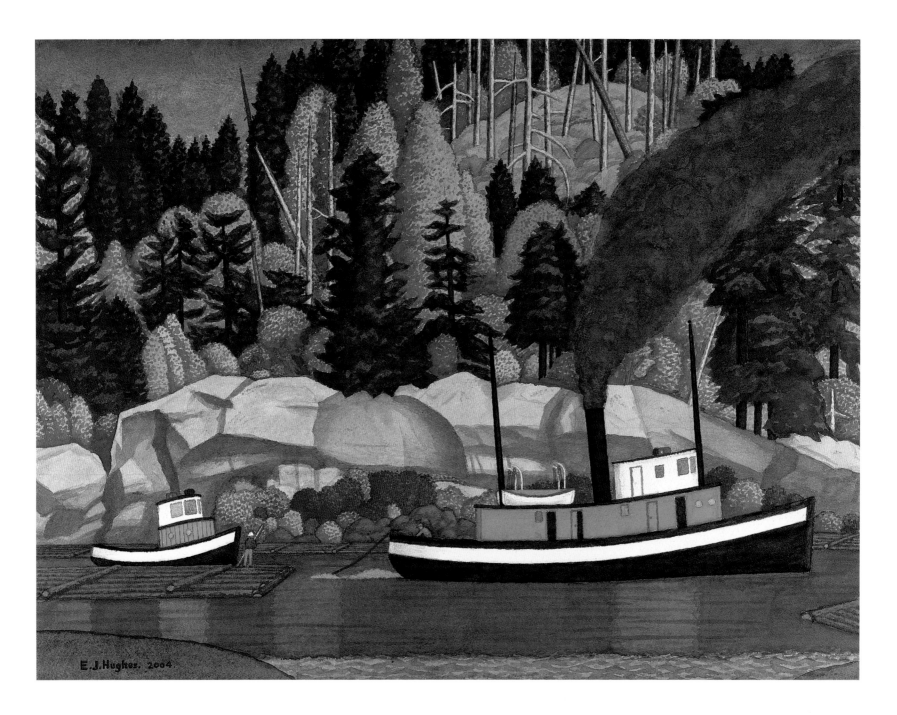

Tugboats at Ladysmith Harbour

2004 watercolour, 50.8 x 61 cm

Anxious to give E.J. Hughes and Pat Salmon the Quilchena sketch album, I asked Jim Allan to fly us to Shawnigan Lake on Thursday, May 13, 2004. It was another one of those grand spring days when the lake and its resplendent shoreline is most inviting. It was a perfect setting to share a few moments—and an apple/berry crumble—with my favourite aesthetic soul mates. Pat was as enthralled as I was with Bladen's classmates' interpretations of Hughes' paintings. As usual, E.J. kept his emotions in check, preferring to savour the sketches leisurely in the privacy of his home, undisturbed by others. His reaction was the same when he received the first copy of Ian Thom's *E.J. Hughes.* I knew that the sketchbook had hit the mark.

Hughes was captivated. This was the first time that anyone, never mind a group of eight-year-old students, had systematically attempted to interpret his work. It is amazing how a simple show-and-tell class demonstration led to such an extraordinary interpretation of Hughes' art.

Another Perspective

If the album was the surprise on our menu for lunch, Pat Salmon came prepared to meet the challenge when she handed me *The Car Ferry at Sidney, B.C., 2004* (page 120), a magnificent watercolour rendition of its 1952 oil counterpart (of the same name) in the National Gallery of Canada. The subject is the quintessential Hughes showstopper. It resonates like an Edward Weston silver print photograph. The acidic white tonality of the ferry carries the message and sets the tone. Enveloped by the subdued coastal shores, the ferry is omnipresent. There is no hint of timidity here. It is a Teutonic lifeline—strong and confident. Compare it with *Steamer in Grenville Channel, B.C.* (page 1) and appreciate the atmospheric variation, so illustrative of Hughes' strategic ability. Two ferries indeed, but what a difference in intellectual impact—one generating introspection and meditation, the other conviction and authority. What a tableau for contemplation! What a resplendent addition to the collection!

The Watercolour

Hughes continues to amaze whenever he introduces another new watercolour to the community. If one could only match his professional skills at ninety-one, when he completed *Tugboats at Ladysmith Harbour!* Perhaps this is an opportune time to reflect on his living and working habits. It is difficult not to overemphasize how committed Hughes has been to his profession. Ten- to twelve-hour days were the norm until he was well into his eighties. In the early days, after painting all day, his evenings were devoted to drafting his meticulous cartoons—for relaxation! He had no hobbies or other pastimes (except to read art books) to impinge on his strenuous work schedule. A serene and secluded lifestyle was required and willingly accepted.

Apart from a close relationship with his beloved wife Fern until her untimely death in 1973, friends were few and relations with fellow artists were almost non-existent. His life *was* his work. For him it was a matter of culture. You

worked every day, pausing only for meals and sleep. Though he loved his profession, there must have been times when producing yet another painting in order to make a living must have been a bit of a grind. Yet the economics of art in Canada at the time simply did not accommodate the leisure available to the average professional.

Once the work ethic was ingrained, he became addicted to the lifestyle, though in the past few years, he admits to taking a few hours off every day. Yes, E.J. Hughes is now being recognized as one of Canada's leading painters, but his success was not accidental. It is in large part attributable to his perseverance, artistic talents and very hard work. He is the model for any artist seeking fulfillment in his profession. Talent is all-important, but without hard work it comes to naught.

It's disconcerting that so little recognition is given to Lawren Harris for supporting E.J. Hughes in the early stage of his career. Hughes was not only discovered but also enthusiastically promoted by this renowned Group of Seven member. Harris was the imprimatur of Hughes' professional standing in Canada. His commitment to Hughes is encapsulated in a letter to the National Gallery in reference to *Tugboats, Ladysmith Harbour* (1950): "Nothing quite like [it] has been done here or anywhere in the country. Everybody likes it, painters, laymen and just folks. It's the kind of painting—factual, detailed, accurate, full of interest but its art quality transcends all of these" (quoted in Thom, p. 85). How magnificent for this renowned and established artist to signal Hughes' aesthetic relevance in Canada—a *beau geste* indeed. Unfortunately, there were not too many in the country who had Harris' sensitivity to appreciate Hughes' singular talent.

Yet the National Gallery admirably espoused the cause so passionately promoted by Lawren Harris. In 1951, the gallery acquired its first Hughes—*Tugboats, Ladysmith Harbour*—followed by the acquisition of *Beach at Savary Island, B.C.* in 1953, *The Car Ferry at Sidney, B.C.* in 1955 and *Village Wharf* in 1957. The Beaverbrook Art Gallery followed the lead in 1959 when it acquired *House at Qualicum Beach, B.C.* These acquisitions—each of which resonates as they did fifty years ago—joined the 1949 acquisitions of *Farm near Courtenay*, by the Vancouver Art Gallery, and *Logs, Ladysmith Harbour* by the Ontario Art Gallery so that by the end of the 1950s Hughes' art was better represented in public galleries than that of any of his peers. Though his art was now professionally authenticated and aesthetically recognized, it would be another forty years before the general public would know his name.

The watercolour *Tugboats at Ladysmith Harbour* justly synthesizes all of the laudatory adjectives I have used previously to describe the art of E.J. Hughes. The watercolour echoes the spirituality of its oil counterpart now in the National Gallery. The tactical use of colour is symphonic. In this watercolour, Hughes again modified the curvature of the two vessels from that seen in the 1950 oil version, similar to the treatment accorded *Fishboats, Rivers Inlet*. One can only wonder why he corrected this distortion. Was it because he realized that his artistic rendering no longer required this theatrical ploy? The realignment is delicately effected so as not to disturb the masterful capture of the moment, the *Zeitgemälde*. This is British Columbia!

Art is not what you see, but what you make others see. —Edgar Degas

The Finale?

After much effort, I finally succeeded in acquiring the "astonishing" portrait of E.J. Hughes' mother on July 14, 2004. The painting had recently returned to its owner—Roslyn Klein—in Montreal after touring Canada as part of the E.J. Hughes exhibition. It was originally acquired by her husband, Jack Klein, from the Dominion Gallery in 1983. Michel Moreault, who had maintained a close relationship with the owner, persuaded her that perhaps the painting would be best repatriated to British Columbia, albeit with a token of my appreciation.

Ian Thom had little difficulty in acclaiming this intriguing masterpiece, *Painter's Mother* (overleaf), as one in which "Hughes gives his mother a dignity and forthrightness that mark him as a portraitist of great sympathy and skill, and as a major painter." Thom appears mesmerized—and justly so—by the composition of this early work. The "careful delineation of texture, the simple but forceful placement of the figure and the exquisite play of light across Mrs. Hughes's face" are singled out. "Equally striking is the command of colour. Hughes used intense, bright colours, together with more sombre shades, and the tones of the face and the background fabric are particularly accomplished," wrote Thom (p. 54), all the more remarkable as the artist was merely twenty-eight at the time.

As much as I would like to take credit for recognizing this masterpiece on sight, I cannot. I found *Painter's Mother* interesting, but it did not immediately arouse any compulsive response. It was Ian Thom who prompted me to have a better look. He spoke highly—and emotionally—of the work and its intricate composition. He made me pause and I began to look. It is only when I could divorce the painting from the typical Hughes landscapes that I began to appreciate the portrait. Somehow I began to think of *Painter's Mother* in terms of the expressionist style, where the aim is not to replicate or reinterpret a scene or a figure but rather to fashion an impression (read expression) of the subject to create a commanding mood.

In expressionist art, the realism of the scene (or the portrait) is subservient to the emotional impact of the work. The emotive effect is thus pre-eminent. It supersedes the "beautiful" and the mere realistic. No, Edward Hughes is no Edvard Munch or Edward Kirchner, yet there is a commonality between them. *Painter's Mother* is a hard-edge painting. Look at the mother's eyes; there is no levity here. They are arresting, piercing and icy. Discipline and control are paramount. The eyes galvanize the persona of Katherine Mary Hughes. The lady is not for frivolity. The object of the composition is to create an impression of Mrs. Hughes' character. The painting is not a gushy sentimental piece to enhance his mother's appearance. It is her persona that Hughes is trying to convey—strong, commanding, if not overwhelming. He accomplishes his goal magnificently.

Painter's Mother is not the typical picturesque Hughes. It caters to a different audience—his own! Neither the marketplace nor Dr. Stern had any influence on the artist at this stage in his life. This was art for art's sake—selfish and focussed. The work is no less than a monument to his mother. Yes, it was an experiment, but one accomplished with vigour and integrity—a worthy memorial. In the words of Ian Thom, it is a "fabulous" painting.

Painter's Mother

1939–51 oil on board, 48.26 x 35.6 cm

Painter's Mother is dated 1939, though it was not completed until 1951. E.J. Hughes began to paint his mother at home in Vancouver some months before joining the army—as a gunner in the Royal Canadian artillery—in September 1939. Shortly after war was declared, Hughes applied for an official war artist posting. The process was initiated when he was called to Ottawa to serve with a temporary accreditation. As a result he stored all of his artistic possessions—including the unfinished *Painter's Mother*—and made his way to Ottawa with his new bride, Fern, whom he had married in February 1940. It was well after the end of the war, with his parent living close by in Shawnigan Lake, that he decided to complete the painting—*Painter's Mother*—in 1951. With E.J. Hughes' approbation the painting is now to be dated 1939–51 to reflect the more accurate period of its execution.

Some months after completing this monograph in July 2004, I came to the conclusion that the frame grossly undermined the painting. It dawned on me that the frame rather than the painting might have caused my initial indifference to *Painter's Mother*. Unlike Ian Thom, I was sidetracked by this blemish. Ian simply ignored the inverted acidy yellowish frame to concentrate on the work itself. Such a biographical icon deserved better. So, as described on page 152, a new frame was designed to reintroduce *Painter's Mother* to the public. And what a transformation, what a change in tonality!

Though it would have been easy to redraft the monograph to accommodate a reinterpretation of the painting, I thought it more appropriate to record my reaction to the portrait in both its new and its original frame. The comparison would highlight the interaction of the frame with the painting. It would reflect the aesthetic impact of the frame upon the painting. In this instance, the painting assumes a distinct mode in each of the frames. In its original frame, the background is subservient to the portrait. In the new frame, the background merges with the subject to soften the tonality of the portrait.

Comparing them we are confronted with two Mrs. Hugheses—one portrait somewhat harsh and acidic; the other, though still somewhat stern, offers a more compassionate and softer persona. One might even conjure a discernible trace of a Mona Lisa smile. Mrs. Hughes' complexion is driven by her glazed blonde hair in the first frame, while in the latter it is softened by the lighter hues of the background. The 1940 *maquillage* (makeup) predominates in the first version, to be subsequently mollified by the rosewood tint of the new frame. Yes, the very same person in each, but upon being buffeted by different tonal reflections offers two differing personalities, for such is the power of the frame.

Well, *is* this the finale? Have I now completed the collection? Does *Painter's Mother,* the seventy-sixth acquisition, mark the end of my *Journey?* I think so, but then I said that when I completed the first edition. Still, it must at least be approaching the beginning of the end, as both the cost and the availability of Hughes' work have dampened my acquisitive temperament. The Heffel sale of *Fishboats, Rivers Inlet* for $920,000 on November 24, 2004—the highest price realized for a living Canadian artist—clearly established a new parameter for the collector.

I won't swear that I will not acquire another Hughes in the future. I probably will, but on a much more discreet scale—say, one per decade? But at my age, with time and money no longer considered renewable resources, the story had to be brought up to date to avoid the inevitable and permanent interruption. And Mrs. Hughes' portrait is a sensitive demarcation point, *n'est-ce pas?*

Harbour Scene Nanaimo, B.C.

1970 oil on canvas, 81.3 x 101.6 cm

The Vancouver Art Gallery Exhibition

The long-awaited E.J. Hughes retrospective exhibition opened at the Vancouver Art Gallery on January 30, 2003. It was a momentous event in the history of art in Canada, signalling Hughes' ascent to the ranks of a national *grand maître*.

Some three years earlier I had met with the then director of the Vancouver Art Gallery, Alf Bogusky, to discuss an E.J. Hughes exhibition at the gallery. The meeting was the culmination of years of indiscriminate lobbying on my part that Hughes' art deserved to be so recognized while the artist was still living in his own native province. I doubt that the gallery would have been amenable to such an exhibition without the intervention of Michael Audain, one of its most generous supporters. Through his subtle persuasive powers he was able to convince the gallery to proceed sooner rather than later, to allow Hughes to witness the accolade. Michael Audain is one of those valued citizens who seem to be destined to contribute to the commonwealth of the community. Assiduously, anonymously and discreetly, he has done much to define the art scene on the West Coast.

The E.J. Hughes exhibition was scheduled initially for the spring of 2002, with Ian Thom as its curator. It was to be a retrospective of his lifetime of work. I undertook to raise the necessary funds to produce a first-class catalogue—my talents not being suited for anything else. The task proved easier than everyone had anticipated, thanks to two good friends, Michel Moreault and Stephen Jarislowsky. Rather than canvassing far and wide, it was decided to focus the campaign on a few potential donors. The strategy proved effective. Michel Moreault was successful in convincing Sidney Seldhammer to make a substantial contribution on behalf of the late Dr. Max Stern Painting Trust, which was

followed by an equally generous contribution from Stephen Jarislowski. With a modest add-on on my part the project was totally financed in record time—a first in the history of the gallery, which aptly reflects Hughes' national appeal.

With the appointment of Kathleen Bartels as director of the gallery in 2001, the scheduled Hughes exhibition was postponed for another year, much to my chagrin, as it put my attendance further at risk. At seventy, time has an acute dimension. Notwithstanding the prior commitment—allegedly unknown to the new director—the rescheduling was not subject to debate. The experience taught me a lesson—don't argue with the "Pope."

Ever dutiful, Ian Thom proceeded diligently to write his thesis on the art of E.J. Hughes, which was to be published by October 2002. If truth be told I was a bit anxious about the "catalogue," which term, parenthetically, I find offensive to describe an aesthetic analysis of an artist's work, hence my use of the term "thesis," which connotes a dissertation rather than an auction or mail-order house *catalogue*. Semantics aside, I was concerned that Ian Thom might avoid a forthright assessment of Hughes' oeuvre. I really did not care how he judged Hughes, as long as he adjudicated objectively and frankly. My own commitment was irreversible. My ego—I hoped—was seasoned enough to digest an unfavourable assessment—perhaps easier said than done.

From the outset I had assured Ian Thom of my full co-operation in staging the Hughes exhibition. Any of the artist's works in the collection would be available to him. Some collectors are reticent to exhibit their paintings. I was coached early in my career that you never completely own a painting but merely possess it for a time. The artistic creation is to be shared with the public. Not only did I agree to lend the works, but I also agreed to an acknowledgment of ownership. Why? Here the issue is more delicate. Personally, I always appreciate knowing who owns the work. Yes, it's gossipy, but in small doses who doesn't like a bit of gossip? Yet there is another, less self-serving factor. The ownership of the work is part of the provenance that provides evidence of taste and often of aesthetic insight. If the world-acclaimed art critic Robert Hughes acknowledges ownership of an artwork, that acknowledgment will at least make you look at the painting a little more carefully. It will encourage you to see what attracted him to the exhibited work. The opposite argument is that public disclosure of ownership will encourage someone to steal the work. Perhaps, if you own a Matisse, but doubtful if you are exhibiting a Hughes, with its restricted Canadian marketability. Maybe it is just a question of being discreet, always a noble characteristic. But for me the downside is negligible and the upside—disclosure of ownership—is always entertaining and often educational.

By the summer of 2002, my attention turned to Ian Thom's book (I was getting a bit inquisitive—read nosy). After some protracted negotiations with Dick Kouwenhoven, Scott McIntyre of Douglas & McIntyre had awarded the printing contract to Hemlock Printers of Vancouver. Eager to witness the first press run, I had wrangled an invitation from Ian Thom to be there when the book went to press. The alleged reason was to obtain the "first" copy for E.J. Hughes. The real objective was to satisfy my cancerous curiosity. I was anxious to find out how Ian Thom had adjudicated E.J. Hughes' art, fearful that he might avoid the issue altogether.

A few days before the book went to press, an important addendum was suggested by no less than my son-in-law Jim Allan: a provincial map to pinpoint the locale of Hughes' paintings. This would allow anyone unfamiliar with B.C. to ascertain the location of a given site—for instance, where Ladysmith is to be found. More importantly, it would ensure that the location would be identifiable for generations, should the current name disappear or be modified. Try, for instance, to locate Saseenos, B.C., where E.J. Hughes crafted *Cooper's Cove.* It has vanished, no longer to be found on a modern map.

Nepotism aside, Jim Allan's diktat appeared convincing. The publisher, Scott McIntyre, though sympathetic, was far from elated at the prospect of re-engineering the book at this late date. That the budget did not allow for such an expensive addendum was the proffered excuse to avoid the issue. A little cultural persuasion was required and duly provided. Surely such a historic document was not to be published without recognizing our responsibility to future generations? Our patrimony was at stake! The rhetoric worked. No one wants to be a historical party-pooper. With the added commitment from Stephen Jarislowsky and me to buy a few additional copies of Ian Thom's book, Scott McIntyre agreed to insert the site maps. With the assistance of Pat Salmon, Saeko Usukawa (the book's editor) integrated a series of site maps that added much to the historical value of this great Canadian art book—thanks to Jim Allan.

Finally, in late September 2002, the word slipped out that a proof draft of Ian Thom's book was about to be released. He arranged for me to obtain a copy from Dick Kouwenhoven of Hemlock Printers. Being prone to capricious use of superlatives is a handicap when one is really required. The mock copy of *E.J. Hughes* was simply arresting. I was overwhelmed. I was stunned. I was positively enthralled with it. I read it and reread it. It exceeded all my expectations. Here was *the* book on E.J. Hughes. This would become the authority on his oeuvre. It is a catalogue *bien raisonné.* Thom had immortalized Hughes in the aesthetic culture of the nation.

The cover so creatively fashioned out of Hughes' *Steamers,* by the brilliant young designer Mark Timmings, set the tone. It was dramatic. With the embossed name E.J. Hughes, the jacket featuring both the sketch and the finished painting encapsulated the essence of the artist's work. While the wrapping is always secondary to the content, in this case, the packaging was the attention-getter. It mandated a review of the content. It was the aesthetic preamble to the thesis. It seduced the bystander to pick up the book and read it—what an accomplishment for the designer.

Art book publishing in Canada is not undertaken for fortune, and if for fame, it is a fleeting benefit. Book printing is even more challenging. Basically, people can no longer afford the product. Irrespective of these financial and marketing constraints, Scott McIntyre undertook to publish the E.J. Hughes book in partnership with the Vancouver Art Gallery. Dick Kouwenhoven assumed responsibility for the book's printing with remarkable professionalism and community spirit. He was determined to make *E.J. Hughes* the best that could be produced. Inheriting a set of digital photographs, he commissioned the technically astute Peter Medlinger to match the digitized versions with the original works, whether located in Montreal, Ottawa, Toronto or Vancouver—a time- and money-consuming due diligence

exercise to achieve his self-imposed objective. The formula seems to have worked, since by the end of 2004 the first edition of 5,000 copies was sold out—an enviable record for a West Coast artist.

In his book (and in staging the exhibition at the Vancouver Art Gallery), Ian Thom traced Hughes' progression step by step. The whole scope of the artist's work was reflected by some one hundred examples, including youthful sketches, woodblocks, etchings, watercolours and paintings from every decade of his professional life. The effect was *awesome*. Everyone from newcomer to long-time aficionado was overcome by the majesty of it all. No one before had grasped the scale of Hughes' oeuvre—the strength of his brush, the variety of his intensity, the strategy of his composition, the subtlety of his colour manipulation, the stylistic identification of his signature, and his catalytic energy to depict an aesthetically captivating British Columbia. What a striking revelation!

In all my euphoria over the mock copy of the book, I completely failed to note the absence of an index. Yes, to some this is of little consequence; indeed, to bypass an index in art books appears standard practice in Canada. Possibly the omission is dictated by financial constraints, although an aesthetic *hauteur* also seems to govern—an index is simply too commercial. Yet to me an index is the spine of the book. It's the *sine qua non* of a reference work. It gives the text historical value. It's the road map for the reader. If I had been only a bit more attentive, a few extra dollars could have been raised to make the book *whole!* Oh well, there will be a next time.

The book finally went to press in early October, under the supervision of Ian Thom and Mark Timmings, the designer. My sole function was to obtain the first proof copy for E.J. Hughes and the second for Pat Salmon. The finished product was *de grande classe*. It is the best art book ever produced in British Columbia and certainly one of the best ever published in Canada. Both Ian Thom and I were anxious to deliver the finished product to E.J. Hughes. The "unveiling" took place at the famous Dog House restaurant in Duncan on a beautiful Saturday afternoon, October 9, 2002. Ian Thom tendered his book to E.J. Hughes, who, immediately seized by its dramatic cover, simply paused and let his fingers trace the embossed title *E.J. Hughes,* again and yet again. He appeared completely taken aback. He was transfixed. A deep sense of contentment seemed to pervade. It was as if the book was the official confirmation of his art and the evidence of its permanence. The imprimatur had been issued: this opus certified Hughes' place among the great Canadian painters. E.J. was subdued, but he was honoured by it all, and justifiably so.

With the distribution of *E.J. Hughes,* the press and hence the public slowly became aware of the existence of the artist and began to look forward to the forthcoming exhibition. The most common reaction was surprise that the artist was not better known. Indeed, why *is* E.J. Hughes' art so little known, particularly in his native province? While recognized in the marketplace, E.J. Hughes was never a *vedette* on the public marquee. As a publicist he was no Andy Warhol. He is and continues to be an introspective man who cares little to publicize himself or his art. It is not that he does not care, but that such activities significantly undermine his artistic pursuits. A few hours' interview, a public attendance will result in three days of anxiety both before and after the event, with a consequential layoff from his easel. This was the rationale for the arrangement with his dealer, Max Stern—Hughes would paint and Stern would take care of promoting and selling the artwork.

Hughes accepted the attendant costs of his entente with Stern, so long as he could be isolated from the demands of the marketplace and the public generally. His art required all of his attention. Anything that impinged on his peace of mind would detract from his creativity. He was a fully committed artist, his sole focus to create works of art. The marketing function was delegated to Dr. Stern. He made the choice and he paid the price. It was a decision worthy of understanding and respect. Unlike others, I have never criticized him for avoiding public intercourse. The cost to him of doing otherwise was too great. It is the painting that matters, not the social cachet of having chitchatted with him for a few moments about whatever. As E.J. Hughes often said, the painting speaks for itself, and so it does.

Another, more substantial reason for Hughes' low profile is the abstract art monomania of the 1960s, which lasted for at least another two decades. During this period representative art was considered passé. Abstract art was now to be the only art form. This was a difficult period for realist artists such as E.J. Hughes. Think of it: after years of study and dedication you are classed all of a sudden as a non-artist—picture maker, living-room decorator. Some artists bought into abstract art—with mixed results. Others, like E.J. Hughes, confident in their art and armed with an acute historical perspective, had the courage and fortitude to carry on. But the marketplace was not so accommodating. The wannabes jumped in with their wallets open and their mind fixated by the media. Harold Town in Toronto and Toni Onley in Vancouver were the preferred choice for the living room. (To the regret of their early admirers, both Peter Aspel and Jack Shadbolt, two highly adroit draftsmen, opted for the non-figurative. Interestingly, their pre-abstract works now often command the higher prices.)

The press, throughout this so-called emancipation, maintained its insatiable campaign to promote non-figurative art, whether good, bad or indifferent. With time, anyone who could hold a brush in his hand was *creating* abstract art. Eventually most of it became less valuable than a Turkish lire—for corroborating evidence, compare old and current auction catalogues. But in the interim Hughes' name and his art suffered. His reputation was at a standstill. He remained, however, the icon to a small group of collectors. Aside from this hamlet of support, the rest of the public remained largely ignorant of his art. Even Jane Young's national E.J. Hughes exhibition in 1983 failed to arouse any serious market interest.

That E.J. Hughes' exclusive dealer was located in Montreal is yet another factor that may explain Hughes' anonymity, particularly in western Canada. Not that he was sought after by the francophone community, or for that matter by the anglophones either. Beginning with the Jewish community, both in Montreal and in New York, Dr. Stern slowly introduced Hughes' work to Toronto, to Calgary and to Edmonton. In Vancouver it was Elizabeth Nichol, of the prestigious Equinox Gallery, who undertook to arrange an exhibition of some extraordinary Hughes paintings in May 1982. Notwithstanding these noble efforts, Hughes and his art remained known and cherished by only a few devoted collectors at least until the late 1990s.

Yet another reason—and a highly delicate one—may explain the public reaction to E.J. Hughes. His sudden overnight celebrity may have generated a certain antipathy, if not covert resentment. The capricious media and the general public wondered: Why had they been neglected? Why had they not heard of him before? Why had they missed the

opportunity to acquire his work? How could he reach the pinnacle of his profession without their knowledge? Why was he not the artist of choice in gossip circles? Why, oh why had he been so isolated from them? Why was he so famous and expensive all of a sudden? The answer—difficult to configure—lies in the interaction between a public misconception of the man and the politically induced myopia of the press.

The fundamental misconception about Hughes—the man—is that he is well-off, as reflected by the price of his work; that he is part of the establishment, as reflected by his prestigious dealer; and that, as a conservative ideologue, he is insensitive to the ideals of the liberal/left constituency. In short, Hughes is thought to be an elitist, selfish and isolated. No wonder the media was less than enthralled with him. The facts about the man suggest an entirely different persona.

Hughes is far from wealthy, particularly in comparison with some of his better known colleagues in British Columbia. He is financially independent, but just barely. Money has never been important to him. His current lifestyle is more akin to that of a poor curate than that of an affluent artist. Yes, he was represented by Canada's leading art dealer—Dr. Stern of the Dominion Gallery in Montreal. But it was Stern who sought out Hughes on Vancouver Island, where he was barely subsisting. The alternative would have been to sell his art himself to meet the same type of fate as Emily Carr. There were no dealers in Vancouver in the early 1950s either interested in or capable of representing him. Montreal could and did afford an efficient market for his work.

As to his personality, there is no doubt he was a bit of a recluse, primarily, as previously indicated, to accommodate the demands of his profession. As anyone who has met him can attest, he is a warm, enchanting, humane and stimulating individual. He is compassionate and charitable beyond his means—both intellectually and financially. But he is conservative in his outlook. A shirt and tie is *de rigueur* at all times. The government is to serve the people rather than vice versa. Discipline in all matters is to be self-imposed. Work for the betterment of society is a function of life. Government subventions, like medical ministrations, should be directed solely to those in need. If having a table reserved for him at the Dog House restaurant is the criteria, then he is certainly part of the Duncan establishment. A right-wing conservative, hardly!

As for the media, Hughes never pandered to it, relying on his art to carry the message. Although he enjoyed an unannounced meeting with the press, he avoided any sort of public relations exercise—that was the dealer's job. The media was fair to him but no more than that. Perhaps his art was not sufficiently revisionist to generate a passionate response, particularly in the 1970s and 1980s. He was too good to ignore, but not plebeian enough to warrant agitating the populace.

In the non-pejorative sense, yes, he was an elitist. He did not believe in arousing the emotions by talking about himself. He did not believe that he was a necessary appendage to his paintings. He did not believe in explaining his paintings. He was not about to vulgarize his work. His art was to stand alone, as it did. He challenged the viewer to

make up his own mind, without outside interference. He persevered confident that the public would in time respond with their heart and mind. So he *is* an elitist, selfish and isolated, but only to create art that will live on as part of our aesthetic patrimony. It is his bequest to the nation.

With the introduction of Ian Thom's book the press suddenly woke up to the fact that Hughes might be Canada's pre-eminent artist who might just eclipse the Group of Seven. Finally some emotion was introduced into their critique. (One commentator opined that Hughes' work had a religious fervour.) The book was a revelation. A few pieces, such as *Indian Church,* had been reproduced often and were well known. But no one had ever seen such an assemblage of his work. The press reacted and E.J. Hughes became for the first time a topic of conversation. Fame, however belatedly, was forthcoming.

In his column in the *Vancouver Sun* of January 23, 2003, Malcolm Parry provided the catalytic spark to arouse the public's interest in the Hughes exhibition that was to be opened on January 29 at the Vancouver Art Gallery. Though advertisements are effective, a brief critique by such a noted social commentator as Malcolm Parry has a special impact among those who are not normally gallery-goers. He converted an aesthetic invitation into a social command. This exhibition had to be seen. His pronouncement was heard and heeded—the people came!

The Vancouver Art Gallery undertook a particularly effective advertising campaign prior to and during the exhibition, which extended to June 5, 2003. Thematically geared to Mark Timmings' rendition of a few of E.J. Hughes' works, the promotional material was as artistic as it was seductive. It was a first-class campaign and, I might add, without precedent. By this time the Vancouver Art Gallery was fully committed—and so was its ubiquitous director, Kathleen Bartels.

The official opening of the E.J. Hughes exhibition was *tout un événement.* It was a majestic affair. Everything came together in perfect unison. It was electrifying—the art, the theme and the setting so masterfully integrated to generate the aura of a momentous event. The audience captured the mood and recognized the importance of the occasion. There was a subdued elegance about the whole thing—a certain spiritual joie de vivre. This was a historic event. It was an artistic experience that would not soon—if ever—be duplicated. Everyone concerned with the production of the exhibition had performed admirably, exploiting their professional talents to the fullest. It was one of those rare occasions where everything goes right.

Kathleen Bartels directed a brilliant and astute campaign to introduce E.J. Hughes' art to the Canadian public. The inimitable Ian Thom was in all senses the major domo of the whole production. His gallery of some one hundred works will remain the definitive Hughes biography. He could not have fulfilled his multifaceted talents any better or for a nobler cause. Mark Timmings encapsulated the art of E.J. Hughes as an effective and seductive facade to tease and seduce the viewer. People came, some 50,000 of them. They saw and the overwhelming majority were conquered by the poignancy of these great works of art. E.J. Hughes' bequest to his fellow Canadians had been authenticated.

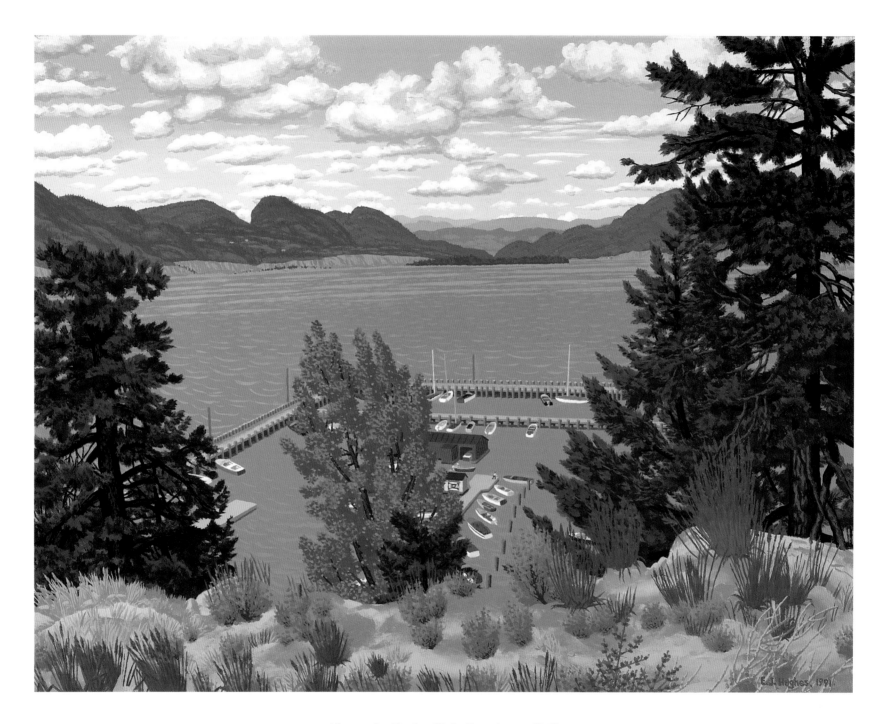

Above the Yacht Club, Penticton, B.C.

1991 acrylic, 63.5 x 81.3 cm

A Thirty-Five-Year Obsession

Et sur mes passions ma raison souveraine. —Francis Henry Taylor, *The Taste of Angels*

With the acquisition of *Painter's Mother* I began to the realize that my journey had come to an end as Hughes' art, so graphically authenticated upon the sale of *Rivers Inlet,* had finally confirmed the artist's pre-eminence in Canada. He now joined the ranks of the great. Though the promotion of Hughes' work was never a predominant motive, the challenge to awaken the community to his art—a principal concern—now seemed a bit redundant. The public had been converted, and it was an auspicious time to conclude the tale.

How fortunate I am to have been seized by the art of E.J. Hughes. More than three decades of enjoyable pursuit and a finale worthy of Wagner. Yes, I have been passionate about the artist, but then so was Lawren Harris. How often does a collector witness the evolution of the unknown West Coast artist to the status of a national *grand maître?* How often in one lifetime does one witness the value of an artist's work rise to that of an international masterpiece? More to the point, how often does an artist witness such public acclaim during his lifetime?

The November 2004 sale of *Fishboats, Rivers Inlet* confirmed the standard of the art and the status of the artist. The name of E.J. Hughes is now recorded on the scrolls of Canada's national identity—his art is validated and his talent authenticated. Yet for all this, the resonance of Hughes' art is far from over. The art of E.J. Hughes will become the international template of Canadian culture. The day will come when Hughes is acclaimed beyond Canada's borders, with Berlin, St. Petersburg and London particularly coming to mind. He is a national treasure, his art to behold for posterity. That is Hughes' bequest to the world.

As to the good Dr. Stern, his place is secured in history as the sponsor of Hughes' work, and Pat Salmon as his loyal confidante for the past twenty-five years.

Why did I become so involved, if not obsessed with the art of E.J. Hughes? I say obsessed since I seem to be compelled to acquire his work. It is as if I had a predestined mission to assemble the collection and repatriate Hughes' artwork to British Columbia. While I flirted with other artists, none has ever neutralized this pervasive obsession. The question as to why I became so obsessed, however, is far from easy to answer. It would be too simplistic merely to answer: "I bought what I liked." In effect, this answer merely begs the questions: "Why Hughes? Why the collection?" An honest answer to each of these questions requires a certain degree of mental introspection. Although this is not an easy task, a little reflection on my part reveals a plausible rationale for my infatuation.

The fact I preferred the Ingres to the Monet exhibition in London a few years ago is indicative of the type of art that "registers" with me, at least at this stage of my life. Clearly, I have become an avowed *académicien* in my taste. Whether this attitude applied some thirty-five years ago when I started to collect "Hugheses" is debatable. Certainly in the late '60s and throughout the '70s I was attracted to some of the popular abstract painters. Abstract art was very much the "in thing" if not the "only game in town." Psychedelic gurus preached the message and the public, aided and abetted by a compliant press, bought the thesis: abstract art was now the only true art form.

Yet, except for my experiment with John Koerner, I was never really converted to this new ideology. While I found some abstract art instantly seductive, the message seemed to "peter out" too quickly after the initial impact: instant gratification, perhaps, but never long-term satisfaction. The typical abstract painting is all too much like a *coup de foudre*—a big bang but little sustained resonance. As a result, I remained during this period more attracted to Kurelek than to any of the abstract painters in Toronto. As for an actual commitment, Henri Masson, as previously mentioned, seemed to meet my basic requirements both financially and intellectually. So in my formative years, while attracted to abstract art, I was actually more committed to representational work.

Now then, why Hughes?

The artist of genius is the one who expresses the soul of his country, and creates a masterpiece when he catches and isolates the very minute. —Rene Gimpel, *Diary of an Art Dealer*

Well, to put it simply, Hughes' art captivates my senses and satisfies my intellect. He synthesizes my interests in art: a continuing message, an aesthetic interpretation of a favourite subject—my adopted province—and a distinctive drafting and compositional structure to provide a solid cerebral context. Dr. Stern was indeed justified when he declared E.J. Hughes to be one of Canada's pre-eminent artists. Without a doubt, the subject matter of Hughes' works has always been of fundamental importance to me. Of equal importance is the discipline of his drafting and resulting composition. Finally, it is the style and mood that he engenders in his art that I find most compelling.

To say that E.J. Hughes is a British Columbia artist is axiomatic. Hughes' art *is* British Columbia. The raw strength of his coastal scenes, the silent majesty of his ferries, the vigorous representations of the fishing and forest industries, and the tender rendering of his inland scenes provide a virtual encyclopedia of this magnificent province.

It is interesting to speculate whether Hughes would have been as attractive to me had he adopted a province other than British Columbia as the primary subject of his paintings. I doubt it, since it is the unique local landscape that ignites his aesthetic creativity.

Hughes captivates the essential character—the heart and soul—of the province of British Columbia. If one is truly addicted to the natural attributes of this province, it is an easy intellectual step to becoming "hooked" on the art of E.J. Hughes—as I so fervently became.

The ability to repatriate Hughes' art to British Columbia has also given me a great deal of satisfaction. Moreover, my initial judgment of and early commitment to this artist seem to have been vindicated by Hughes' ever-increasing popularity. Here I was greatly influenced by those in Vancouver who constantly bemoan having failed to acquire an Emily Carr when they were readily available at a modest price. These *ex post facto* recriminations served me well. I was determined, at almost any cost, to avoid this all too common pitfall.

E.J. Hughes' professional discipline in his drafting and composition is yet another attractive trait. He is not the modern artist who can whip up a painting before lunch. His art is meticulous, precise and studied, as is particularly evidenced by his cartoons. If he lacks fluidity of movement in his brush stroke, he does so to achieve the element of serenity that has become his trademark. He is able to capture the "moment" in still life, to compel appreciation of his work.

As to Hughes' style, it is, in a non-pejorative sense, basically bourgeois, at least at first glance. As Hughes will readily acknowledge, his objective is to create "things of beauty" with "beauty" defined according to G.E. Moore, the Bloomsbury (clan) guru. Still, in many of his works an aura of mysticism appears to filter through his composition. The message is often masked by the obvious appeal of the subject matter. On reflection, a more subdued "missive" is being imparted. In the same painting, Hughes can stimulate the emotion as well as the intellect. Thus, he satisfies the demands of the market without jeopardizing his aesthetic objective. A perfect example of this Machiavellian strategy is to be found in *Steamer in Grenville Channel*. It is only after some quiet contemplation that the full impact of the painting can be discerned. While highly seductive at first glance, the message becomes more complex upon leisurely reflection. At this stage one can perceive a sense of isolation, mysticism and even the macabre. Is this the last voyage?

Particularly in his earlier paintings, Hughes creates both an overt and a rather more covert mood. The obvious aim is to please the senses. But upon further consideration they challenge the imagination and hence the intellect. That is a quality that should be found in any work of art. In Hughes' case, the style attracts the senses while the mood challenges the mind: a perfect merger!

Finally, I could not end this brief summary of the possible reasons for my obsession with the art of E.J. Hughes without mentioning its effect on my daily life. Obviously I cherish every "Hughes." But it is the ensemble of these works on our walls that is noteworthy. While each work has a particular appeal, the ensemble is simply mesmerizing. The Hugheses virtually light up our home. On cold, wet and dark November days, for instance, they effectively counteract the winter melancholy that we know so well on the West Coast. They provide an alternative ambience to that of

the typical cloudy and wet Vancouver winter day. It is at this time of the year one can truly appreciate the sometimes cheerful and always invigorating art of E.J. Hughes.

In this process of self-analysis, there remains the question of why an attempt was made to acquire a representative example of Hughes' work over his seventy-year career. Each decade and every type of media is represented. Here the rationale was somewhat more convoluted. Initially, the aim was simply to acquire whatever was available on the market. Following the publication of Jane Young's 1983 exhibition catalogue, however, I gradually became more and more fascinated with Hughes' artistic road map. With time, my obsession took on a historical perspective. As a result, my initial objective had to be readjusted.

With much patience and study, I implemented a campaign to assemble a complete biographical record of Hughes' artistic production. The establishment of a genealogical link from the old to the new was a captivating, if at times frustrating, exercise that has been only partially accomplished. The experience did, however, expand my appreciation of this unique artist. The art helped me to understand the man and similarly the man helped me understand the art. Thus, the collection is a virtual biography of E.J. Hughes. Every piece is cherished and admired as it fits into the overall composition of his creative life. It has been a truly worthwhile pastime and even a greater challenge, which I have found most rewarding.

Although I attempted to explain why I collected Hughes' work, I have yet to explain why I collected art in the first place. A good question—why *did* I collect paintings? This issue has preoccupied me for some time now. It is not an easy question to answer. It requires a psychological evaluation of the causal connection—the *vera causa*. Let's start with what did not contribute to my obsession—professionally diagnosed as a passion. Firstly, I was not born into a family of art collectors. Neither my parents, grandparent nor siblings were "into" visual art. Decorative acquisition, yes, but no enthusiasm to collect art for art's sake. Nor was I educated in high school or university to understand or appreciate works of art. If there is an answer as to why I collected art, it may lie in my early environment in Montreal and my subsequent attachment to the west coast of British Columbia. The passion only developed in my late forties when I collided with the art of E.J. Hughes.

In the first edition, I refer to a flowery watercolour by Paige Peneo that graced the living room in our flat on Sherbrooke Street in Montreal. What I omitted to mention was the presence of an etching of Fragonard's *Baiser à la dérobée (The Stolen Kiss)* that hung on the opposite wall—on one wall a vibrant 1943 watercolour, on the other, the elegant neo-classic eighteenth-century coloured etching of the oil painting in the Hermitage. These two works found themselves facing each other across our twelve-foot-wide living room overlooking a dreary backyard lane. The impact upon me was significant. They converted what otherwise would have been a small and drab room into a cheerful (the peonies) and elegant (*Le Baiser*) petit salon. Without this aesthetic add-on I would have spent my precious sojourns from boarding school in a depressing pit.

The contrast was the message. Although I never specifically identified the Fragonard and the Peneo, I was acutely sensitive to the euphoric atmosphere they created, in contrast to the desolate brick and concrete *paysage* outside our window. Was it an epiphany? No. At twelve I did not know anything about art, but I "felt" that these works on the wall livened up the living room. They created an aura. They changed the atmosphere from the gloomy to the cheerful—from the dreary to the chic. I did not understand the art but I recognized its impact. It planted a seed—a gene—in me that would re-emerge later in my life.

If my early brick and mortar milieu was the embryo, it was the coastal beauty of British Columbia that aroused and fostered my sense of the aesthetic. How else can anyone react to the magnificence of this scenery? By the early 1960s the psychological imprint had crystallized—paintings had become an essential accoutrement of my life. Later, acquiring a Hughes, particularly at the Dominion Gallery, became an exercise in self-gratification. The art gallery was a virtual safe haven from the vicissitudes of my professional life. Here I was completely insulated from the charivari of my day-to-day world. I could focus on a painting to be admired or to be bought in complete isolation. In popular parlance, it was a mental escape—the aesthetic world was the opiate of choice. Buying a Hughes was psychologically uplifting. After long and exhausting negotiations with the tax department, what better reward than to acquire a painting to acknowledge a successful resolution of the problem? I enjoyed and valued the whole experience. It was forever enjoyable and sporadically addictive.

Does this answer why I collect paintings? I hope so, for it has taken me months of reflection to figure it out. The shortcoming of this plausible thesis is that it fails to explain why I continued to acquire paintings when all the walls were covered. That's all E.J. Hughes' fault! I became intellectually enamoured with his interpretation of the beauty of British Columbia. Each new work introduced a new variation of a well-modulated theme. How does one explain passion? You either have it or you don't. Obviously I have it—at least in matters of art.

Whatever success I have reached in attaining my goal is in no small part due to the support that Margaret gave me throughout my thirty-five-year campaign. Many a time she would have preferred a new kitchen or a new car rather than yet another Hughes. She never complained about these domestic privations and always welcomed the new addition. Thanks to her support I was able to carry out my mission.

A final note of deeply felt appreciation is due to E.J. Hughes and his art. Together they have made my life richer and, in the overall scheme of things, perhaps a bit more worthwhile than it otherwise would have been.

To you, my children and grandchildren, my only hope is that you will obtain the same satisfaction and fulfillment as I experienced in my journey with E.J. Hughes.

The phenomenon of art collecting is too instinctive and common to be dismissed as mere fashion or desire for fame. It is a complex and irrepressible expression of the inner individual.
—Francis Henry Taylor, *The Taste of Angels*

The Beach at Savary Island

1998 watercolour, 50.8 x 61 cm

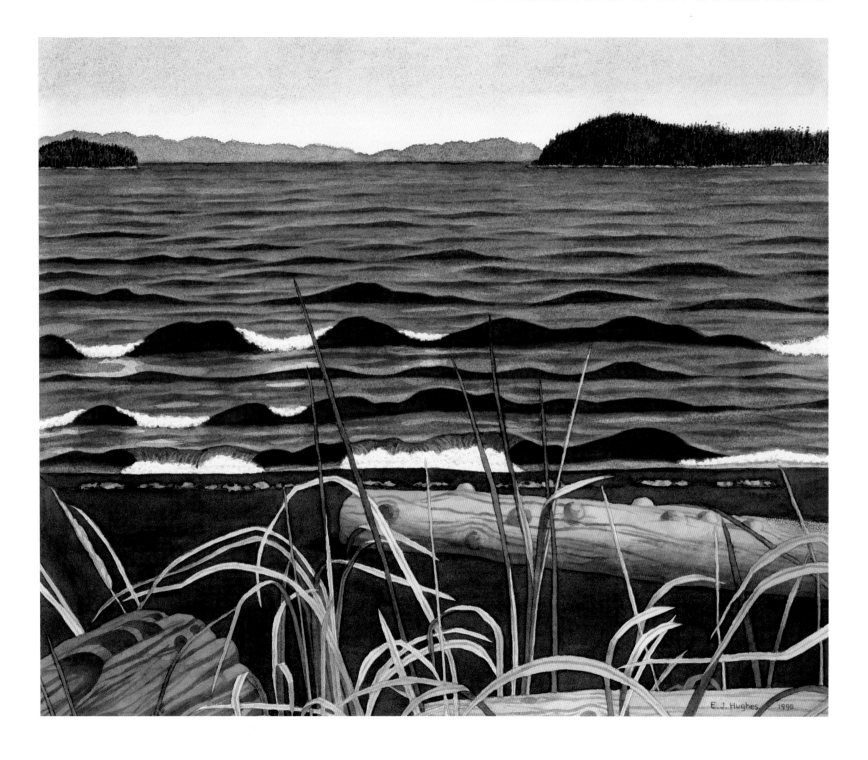

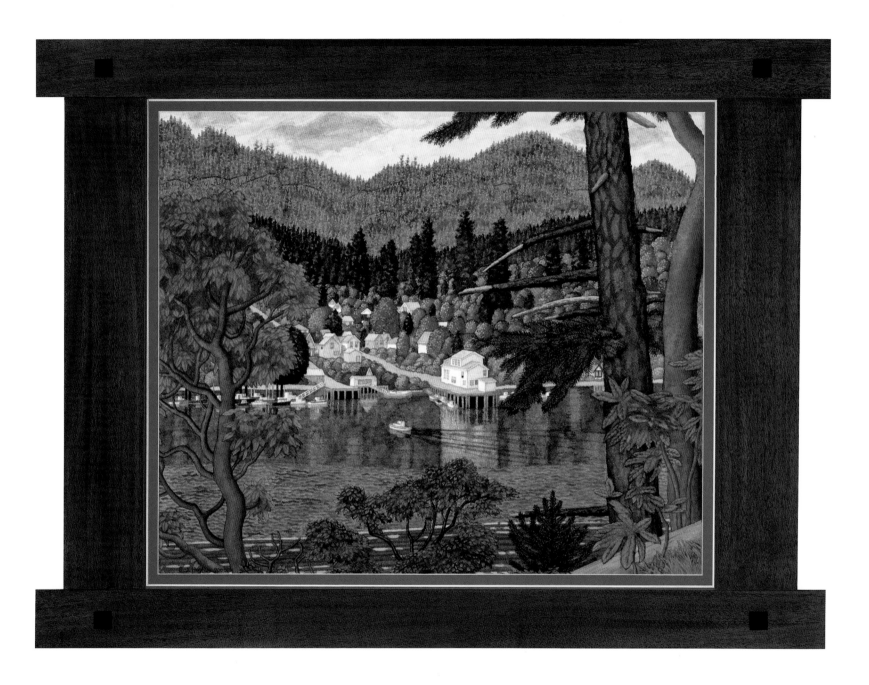

Wharves at Chemainus, 2000

Reframed 2002

On Framing Art

Works of art give rise to narratives of various kinds that are shaped by conditions of presentation and reception. —Nancy J. Troy, *Van Gogh to Mondrian*

Since I began to collect artworks some forty years ago, I have remained generally frustrated with the types of frames found on paintings and watercolours. Seldom did a frame enhance the aesthetic quality of the art. Often it detracted from it. Of all the Hugheses I acquired, only one painting was artistically framed. The rest were mostly *encadré* in some faked gold moulding devoid of any redeeming quality except price. The parsimonious Dr. Stern never did extend his aesthetic sensitivity beyond the painting itself. The frame was inconsequential, other than to keep the canvas secured. It would have been better practice to leave the artwork unadorned. But the spirit of the times dictated otherwise.

If an original frame is so odious, why not reframe the artwork? Today that is easier said then done. Framing is now a "butt and paste" craft. You choose the preferred moulding from a more or less standard inventory, and the framer "butts" it (cuts it) and "pastes" it (either with glue or a staple) to provide the "handcrafted product." As two or three conglomerates control the manufacture of the moulding, the consumer is restricted by the moulding industry standards, which in turn are dictated by what can be mass-produced to be sold at the highest profit margins. Frames are now like men's suits—a variety within a given style. Individuality is not the object; price and convenience govern. The artisan frame maker on Main Street has disappeared. A few more conspicuous establishments remain in places such as New York and London, with a pricing structure in accord with the pretensions of each. Yet if you look closely enough you find an atypical custom frame maker in most large cities in North America. With time and a bit of patience even I discovered two highly skilled artisans, Scott Browning and Brian Dedora, operating in Vancouver as carvers, gilders and picture frame makers—belatedly, but not altogether too late!

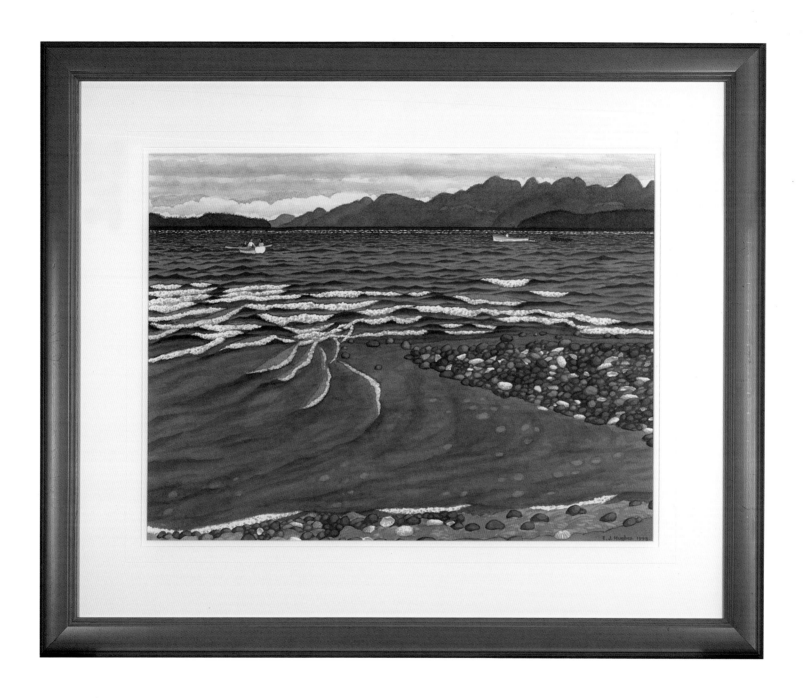

Qualicum Beach

Original frame 1998

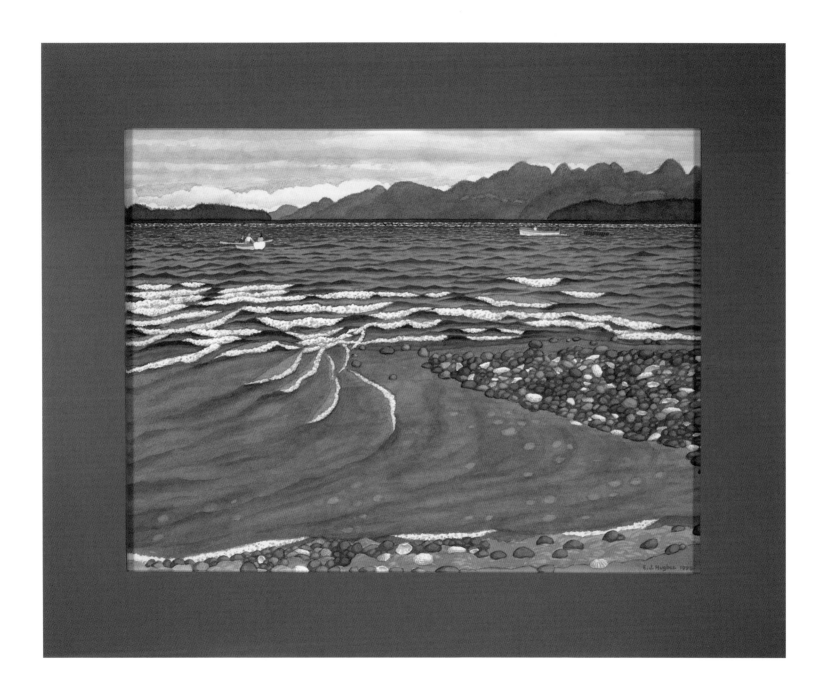

Qualicum Beach

Reframed 2003

Painter's Mother
Original frame 1951

Feeling a bit more confident after the earlier framing attempts, I opted for a more dramatic design to embellish *The Koksilah River*. We needed something startling to project the atmosphere of the painting—something that would accentuate the tranquility of the pastoral scene. The frame was to be the attention-getter. We hoped it would suitably enhance the painting's subtleness. Ours was a dual-purpose strategy—first attract, then seduce. The dark, verging on black tree trunk seemed to provide the cue for the frame. A four-inch-wide ebony shadow box frame appeared likely to achieve our objectives, though we were far from confident that it would.

Ebony being difficult to obtain, unstable over time and never uniformly black in colour, we opted to "ebonize" the frame with a black lacquer. Wow! The experiment proved highly successful. The painting seemed to surge out of its frame. We had achieved our goal; the painting was revitalized by the frame. The message, though ephemerally subtle, was nonetheless resplendent. The ensemble now commanded attention and, yes, admiration—the painting was no longer fit only for the storage room. The frame and the painting were now integrated as a complete unit. The frame, like the symphony director, sets the tone for the message—each subservient in his respective role, but vital together for the proper expression of the artist's work. Our little experiment aptly confirmed that the frame is an adjunct of the painting deserving respect as a true art form. We were proud of the outcome. (For those more commercially oriented, the new frame more than quadrupled the value of the painting!)

Our next challenge was to recontour the charming *Store at Allison Harbour II*. Its run-of-the mill Dominion Gallery frame stifled the effervescence of that painting, but the problem was much easier to diagnose than to remedy. After evaluating a number of alternatives we gambled that a wide shadow box frame in the same green tonality of the painting would do the trick. Available ready-mix lacquer simply did not match the green tones of the painting. Lucky for us, the talented and much experienced Vijay of Mohawk Paints appeared on the scene to custom mix a lacquer that matched perfectly the green tincture of the fir trees in the painting's background. This was the catalyst. The finished product was spectacular. It was as if we had produced a different painting than that served in the old musty

frame, a transformation noted by more than one friend and family member. The impact of *The Store at Allison Harbour* was greatly enhanced—its message more intense and overpowering. The work dominated the entrance hallway, and the viewer was now fully seized by the painting's endearing composition. Oh, for the proper frame!

Now that the team was in place, we began to experiment on how to redefine the borderless watercolour frame. In our first attempt, the watercolour sat at the edge of the frame next to the glass plate. This arrangement seemed to confine the artwork, though in that case it suited the inward perspective of the subject matter, *Trees, Sooke Harbour.* Now we required a frame that would amplify rather than constrain the essence of the watercolour.

The objective was to enhance the work by concentrating its impact. The frame was to be less invasive and more submissive to the painting. A shadow box frame—where the painting is recessed about an inch or so from the glass pane—appeared to meet our objectives. The effect of the encasement in the "box" is akin to looking at the outdoors from an indoor window. In each case the subject matter is accentuated by the confining viewpoint. It gives the painting a third dimension. Not an original idea but one I found effective on a Borduas

Painter's Mother
Reframed 2004

watercolour frame at the 2004 Heffel spring auction. So we decided to adopt this method to frame *The Car Ferry at Sidney, B.C.* (page 120) and *Trees, Savary Island* (page 85). At the last minute, having been completely frustrated with its original 1950s frame, I included *Ottawa River* (page 104) in the package, though it might have better qualified for the inward perspective effect of our initial mahogany format.

The experiment proved highly successful. The aesthetic quality of *Ottawa River* was revealed—perhaps for the first time. The blue lacquer frame with a tonality matching the paler colour of the river channel had a liberating effect on the subject matter. The Ottawa River scene appeared to float, unrestricted by a breach in colour tone between the frame and the watercolour. At last the frame and the painting were in sync. With *The Car Ferry at Sidney* and *Trees, Savary Island,* the effect of the box frame was surprisingly different. Rather than liberate, it confined the message to accentuate its impact on the viewer. The intended objective was met. The off-white frame for the Sidney scene was a

bit of a gamble, but it succeeded in producing the desired "in your face" contact with the painting. For *Trees, Savary Island,* the grey-toned box frame achieved the same result, though a bit more gently.

What else could we do now but reframe three other watercolours that I had originally enclosed in those drab "butt and paste" frames—yes, me, not the Dominion Gallery—just to prove my fallibility? A picture being worth a thousand words, the two versions must be compared to appreciate the conversion (see pages 146 and 147).

My next project involved a new challenge. How to frame the oil *Painter's Mother* (1939–51)? Having experimented till now guided only by intuition, I thought it wise to do a bit of research on the "art of the frame" in accordance with my practice of reading the guides after having visited the site. Books depicting frames—both new and old, books on how to construct the frame, books on gilding, books on the historical development of frames and books on how to hang frames were all part of my educational menu.

Apart from the frame making techniques, I did not learn much that I could use, but it made me more confident in my search to find *the* right frame for each painting. History provided precedents but no governing format to suit each and every painting in this day and age. That issue remained the same. You had to *figure out* the right design that would synchronize the frame with the painting. It was an intellectual exercise. First, define the objective, then plan how best to achieve it within the means available to you, both financially and technically.

Although tempted, I discarded the highly intricate Stanford White type of sculpted gilded frame as a guide and opted for a more pedestrian and somewhat more intimate approach. A design in Jacob Simon's widely respected opus *The Art of the Picture Frame* provided a sympathetic frame motif for *Painter's Mother.* It suggested a four-inch rosewood bolection moulding to project the painting outwards. The natural rust inner tone of the rosewood would mesh with the tonality of the background of the portrait, while the darker outer tone would match Mrs. Hughes' commanding black frock. How then to implement the objective? This was not an insignificant commission.

More by accident than by foresight, I was introduced to Scott Browning, a highly talented professional, who seemed equal to the task and enchanted by the challenge. And so we proceeded to fashion an appropriate strategy to achieve our goal. We agreed at the outset that Simon's pro forma National Portrait Gallery bolection frame suited *Painter's Mother.* Alas, no suitable rosewood planking was available. And even if available, it would not likely generate the reddish hue that we desired. In fact the National Portrait Gallery had adopted a simulated rosewood format. A bit disappointed, we considered a number of different wood frames only to conclude that the London gallery's model did indeed best suit the painting. Instead of the unavailable rosewood, Scott suggested we opt for a Honduras mahogany that could be manipulated to create the desired tonality. And so it was! Did we achieve our goal? See for yourself.

All in all my excursion in designing frames has been most rewarding. It clearly made me more sensitive to the role and function of a frame around a painting. I was gratified in my attempt to enhance the art of the painting by matching it with the right frame. While I was less successful in some cases, generally the new design much improved the

resonance of the artwork. As an add-on, I was instrumental in convincing the frame makers to inscribe their name on the back of the frame—hopefully the practice will continue. My only disappointment is that I can neither draw nor construct a picture frame, but then even if I could, being the *maladroit* that I am, the product would still be amateurish at best. Better to let the artisan fulfill his calling.

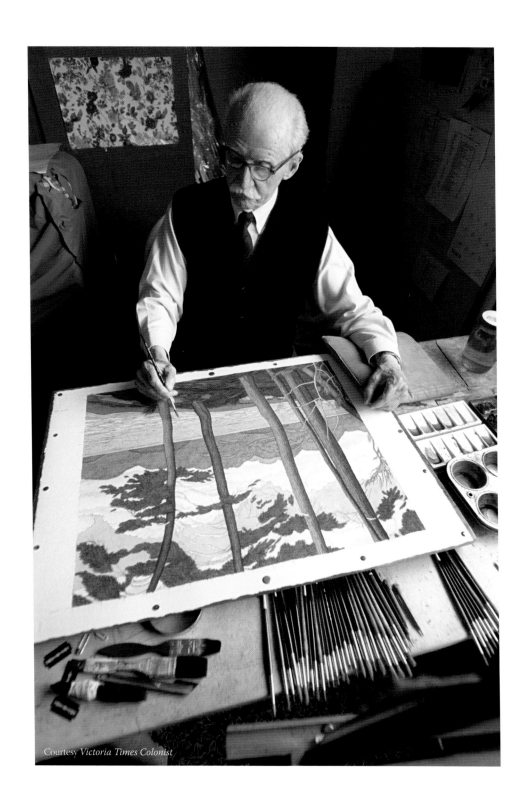

E.J. Hughes
With watercolour *Trees, Savary Island,* 2004

On Buying Paintings

*It is a consoling fact that as a rule, it is only those who buy out of love
who end up making a profit.* —Paul Johnson, *Art: A New History*

There are three types of art buyers; the living-room decorator, the social wannabe and the dedicated collector. A specific buying protocol applies to each them.

All buyers should recognize that buying a painting is not the equivalent of making an investment, since most paintings generally depreciate rather than appreciate in value—a fact not widely disseminated in the art world.

The living-room decorator buys paintings to enhance the atmosphere of the home. It's a periodic experience to accommodate changes in financial and residential status. It's a noble occupation that can be highly rewarding aesthetically if not equally so financially. How then to proceed? First, recognize that what you like at thirty may not be what you will like at fifty—your taste may develop with time. A preference for a sweet white wine at twenty may be substituted for a rich dry red at forty. So don't bet the family farm on your first acquisition, but do buy what you like.

The best place to buy a "decorative" painting is at auction, whether live or on the Internet. In fact this is an efficient forum for all collectors, a vastly superior alternative to impulse buying while strolling Madison Avenue in New York. Though not as emotionally satisfying as gallery shopping, the on-line auction provides a safe haven for the neophyte. The auction market may not be perfect, but it provides multifarious choices at reasonable prices without bias or

To the art establishment Grampp's thesis appears somewhat audacious and provocative. It suggests that marketplace criteria are irrelevant in assessing the integrity of the arts. Perhaps, but to assess periodically the value and merit of the art business on an economic basis is a worthy and purifying engagement. With conflicting sociological demands for public and private funding, even a subjective cost-benefit analysis is useful in setting priorities in the community. To the student collector, Grampp's survey explains the rudiments of the game. It provides a valuable—if not indispensable—background to anyone who is serious about collecting paintings.

The collector is always concerned, albeit in varying degrees, as to how future generations will judge his collection. Although art does become obsolescent as contended by Grampp, not all paintings become worthless. Indeed, as with the Pre-Raphaelites, long-forgotten artists may be subject to a revival exceeding their initial popularity. Even Rosa Bonheur's art is being rejuvenated. Were it not for Wildenstien, where would Fragonard and Watteau be today? Others, such as Seanredam, were only discovered after centuries of oblivion. What is popular today may not be so tomorrow, and to a lesser extent, what is not popular today may be so in the future. To the collector, a historical perspective is a valuable asset.

When a collector acquires a painting, he is normally motivated by his emotion and his judgment. Gerald Reitlinger's insightful study enhances a collector's ability to assess a painting in its historical context as to both its aesthetic and its market value. How many of us have been drawn by the startling originality of a painting only to find out later that it was a stroke-by-stroke imitation of some well-known artist? If, as suggested by Grampp, taste is the equivalent to value in any given market at any given time, then Reitlinger's study provides an empirical analysis of what has happened to taste over the years.

In *The Economics of Taste*, Volume 1, *The Rise and Fall of Picture Prices, 1760–1960*, Reitlinger not only evaluates the trends and tastes of the art world during the two-hundred-year period, but performs a tour de force by compiling the sales records of several hundred of the world's best-known painters over the period—a task never before undertaken. This is a historical road map with a highly practical perspective. Thanks to Christopher Wood, the record has been updated in his highly readable study, *The Great Art Boom, 1970–1997*.

While the past does not govern the future, historical events can be extrapolated to provide current guidelines. Wars, depressions and inflation each have consequences that tend to be duplicated. Similarly, tastes change and sometimes reverse themselves. Old Masters have been abandoned only to return to favour in a different age. To the chartist, Reitlinger even suggests an eighty-year cycle from recognition to acclaim to oblivion and then yet again—from grandfather to grandfather. Today, can the Reitlinger and Wood studies provide a basis to assess the future of abstract expressionism, which appears to have lost some of its appeal? Is this decline in popularity simply a matter of market adjustment or is abstract art to be replaced by photo conceptualism?

Reitlinger's eighty-year-cycle theory is aptly supported by the price history of Rosa Bonheur's paintings—that highly rewarded lady with the cow fetish. The price of her paintings rose from £1,417 in 1860 (in excess of $100,000 in today's dollars) to £12,000 at her peak of popularity in 1886, only to fall to £110 in 1940. Christopher Wood picks up the study in *The Great Art Boom,* to document the reincarnation of this amazing lady. By 1975, one of her paintings—*Cavaliers in a Shower*—fetched £11,390, followed in 1976 by another sale at £35,310. By 1996, the price of another painting—*Royal Tiger*—had reached £81,250. The end of the cycle was in sight.

The same story can be told about the Pre-Raphaelites. By 1860, a William Holman Hunt painting sold for £5,775; in 1874 another, *The Shadow of Death,* sold for a record £11,000. By the 1940s his paintings were selling for a few hundred pounds. But William Holman, like the other Pre-Raphaelites, was to be reincarnated. According to Christopher Wood the revival began in 1973 when one of his paintings—*Rienzi Vowing to Obtain Justice*—fetched £48,000. By 1995 he had fully recovered his former glory when his *Morning Prayer* sold for £260,000. What a recovery!

Here a word of caution: it's not every eighty-year-old painting that will again become fashionable. In each example the painting was well accepted and valued in the first place. The artist was well established and, particularly in the case of Rosa Bonheur, was well represented by her dealer, the imperious Ernest Gambart. The revival only begs the question of what made the artwork valuable in the first place. That issue is the conundrum of every dealer and collector. Peer recognition is perhaps the foremost attribute of the successful painter—the few exceptions prove the rule. Without denigrating other requirements, the function of a competent dealer cannot be overemphasized. Though a talented artist may succeed on his own, the chances of doing so are limited, to say the least. The days when the Académie recognized and promoted the gifted painter are gone. Now the dealer is the arbiter of talent and the judge of the marketplace.

That an artist is well respected and admired by his peers will not fail to be noticed by the dealer. The greater the admiration, the more competition will arise among dealers to represent him. Picasso's is a case in point. As a corollary, the prices of an artist's paintings will parallel his fame first among his fellow artists, then among critics and finally among collectors. At each level the price of his paintings will appear expensive. That's what separates the neophytes from the professional collector. "Good art" has never been cheap, particularly vis-à-vis the imitator or the second-class artist. The dedicated collector knows that one good painting is worth much more than a second-rate one, and he is willing to pay the premium for it. This is not a numbers game, but a pursuit of quality. For quality is the basis upon which "value" is maintained and the essential factor to generate a revival in popularity should the artist fall into disfavour temporarily, say for eighty years or so.

So much for the economics of the art market. What about actually buying a painting? Where does the dealer fit in? The first thing to remember is that the dealer is in the business of selling paintings from his inventory. He is not

an unbiased consultant or an independent referral resource. He wants you to buy what he has on hand. That being established, a competent dealer can be most helpful in building a collection, particularly where he is the exclusive agent for the painter of choice. When dealing with a reputable dealer, the proverbial issue is whether you should attempt to bargain with him and, if so, to what extent. Negotiating with a dealer has been vulgarized as an acceptable practice. The dealer, being a professional, is fully aware of this phenomenon and acts accordingly. First there is a rather secretive official price—the tag price—and then a two-price structure comes into play. The tag price sets the goal posts. To the dedicated collector it sets a base and to the uninitiated the selling price.

For reasons that will become obvious, the dealer is reluctant to disclose the tag price unless he is asked or is required by law to do so, as in the state of New York. In the art world, pricing is always a shield and sometimes a sword. Now to the two-price protocol. One is to accommodate the obsessive haggler and the other to serve the valued client. If you are known as a constant haggler, the dealer will "adjust" his first quote to allow the client to achieve the required discount. If the collector normally demands a 25 percent discount, the "price" will be first adjusted upwards to allow for the necessary reduction—leaving both the dealer and the client happy. *Quelle finesse!*

For the valued non-haggling collector, the dealer will normally begin with a realistic price that he will reduce by the normal 10 to 15 percent to establish the final price. Yes, the haggler, proud of his bargaining prowess, will normally pay more than the price demanded from the valued client—not much more, but more. By far the best strategy if the price appears too high is to simply tell the dealer that you will think about it. In time this approach will indicate to the dealer that you consider the price to be inappropriate for a loyal patron. You will avoid appearing unreasonable and sidestep pernicious negotiations.

A good relation with a dealer is paramount if you are attending a *vernissage* of an up-and-coming or a highly popular artist. On these occasions, for reasons that are entirely capricious, the paintings are sold by the inch. All 20 x 30s are marked at the same price, though the quality of each will vary significantly. An entrée with the dealer may allow you to acquire the best of the collection. Obviously the dealer will prefer the genial buyer to the perpetual haggler. The preferred-client status has both aesthetic and financial advantages. The better painting is acquired, and at a price that may be substantially lower than that of its counterpart in the collection. Artists themselves will admit that their paintings vary in quality. Some are average, others are good and a very few may be superb, yet they are all offered at the same price. The normal rule of thumb, evidence at auction, suggests that a great painting should command four times the price of an average painting from the same artist. On that basis, having the choice of buying a superb painting at the same price of an average one is truly a good buy for the wise collector. Sensitivity and good manners are always rewarded!

Buying a painting directly from the artist is a stimulating experience—not always satisfactory but usually enlightening. All artists, whether "tied" to a dealer or not, have a vicarious desire to sell directly to the collector. Being intro-

duced helps, but a cold call will do. Meeting the artist will amplify the quality of the work, but it may also detract from your vision of the typical aesthete artist—beware of what you wish for . . . Generally, the rendezvous will be enjoyable and beneficial. It may help you to better understand the artist's message. The creative persona is a relevant hinge to his painting. Any serious collector will attempt to match the artist with the painting whenever possible. As to price, do not expect any bargain. Professional integrity is at play, to bolster the artist's pride that he can do as well, if not better, than a dealer.

Finally a word, or should I say a caveat, about *giclée*—that fascinating French reproduction process. This ability to reproduce original works of art—paintings or watercolours—may have revolutionized the art market. Beginning with a true digital photograph, a painting can be reproduced on canvas or on paper within thirty minutes—and from ten feet away be indistinguishable from the original. The ink-jet process is a digital wonder. Inexpensive and quick, it will allow the public to surround itself with an art form that is as expressive as its original counterpart. Yet some aesthetes consider the whole process repulsive, regarding the copy pejoratively as a "fake." They ignore that copy-making was a noble art in Europe in the 1700s—better a copy of a great painting than the original of a poor one! Indeed, even the great Cardinal Richelieu lived with a copy of Poussin's *Destruction of the Temple at Jerusalem* in the Palais Cardinal. The skeptics are of the same ilk that find Balthus vulgar, Madonna without talent, Céline Dion trashy and Glenn Gould too bombastic. Finally, if the archival longevity of an ink-jet print is limited, which has yet to be proven, so be it; after fifty years another copy can be acquired for a few dollars. As to keeping the *giclée* print away from direct sunlight, that safeguard applies equally to the original source. As to the future impact of this art form, canvass the Web to appreciate how far this process has been adopted by the artist. This is the "cyborg" culture.

All in all buying art, like any other endeavour, requires know-how and focus. It's a stimulating pastime because, unlike others, it combines the aesthetic with the mercantile, a perfect intellectual sandwich.

Remember, a house without art is like an army barrack—functional but soulless.

List of Works ❦ *Biographical Overview* ❦ *References* ❦ *Index*

33 *Rivers Inlet*
1953 oil on canvas
19 x 23 inches / 48.26 x 58.4 cm

34 *Kelly Logging Co., Cumshewa Inlet, Q.C.I.*
1953 pencil
8¾ x 12 inches / 22.23 x 30.5 cm

35 *Unloading Logs, Comox Harbour*
1953 oil on canvas
20 x 26 inches / 50.8 x 66.04 cm

36 *Allison Harbour*
1955 graphite cartoon
15 x 19¼ inches / 38.1 x 48.9 cm

37 *Wharves at Ladysmith, B.C.*
1955 graphite cartoon
15¼ x 18¾ inches / 38.7 x 47.62 cm

38 *Looking North from Qualicum Beach*
1955 oil on canvas
18 x 24 inches / 45.7 x 61 cm

39 *Eagle Pass at Revelstoke—Study*
1958 pencil
12 x 8½ inches / 30.5 x 21.59 cm

40 *West Coast of Vancouver Island*
1958 pencil
9 x 11½ inches / 22.86 x 29.21 cm

41 *Museum Ship, Penticton, B.C.*
1959 graphite cartoon
18 x 21 inches / 45.7 x 53.34 cm

42 *Eagle Pass at Revelstoke*
1961 graphite cartoon
18½ x 23½ inches / 46.99 x 59.69 cm

43 *Old Baldy Mountain, Shawnigan Lake*
1961 oil on canvas
24 x 36 inches / 61 x 91.44 cm

44 *Looking South over Shawnigan Lake*
1962 watercolour
8½ x 10½ inches / 21.59 x 26.67 cm

45 *Overlooking Finlayson Arm*
1963 pencil
10¾ x 13½ inches /27.3 x 34.3 cm

46 *Takakkaw Falls*
1963 pencil
12 x 9 inches / 30.5 x 22.86 cm

47 *Maple Bay*
1963 watercolour
18⅞ x 23½ inches / 48 x 50.8 cm

48 *Farm near Cobble Hill, B.C.*
1965 oil on canvas
25 x 31⅞ inches / 63.5 x 81 cm

49 *Mount Rocher de Boule near Hazelton*
1968 watercolour
18 x 24 inches / 45.72 x 61 cm

50 *Entrance to West Arm (Shawnigan Lake)*
1968 watercolour
15 x 18 inches / 38.1 x 45.72 cm

51 *Boathouses on the Beach, Ladysmith*
1969 oil on canvas
25 x 32 inches / 63.5 x 81.28 cm

52 *Harbour Scene Nanaimo, B.C.*
1970 oil on canvas
32 x 40 inches / 81.3 x 101.6 cm

53 *Shawnigan Lake (Rose Island)*
1971 watercolour
20 x 24 inches / 50.8 x 61 cm

54 *Cowichan Bay and Mount Prevost*
1975 acrylic on canvas
25 x 32 inches / 63.5 x 81.28 cm

55 *Ladysmith, B.C.*
1982 acrylic on canvas
24 x 36 inches / 61 x 91.44 cm

56 *Ship with a Blue Hull, Cowichan Bay*
1982 acrylic on canvas
32 x 40 inches / 81.3 x 101.6 cm

57 *Mrs. S. on Heather Street*
1984 acrylic on canvas
25 x 32 inches / 63.5 x 81.3 cm

58 *Above Maple Bay, Mount Maxwell*
1986 pencil
10¾ x 13½ inches / 27.3 x 34.3 cm

59 *Cumshewa Inlet, Queen Charlotte Islands*
1990 acrylic on canvas
25 x 32 inches / 63.5 x 81.3 cm

60 *Saanich Inlet*
1990 acrylic on canvas
40 x 32 inches / 101.6 x 81.3 cm

61 *The Koksilah River at Cowichan Bay*
1990 acrylic on canvas
25 x 32 inches / 63.5 x 81.3 cm

62 *The Store at Allison Harbour II*
1991 acrylic on canvas
24 x 36 inches / 61 x 91.44 cm

63 *Above the Yacht Club, Penticton, B.C.*
1991 acrylic
25 x 32 inches / 63.5 x 81.3 cm

64 *The Beach at Savary Island*
1998 watercolour
20 x 24 inches / 50.8 x 61 cm

65 *The Seashore at Crofton*
1998 woodblock
22 x 28 inches / 56 x 71.12 cm

66 *Qualicum Beach 1998*
1998 watercolour
18 x 24 inches / 45.72 x 61 cm

67 *Wharves at Chemainus, 2000*
2000 watercolour
18 x 24 inches / 45.72 x 61 cm

68 *Englewood*
2002 watercolour
20 x 24 inches / 50.8 x 61 cm

69 *Rivers Inlet 2002*
2002 watercolour
20 x 24 inches / 50.8 x 61 cm

70 *Hopkins Landing, Howe Sound, 2002*
2002 watercolour
20 x 24 inches / 50.8 x 61 cm

71 *The Seashore near Crofton*
2002 watercolour
20 x 24 inches / 50.8 x 61 cm

72 *Mouth of the Courtenay River*
2003 watercolour
20 x 24 inches / 50.8 x 61 cm

73 *Trees, Sooke Harbour*
2003 watercolour
20 x 24 inches / 50.8 x 61 cm

74 *Trees, Savary Island, 2004*
2004 watercolour
24 x 20 inches / 61 x 50.8 cm

75 *The Car Ferry at Sidney, B.C., 2004*
2004 watercolour
20 x 24 inches / 50.8 x 61 cm

76 *Tugboats at Ladysmith Harbour*
2004 watercolour
20 x 24 inches / 50.8 x 61 cm

E.J. HUGHES: A BIOGRAPHICAL OVERVIEW

1913 Born February 17, North Vancouver, B.C., son of Edward Samuel Daniel Hughes and Katherine Mary (née McLean), residing in Nanaimo, British Columbia

1923 Family returns to North Vancouver

1926–27 Attends private art classes with Mrs. Verrall at North Star School, North Vancouver

1929 Enrolls in the four-year diploma program at Vancouver School of Decorative and Applied Arts (VSDAA)

1934–35 Awarded post-graduate scholarships at VSDAA

1934 Associates with Paul Gorenson and Orville Fisher to undertake private and public mural commissions as the Western Canada Brotherhood

1935 Group exhibition of drypoints at the Vancouver Art Gallery. First group mural commission, to paint six murals for the First United Church, Vancouver

1936 Second group exhibition of drypoints and colour linoleum block prints at the Vancouver Art Gallery

1937 Second group mural commission, for the W.K. Oriental Gardens Restaurant, Vancouver

1938 Third group mural commission, for the Malaspina Hotel, Nanaimo. Engages in commercial fishing in Rivers Inlet, B.C.

1938–39 Fourth group mural commission, for British Columbia Building at the Golden Gate Exposition, San Francisco

1939 Enlists as gunner in the Royal Canadian Artillery

1940 Posted to Ottawa and then to Camp Petawawa, with the rank acting sergeant
Marries Rosabell Fern Irvine Smith

1942 Appointed official war artist, Army Historical Section, with the rank of second lieutenant. Posted to England

1943 Promoted to lieutenant. Posted to Kiska, Aleutian Islands, Alaska

1944 Promoted to rank of captain and posted to Ottawa
Travels twice to New York to visit museums

1946 Receives honourable discharge from the Army and settles in Victoria, B.C.

1947	Awarded Emily Carr Scholarship upon being nominated by Lawren S. Harris and Ira Dilworth
1948	Elected to the Canadian Group of Painters after being nominated by A.Y. Jackson and George Pepper
	Sketches on Vancouver Island
1949	*Farm near Courtenay*, 1949, oil on canvas, acquired by the Vancouver Art Gallery
	Logs, Ladysmith Harbour, 1949, oil on canvas, acquired by the Ontario Art Gallery
1951	Moves to Shawnigan Lake, Vancouver Island, and establishes relationship with Dr. Max Stern of Dominion Gallery, Montreal
	Tugboats, Ladysmith Harbour, 1950, oil on canvas, acquired by the National Gallery of Canada
1953	First solo exhibition at Dominion Gallery, Montreal
	Beach at Savary Island, B.C., 1952, oil on canvas, acquired by the National Gallery
	Stanley Park, Vancouver, B.C., 1946 cartoon, acquired by the Montreal Museum of Art
1954	Commissioned by the Canadian Pacific Railway to paint a mural for the Tweedsmuir Park car on *The Canadian* train service
	Houses at Qualicum Beach, B.C., 1949, cartoon, acquired by the Art Gallery of Hamilton
1955	Hughes/Shadbolt exhibition, Montreal Museum of Fine Arts
	The Car Ferry at Sidney, B.C., 1952, oil on canvas, acquired by the National Gallery
	Calgary, Alberta, 1955, watercolour, acquired by the Glenbow Museum
1957	*Village Wharf*, 1956, oil on canvas, acquired by the National Gallery. (For later acquisitions, refer to www.chin.gc.ca.)
1958	Awarded Canada Council Fellowship to sketch throughout British Columbia
1959	*House at Qualicum Beach, B.C.*, 1949, oil on canvas, acquired by the Beaverbrook Art Gallery
1963	Awarded second Canada Council grant
	Sketches in the interiors of British Columbia and Alberta
1966	Elected as Associate of the Royal Canadian Academy
1967	Awarded third Canada Council grant
	Sketches in British Columbia

1967	Retrospective exhibition organized by Doris Shadbolt for the Vancouver Art Gallery and subsequently shown at York University in Toronto
1968	Elected Academician of the Royal Canadian Academy of Arts
1970	Awarded fourth Canada Council grant Sketches on the east side of Vancouver Island
1972	Moves to Cobble Hill near Duncan, Vancouver Island
1974	His beloved wife, Fern, dies
1975	Moves to Duncan and then to Ladysmith, both on Vancouver Island
1977	Moves back to Duncan, where he continues to reside
1983–85	National retrospective exhibition organized by Jane Young for the Surrey Art Gallery (also shown at the Art Gallery of Greater Victoria; Edmonton Art Gallery; Glenbow Museum, Calgary; National Gallery of Canada; and the Beaverbrook Art Gallery, Fredericton)
1985	Receives honorary diploma from Emily Carr College of Art and Design
1987	Dr. Max Stern dies
1990	Solo exhibition, Heffel Gallery, Vancouver
1991	Solo exhibition, Dominion Gallery, Montreal
1992	Canada Post issues stamp featuring Hughes' work *Christie Passage, Hurst Island, B.C.*, 1962
1993	Solo exhibition organized by Patricia Salmon for the Nanaimo Art Gallery, featuring sketches of Vancouver Island
1994	*The Vast and Beautiful Interior*, exhibition organized by Jann L.M. Bailey for the Kamloops Art Gallery (also shown at the Grand Forks Art Gallery, Vernon Art Gallery, Kelowna Art Gallery, Art Gallery of the South Okanagan, Prince George Art Gallery)
1995	Receives honorary degree of Doctor of Fine Arts from the University of Victoria
1997	Receives honorary degree of Doctor of Letters from Emily Carr Institute of Art and Design

2000 Receives honorary degree of Doctor of Fine Arts from Malaspina University-College
 Dominion Gallery ceases operations

2001 Receives the Order of Canada

2003 National retrospective exhibition organized by Ian Thom for the Vancouver Art Gallery (also touring to
 the McMichael gallery, Kleinburg, Ontario; the Art Gallery of Nova Scotia, Halifax; the Art Gallery of
 Greater Victoria)

2005 Receives the Order of British Columbia

REFERENCES

Books

Bailey, W.H. *Defining Edges: A New Look at Picture Frames.* New York: Harry Abrams, 2002.

Gimpel, René. *Diary of an Art Dealer.* Translated by John Rosenberg. New York: Farrar, Straus and Giroux, 1966.

Grampp, William. *Pricing the Priceless: Art, Artists and Economics.* New York: Basic Books, 1989.

Grenville, Bruce, ed. *The Uncanny: Experiments in Cyborg Culture.* Vancouver: Vancouver Art Gallery and Arsenal Pulp Press, 2001.

Guggenheim, M. *Le cornici italiene dalla meta del secolo XV allod del scorio XVI.* Milan, 1897.

Johnson, Paul. *Art: A New History.* New York: HarperCollins, 2003.

Maas, Jeremy. *Gambart: Prince of the Victorian Art World.* London: Barrie & Jenkins, 1975.

Meech-Pekarik, Julia. *Frank Lloyd Wright and the Art of Japan: The Architect's Other Passion.* New York: Harry N. Abrams, 2001.

Milroy, Sarah. "Between a Rock and a Landscape." *Globe and Mail,* January 31, 2004.

Mitchell, Paul, and Lynn Roberts. *A History of European Picture Frames.* London: Paul Mitchell Limited: Merrell Holberton, 1996.

Muensterberger, Werner. *Collecting: An Unruly Passion: Psychological Perspectives.* Princeton: Princeton University Press, 1993.

Reitlinger, Gerald. *The Economics of Taste.* Vol. 1, *The Rise and Fall of Picture Prices, 1760–1960.* New York: Holt, Rinehart & Winston, 1965.

Rodwell, Jenny, and George Short. *The Complete Guide to Picture Framing.* New York: Macdonald Illustrated Books, 1992.

Russell, John. *Matisse: Father and Son.* New York: Harry Abrams, 1999.

Salmon, Patricia, and Leslie Forsyth Black. "E.J. Hughes: Painter of the Raincoast." In *Raincoast Chronicles Ten.* Madeira Park, B.C.: Harbour Publishing, 1982.

Simon, Jacob. *The Art of the Picture Frame.* London: National Portrait Gallery, 1996.

Wood, Christopher. *The Great Art Boom, 1970–1997.* Surrey, U.K.: Art Sales Index, 1997.

Exhibition Catalogues

Dawn, Leslie Allan, and Patricia Salmon. *E.J. Hughes: The Vast and Beautiful Interior.* Kamloops: Kamlops Art Gallery, 1994.

Salmon, Patricia. *E.J. Hughes: Paintings, Drawings and Watercolours.* Vancouver: Heffel Gallery, 1990.

———. *E.J. Hughes: 40 ans avec la galerie / 40 Years with the Gallery.* Montreal: Galerie Dominion, 1991.

———. *From Sketches to Finished Works by E.J. Hughes.* Nanaimo: Nanaimo Art Gallery and Exhibition Centre, 1993.

Shadbolt, Doris. *E.J. Hughes: A Retrospective Exhibition Organized by the Vancouver Art Gallery.* Vancouver: Vancouver Art Gallery, 1967.

Thom, Ian. *E.J. Hughes.* Vancouver: Douglas & McIntyre, 2002.

Young, Jane. *E.J. Hughes, 1931–1982: A Retrospective Exhibition.* Surrey, B.C.: Surrey Art Gallery, 1983.

INDEX

Works from the Barbeau Foundation Collection are designated with the # that corresponds with the list on pages 164–68; all remaining works are in other collections. Page numbers in *italic* refer to illustrations.

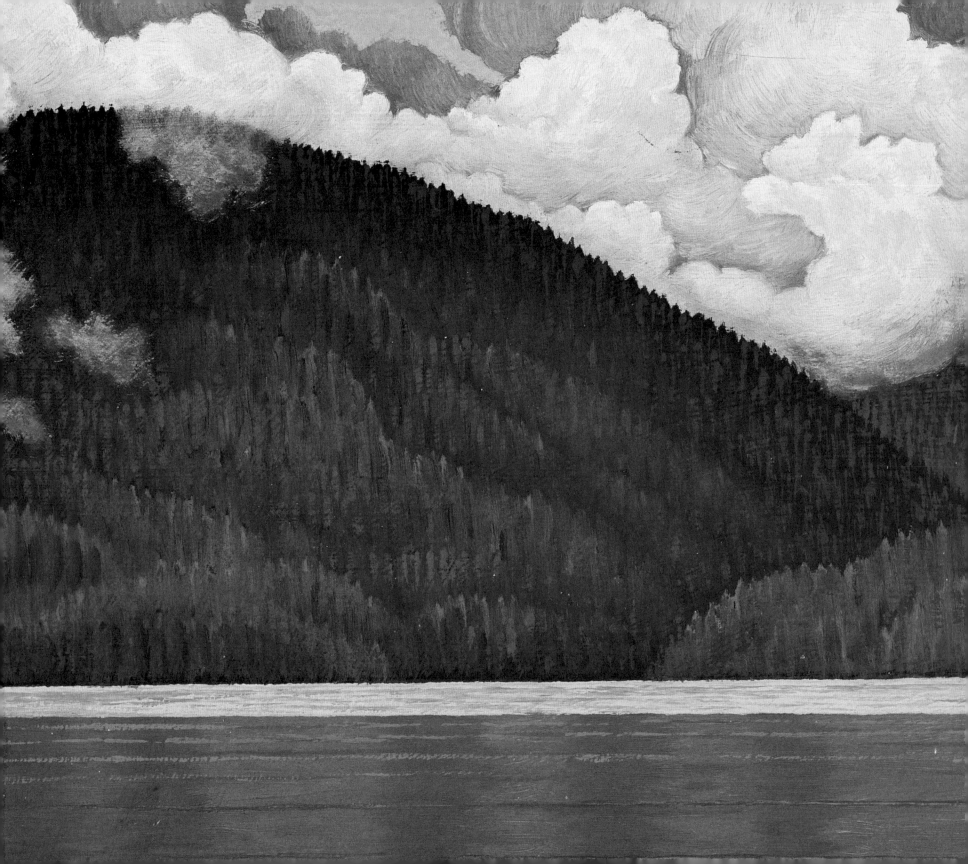